IMAGES
of America

HULL
AND NANTASKET BEACH

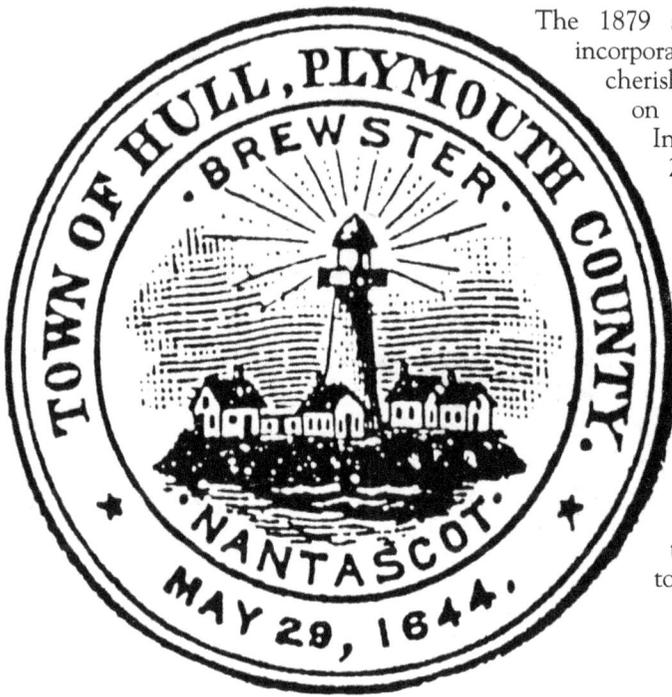

The 1879 seal of the Town of Hull incorporates one of its most cherished sites—Boston Light on Little Brewster Island. Incorporated as Hull on May 29, 1644, Hull was originally known as Nantascot, the name given to the land by Native Americans. It means "the place between the tides," referring to Hull's unique geography of being a peninsula between the ocean and the bay. Although part of Plymouth County since the 1800s, Hull was originally part of Suffolk County until all but the Brewster Islands was added to Plymouth County.

The Nantasket Steamboat Company operated the longest running passenger line in the country. Beginning in 1818 with the maiden voyage of the *Eagle* from Boston to Hull, the Nantasket Steamboat Company proudly operated without loss of a passenger until it ceased operations in 1929. Recognizing the soundness of the company and the strong market it had with its runs to Hull and Nantasket Beach, many people purchased shares in the company.

IMAGES
of America

HULL
AND NANTASKET BEACH

The Committee for the
Preservation of Hull's History

ARCADIA
PUBLISHING

Published by Arcadia Publishing
Charleston, South Carolina

Library of Congress Catalog Card Number: 00-100307

For all general information contact Arcadia Publishing at:
Telephone 843-853-2070
Fax 843-853-0044
E-mail sales@arcadiapublishing.com
For customer service and orders:
Toll-Free 1-888-313-2665

Visit us on the Internet at www.arcadiapublishing.com

CONTENTS

EMBERTON

FORT REVERE PARK

STONY BEACH

WIND EMERE

ALLERTON

ALLERTON HARBOR

HULL VILLAGE

GALLOPS HILL

BAY SIDE

HINGHAM BAY

MASSACHUSETTS BAY

WAVE LAND

STRAWBERRY HILL

KENBERMA

SUNSET POINT

WHITE HEAD

SAGAMORE HILL

SURF SIDE

WEIR RIVER

HAMPTON HILL

NANTASKET HARBOR

NANTASKET BEACH

ATLANTIC HILL

GUNROCK BEACH

CRESCENT BEACH

STRAITS POND

ROCKAWAY ANNEX

HINGHAM

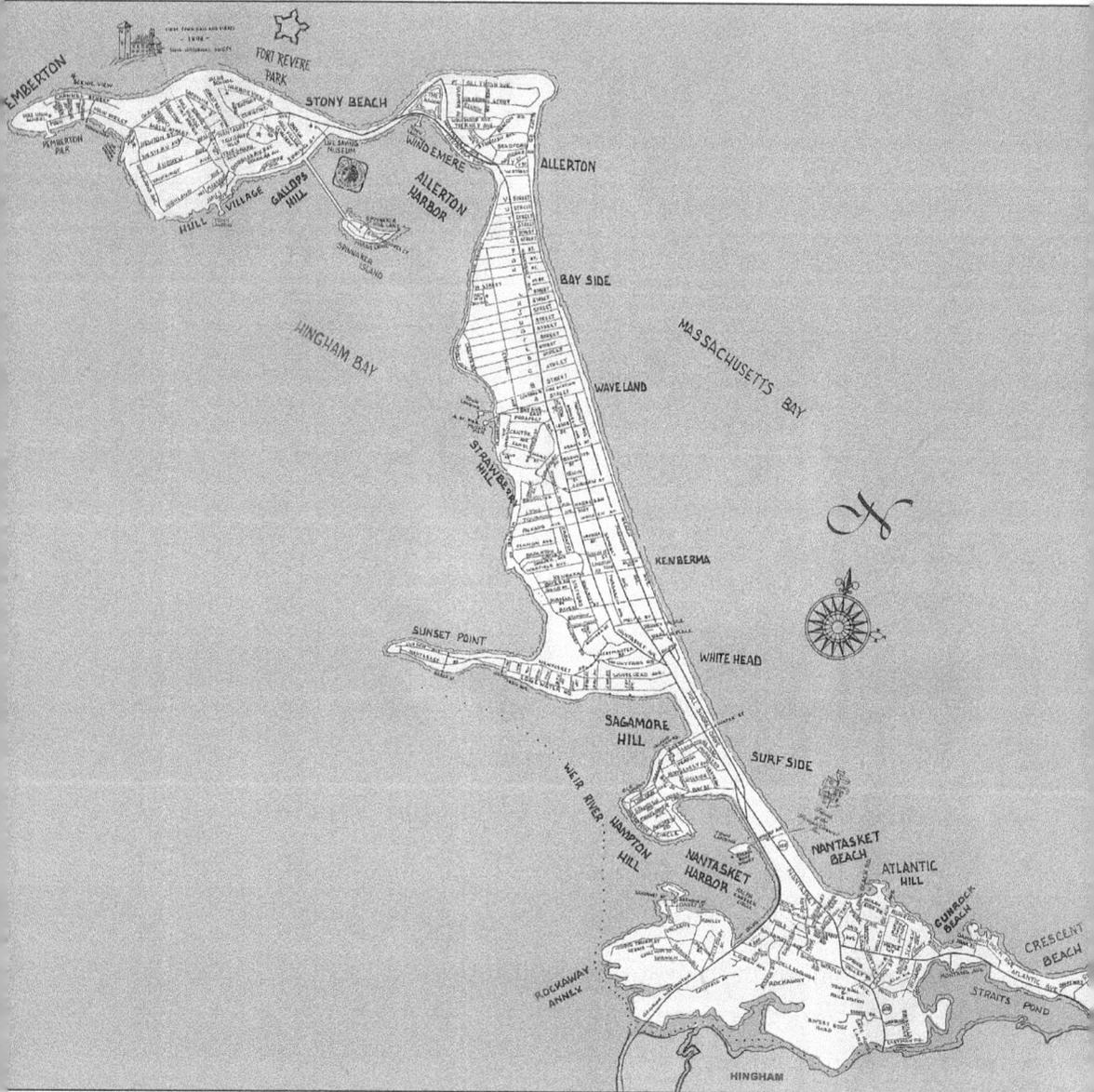

Full size copies of the map are available at most local museums, businesses, and the town hall.
(Use of map courtesy of the Fieldstone Publishing Company, Marshfield, Massachusetts.)

INTRODUCTION

There has never been a comprehensive history written on the town of Hull. Over the course of the past few centuries numerous writers have attempted, to varying degrees of success, to accomplish such a feat, but all have found that there simply exists too much history for any one person to collect, interpret, and disseminate. Professor John Moore wrote 27 chapters at the turn of the last century before giving up, and he was writing before the advent of Paragon Park, the story of which alone could fill volumes. Dr. William M. Bergan published the best generally acknowledged tome of local lore in his 1968 *Old Nantasket*, but even that book, while wildly entertaining and revealing, falls short of giving a thorough and complete overview of the storied past of the Hull peninsula. The town is in desperate need of a scholarly history that reaches from its earliest European settlers to the present day.

This book is not that book.

Images of America: Hull Nantasket Beach will take the reader from 1621 to the present day through words and pictures, but its authors do not profess it to be the "be-all, end-all" history of the town. Inside these pages you will find many of the familiar stories and legends that still waft through the town via the oral tradition, and hopefully you will find something new on just about every page.

The book starts where the town's history began; between the hills at the head of the peninsula, in the section known as Hull Village. Changes that have taken place in the Village for almost four centuries have shadowed those that have shaken American coastal society as a whole. Open colonial farmland gave way to Victorian mansions in an age of opulence and a seaside getaway, finally reverting back to a predominantly year-round community during this century. Along the way, the Village has been home to American presidents, captains of industry, and entertainment and sports heroes, but has never lost the small town feel that defines it even today. The old names are still there, as Cleverlys and Popes still mingle with Mitchells and Means much like they did one hundred years ago.

Throughout the book you will meet many of the personalities that have given Hull its character, from politicians and hard-working local entrepreneurs to nationally recognized lifesaving heroes and nosey newspaper editors. Many of the images contained within these pages will seem very familiar, as some of us still live in the venerable estates around town. Others are long ago disappeared reminders of what used to be, and will be seen for the first time by many people. There are hotels that once stood on every inch of the shore, placing visitors as close as possible to the sea without actually depositing them in it. On the extreme northern bluffs of

the peninsula, the military stood in readiness to defend Boston Harbor in times of war when some of the country's most powerful weaponry vigilantly pointed out to the Atlantic. Municipal and religious buildings, our local landmarks, the places where we work, learn, and pray form a chapter unto themselves. Sea-going and rail-bound transportation, how millions came to Hull, link up once again in this book as they did so many years ago.

We hope you will use this book as a starting point in your education on the history of Hull. If we have succeeded, it will send you off to the Hull Public Library or one of the many beckoning nonprofit societies to learn more. Enjoy.

One

HULL VILLAGE

WHERE IT ALL BEGAN

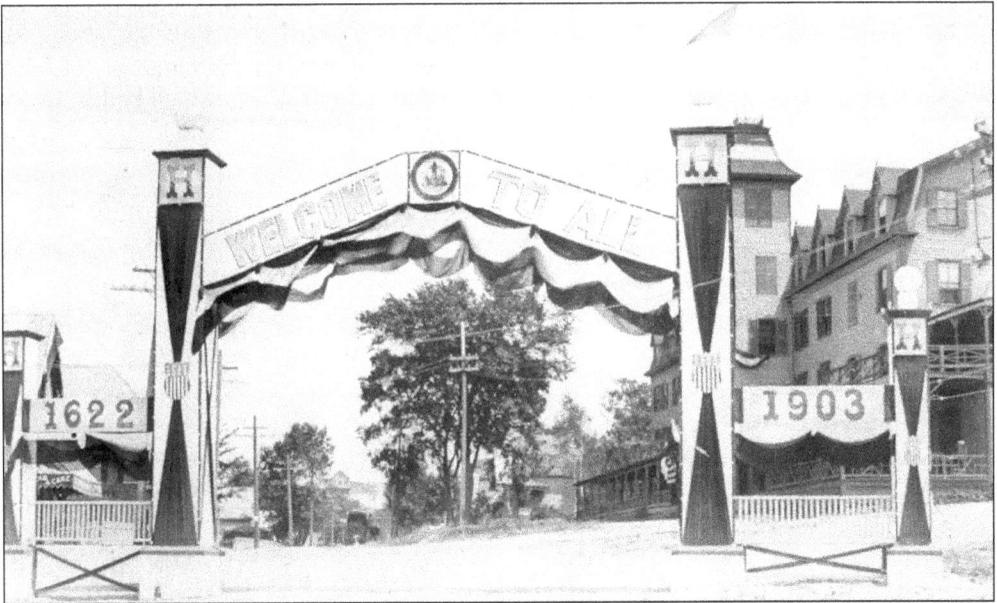

In 1903, the organizers of Hull's first Old Home Week Celebration made plans for erection of a welcome gate at the western end of Hull Village. However, they had no idea what kind of an archeological discovery they had set themselves up to make. Uncovering a clay-walled cellar, they stumbled across the alleged foundation of Myles Standish's *c.* 1621 trading post. The Pilgrims' first visit to Hull preceded the first true European settlement by one year. In 1622, three stray Englishmen purchased the Nantasket peninsula from the local Wampanoag sachem and settled in the protected vale between Hull and Telegraph Hills to start a fishing village. That village has gone from quiet and industrious solitude to playground of the rich and famous, and then again became happily hidden away, but for nearly four centuries the Village has remained the heart of Hull.

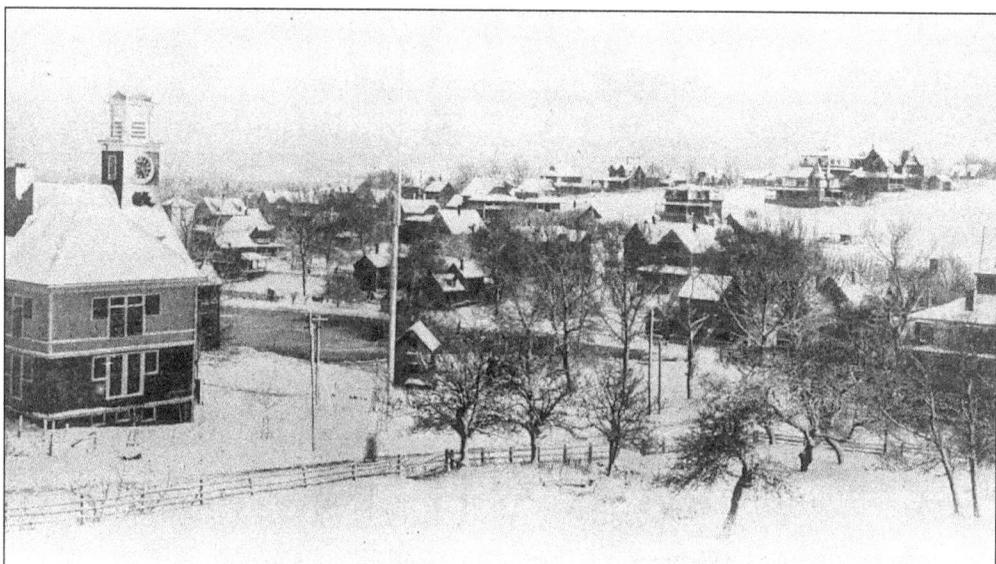

Birdseye View of Hull looking South (in winter), Hull, Mass.

Peeking to the south from just alongside Nantasket Avenue on Souther's Hill, the Village School looms prominently at the left across from the 1848 Town Hall and the frozen pond at the Village Park. In the foreground fruit trees temporarily stand over the future site of John Wheeler's garage, while in the background summer homes sparsely decorate Hull Hill.

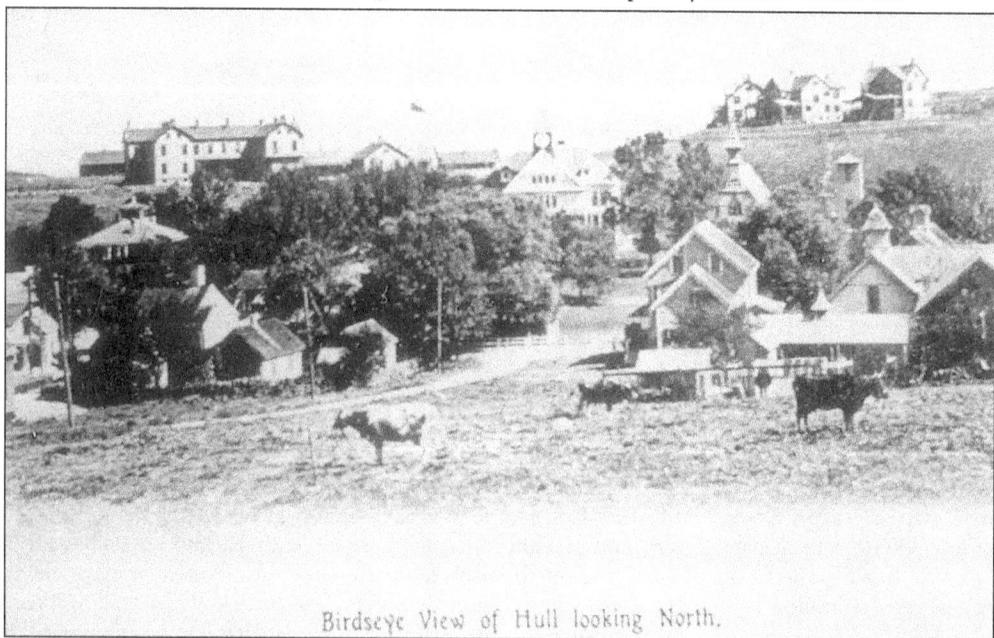

Birdseye View of Hull looking North.

Standing on Hull Hill and looking north, a trio of famous Village landmarks stare back. In the center stands the Village School, while to the right the 1880 Hull Methodist Episcopalian Church points skyward. To the right of the church, the square tower of the old Town Hall stands above the trees. In the foreground, cows graze on abundant open land— both rarely seen in Hull these days.

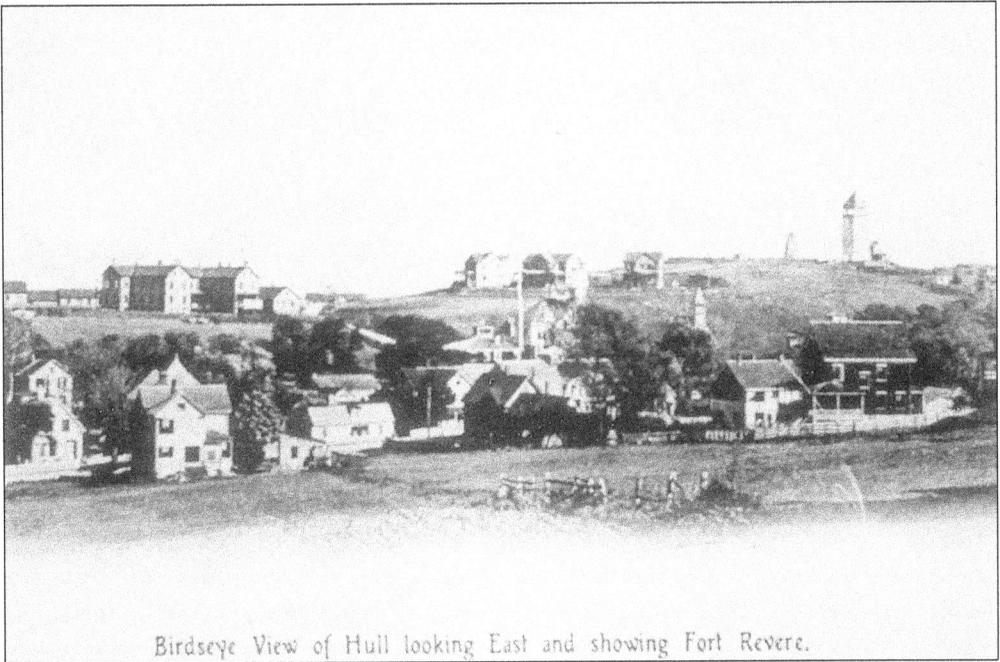

Birdseye View of Hull looking East and showing Fort Revere.

From a similar stance looking eastward, the layout of Fort Revere becomes increasingly apparent. Beside the 1903 water tower stands the shorter marine telegraph station. The officers' housing stands a plateau below to the left, while the ever-visible facades of the Methodist Episcopalian Church and the Village School appear again.

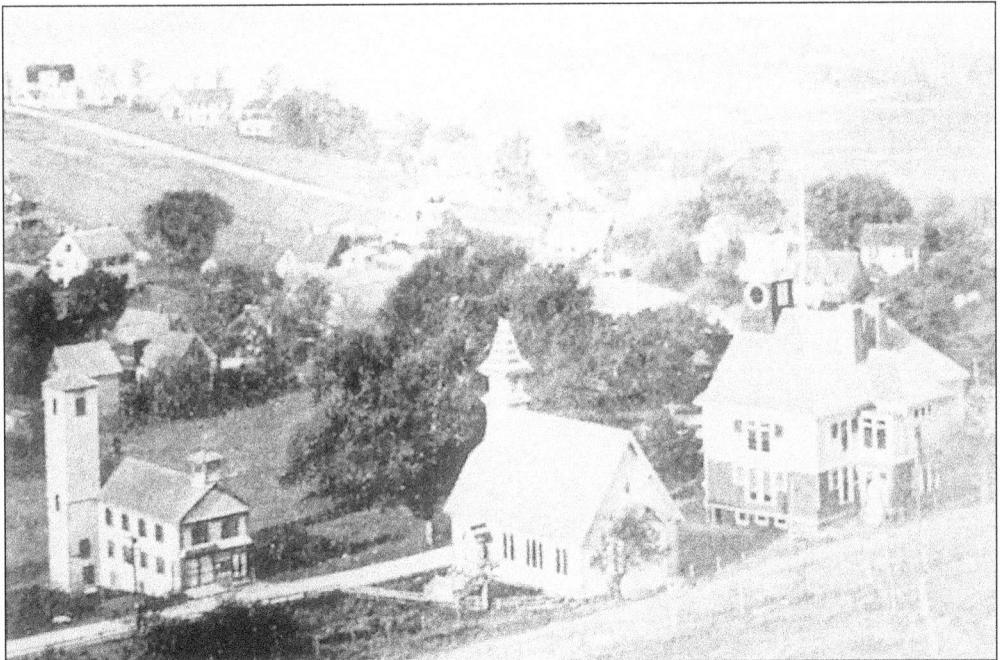

Looking over the shoulders of the church and school, the spectator can see a bird's-eye view out of Hull Village to Windmill Point and the Pemberton Hotel. The rough and unsettled face of Peddocks Island contrasts the increasingly populous roadways of Hull.

11

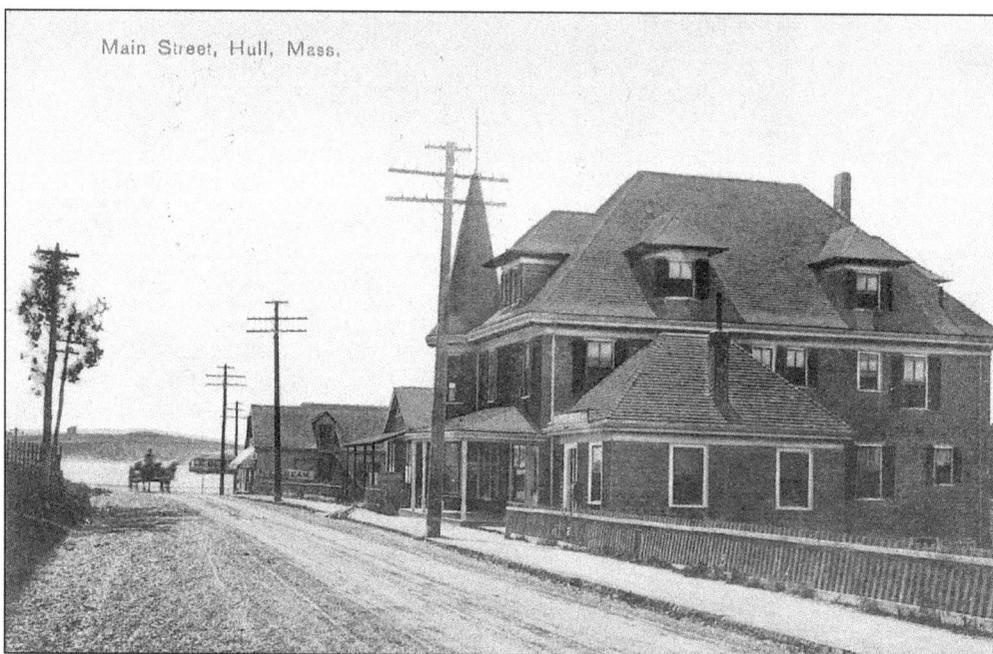

Heading west down Main Street one passes the small Village Post Office on the right, now a private residence. The building at the end on the right has always been some type of a local food-related business. Today it is the headquarters for Z-Chef, a catering concern. The Oregon House was located across the street, where today is the former St. Mary's of the Bay Catholic Church, now a private residence.

At the intersection of Spring Street and Nantasket Avenue is the garage and base of operations for John R. Wheeler, the financier of the Old Ring, described in more detail in chapter nine. Wheeler sold Studebakers from this location. Today it is a marine service center and garage.

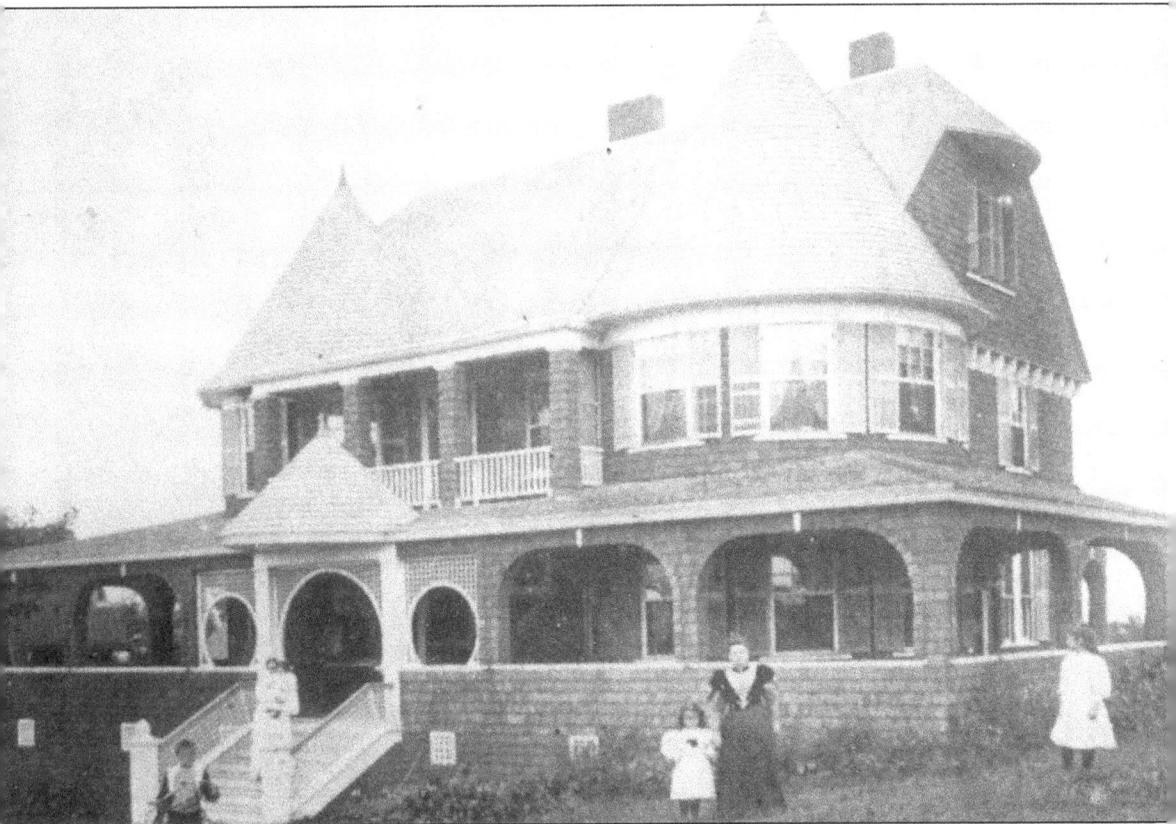

Hull Village exhibits a wide range of architectural forms, from the colonial Cape Cod–style Loring House on Spring Street to the fanciful and elaborately decorative Victorian and Queen Anne–style homes on Hull Hill. This fine example of such a home still exists today on the corner of Newton Street and Highland Avenue. Following the Industrial Revolution, American architecture moved from simple efficiency to the whimsically ornate. These structures enabled the occupant to enjoy the ocean breezes and panoramic views from the wide porches, balconies, and turrets. The invention of steam heat and duct work enabled there to be a more flexible design of homes, since the rooms were no longer dependent on a central chimney. Many homes on Hull Hill took in boarders for short terms, as well as vacationers exchanging the smog, noise, and unpleasantness of the cities for the refreshing salt air and invigorating swims in the waters surrounding the Nantasket peninsula.

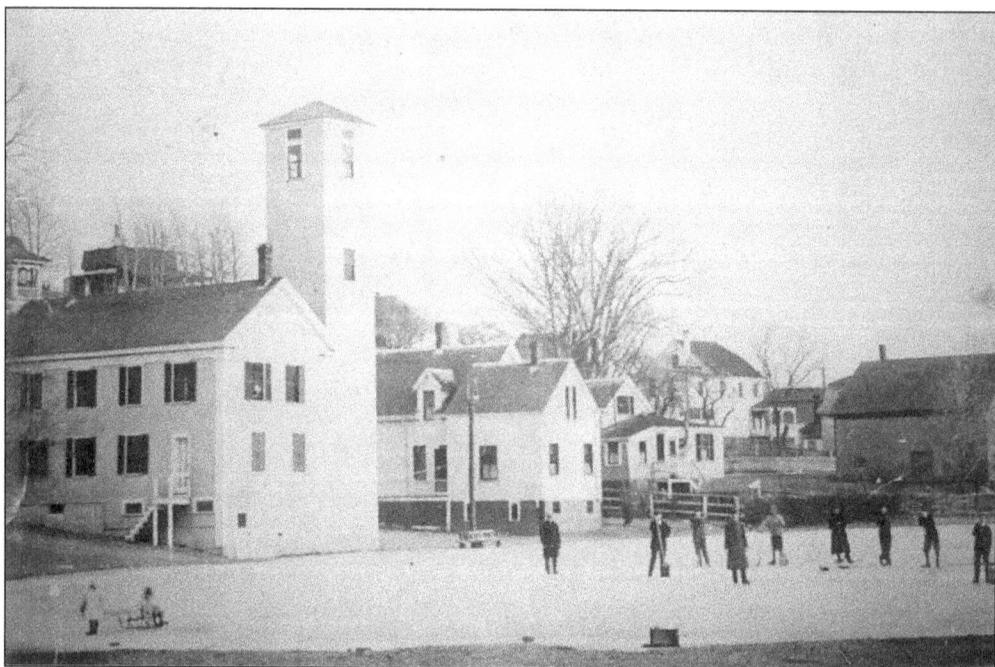

The Village Park, behind the old Town Hall, was a popular spot in the winter, when the natural spring water was frozen over creating a skating pond. This tradition continues to the present day. The tower shown was used for the fire station located on the Town Hall's first floor, but has since been shortened.

The old Hunt estate, located at the site of the present Hull Public Library on Main Street, is shown in this picture when it served as the summer home of John Boyle O'Reilly, the noted Irish patriot. He eventually razed this home in 1889 and built a magnificent residence in its place. The new home became the Hull Public Library in 1913, several years after O'Reilly's death.

14

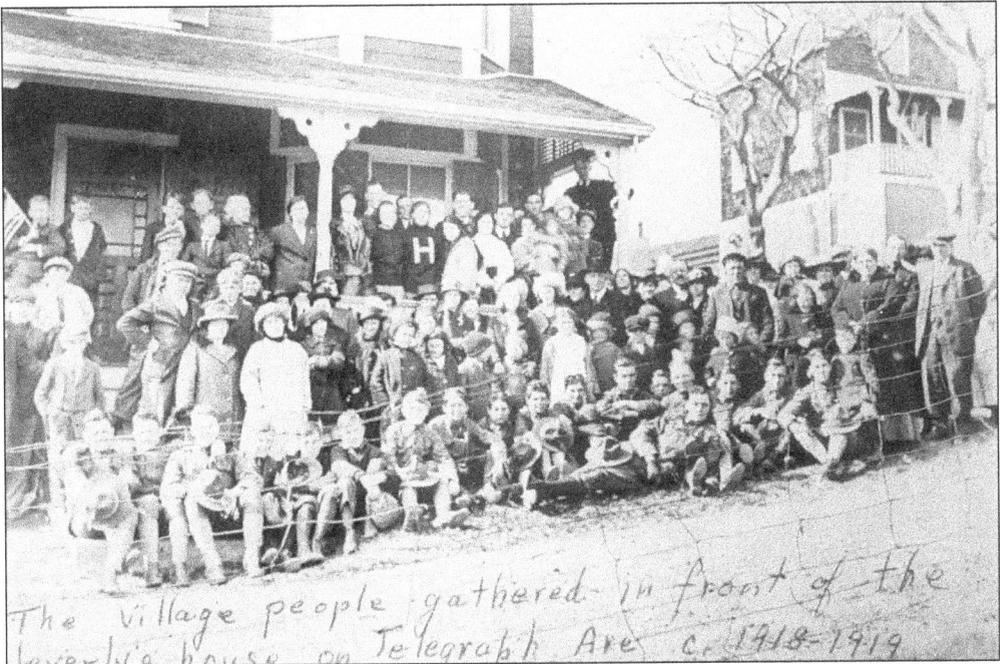

The village people gathered in front of the Cleverly house on Telegraph Ave c. 1918-1919

Hull Village residents gathered often for family and holiday events. The Cleverly family is shown in this 1918–1919–era picture at a patriotic gathering on Telegraph Avenue. Descendants of the Cleverly family, whose surname first appears in Hull records in the 1830s, still live in Hull.

Along Spring Street, just past the site of the Hull Cemetery, several homes are situated on Gallops Hill, overlooking Hull Bay. Included is the summer home of Boston Mayor James Michael Curley (at right). Curley left Hull after the death of his wife, not willing to continue without her at the scene of so many happy memories.

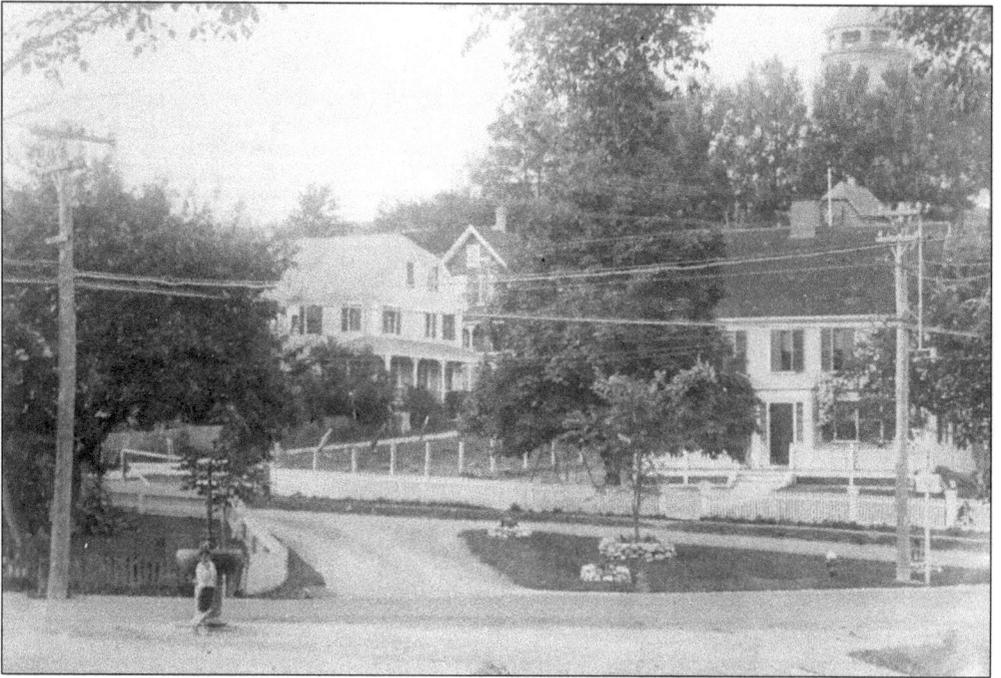

Situated on the right, across from the lawn of the O'Reilly estate at Elm Square, the intersection of Main Street and Spring Street, is the home of Simon Peter Lucihe, who was the telegraph operator atop the hill behind his home.

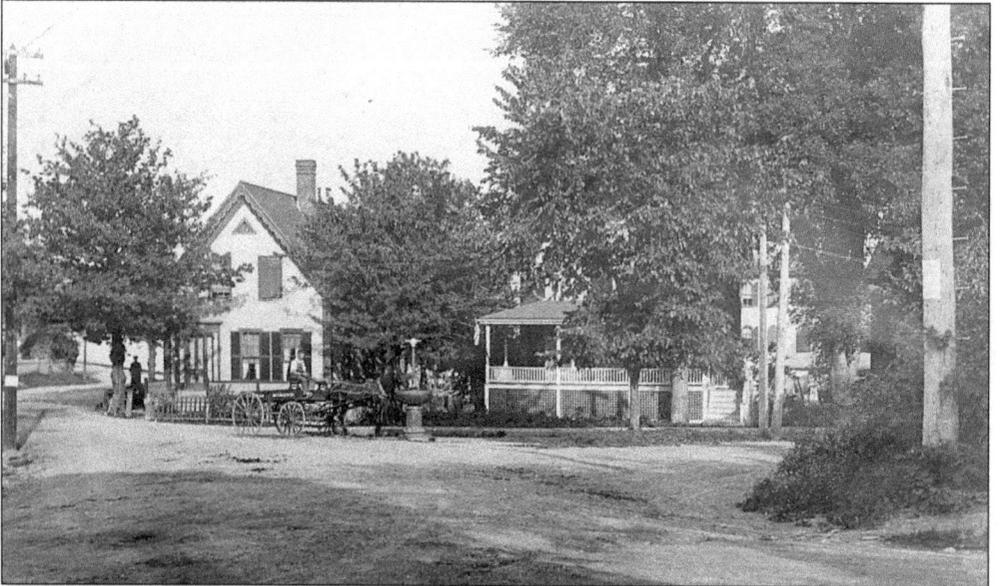

Quaint Hull Village is seen in this view of Elm Square across from the O'Reilly estate, at the intersection of Vautrinot Avenue and Main Street, today the site of the public library. A wagon from Daley and Wanzer, then a local livery service which became a nationwide moving company still operating out of Hull by the Fleck family, stops at a fountain for its horse's refreshment. The charm of the Village will always remain, as this area has been designated an historic district by the town.

Two

MARITIME TRADITIONS
LIFE BY THE SEA

Born in a town surrounded on three sides by water, most Hull young men grew up dreaming of spending the better parts of their lives on the sea. For the most part, those dreams easily came true. Jobs abounded on steamboats, coastal schooners, tugboats, fishing vessels, lobster boats, pilot boats, and in the various sea-related services, such as the Navy, the Life-Saving Service, the Lighthouse Service, and the Revenue Cutter Service. Many rich summer visitors looked to towns like Hull for experienced boatmen to handle their luxurious yachts while they entertained their guests. Whether he became a lifesaver or a lobsterman, each boy hoped to one day earn the right to be called by the name his father and grandfather proudly wore before him—"Captain."

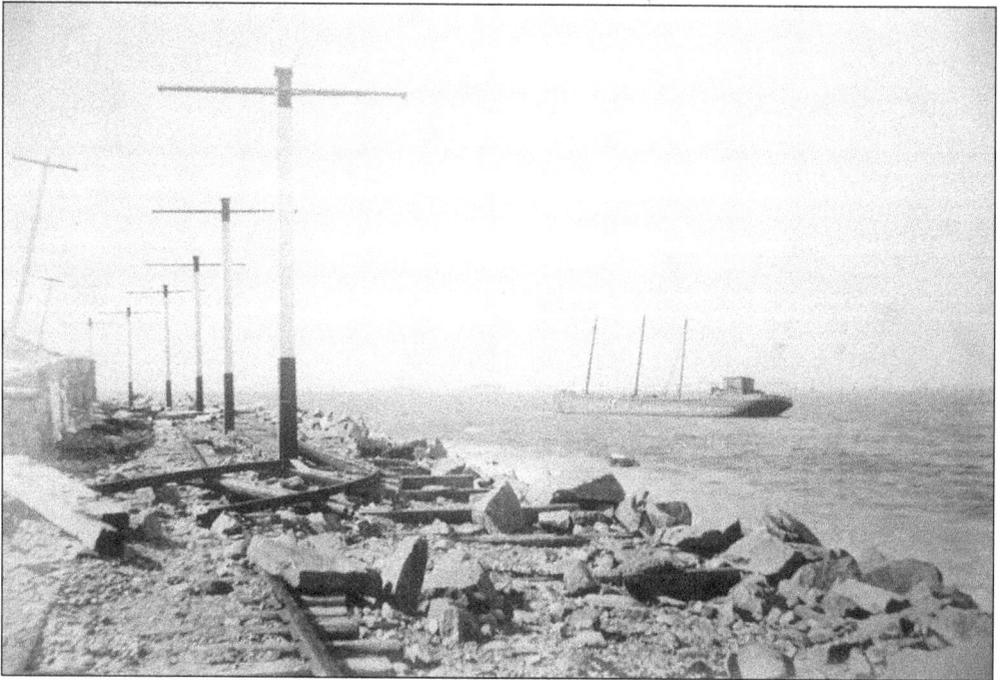

Each boy knew as well, though, that dreams of life on the sea could quickly turn into nightmares. Every sailor, like the four men aboard the schooner-barge *Glendower* in February of 1899, accepted the chance that his vessel could one day be wrecked in a storm, and his life put in danger.

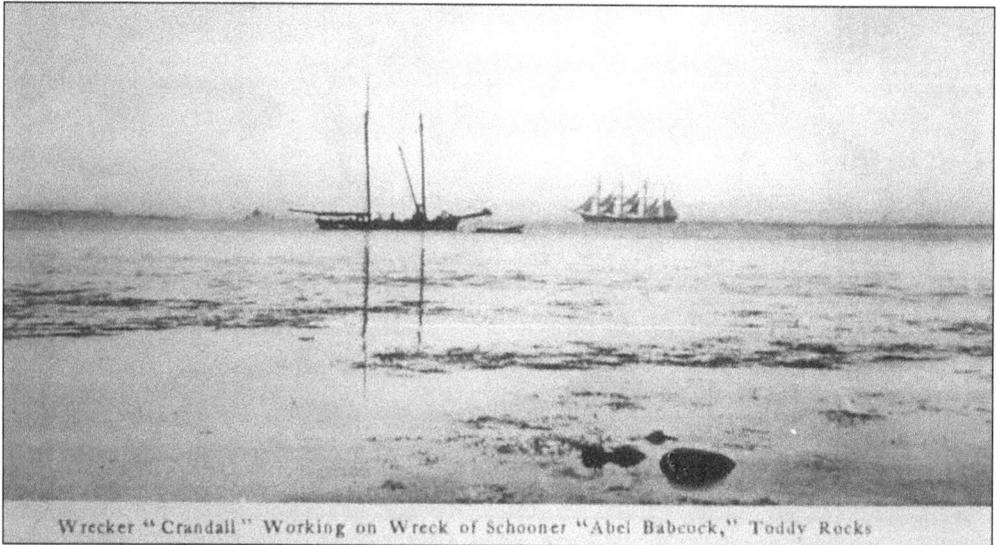

Wrecker "Crandall" Working on Wreck of Schooner "Abel Babcock," Toddy Rocks

Shipwrecks provided even more jobs for local boatmen, as insurance companies paid fees to wreckers who either re-floated or removed cargo from stranded vessels. In between disasters, wreckers could fill their spare time dragging the ocean floor for anchors or anything else of potential value.

18

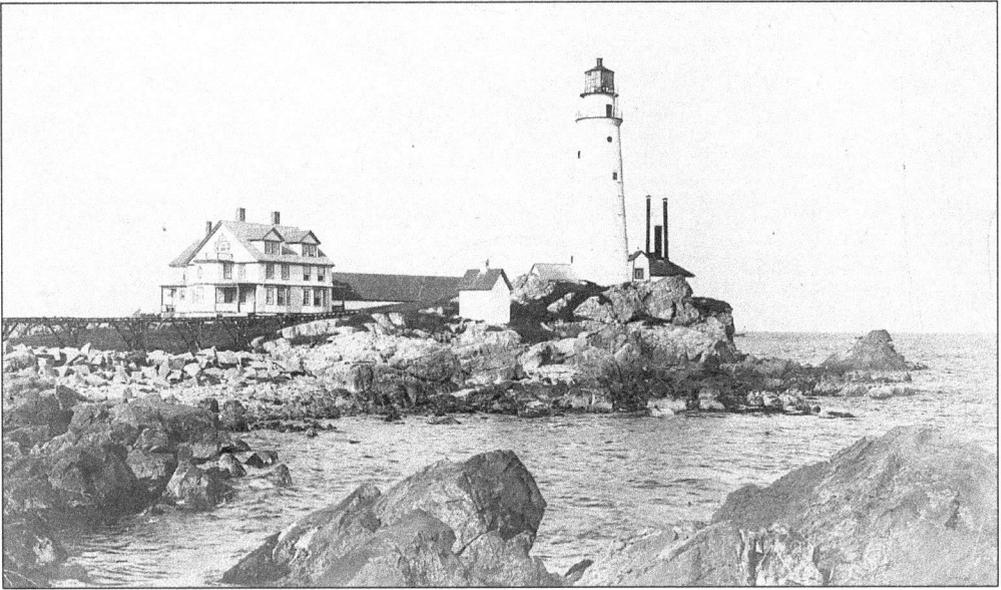

To prevent shipwrecks from occurring, to the dismay of the wreckers, the folks in Hull constructed their first lighted aids to navigation, burning beacons, as early as 1679. In 1715, they donated Little Brewster Island to the Great and General Court at Boston for the purpose of building America's first lighthouse, Boston Light, the following year. The light today receives its electricity through an underwater cable from Hull.

Some beacons, day markers, and lighthouses once known to every passing mariner have come and gone. The 40-foot-tall Point Allerton beacon that once marked the southern boundary of the entrance to the lighthouse channel toppled beneath the waves during a 1920s storm.

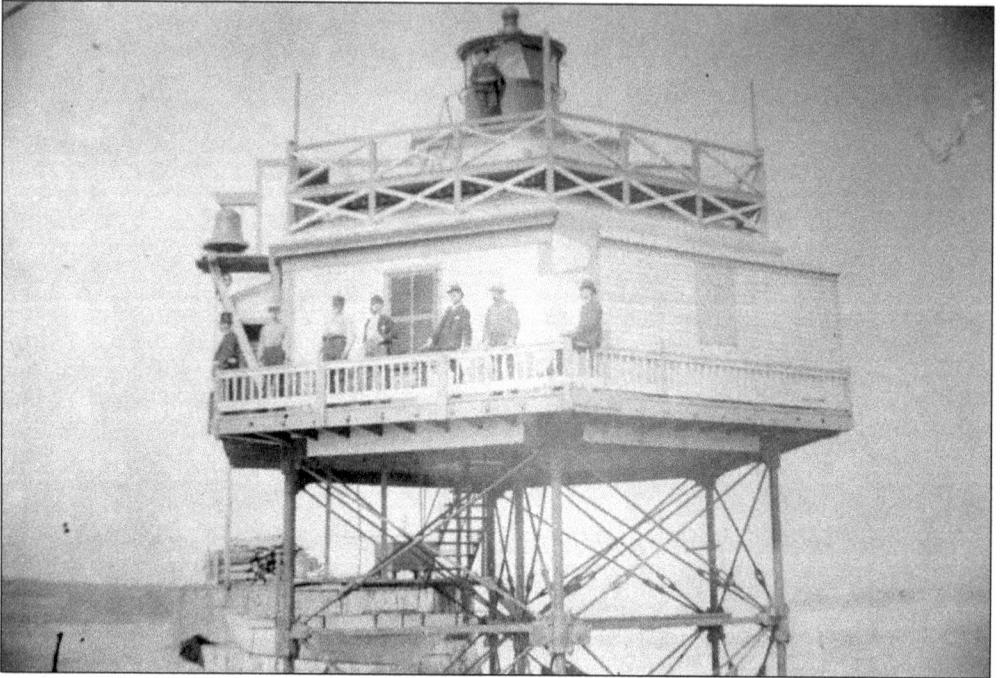

Built in 1856, Narrows Light (also known as Bug or Spit) stood 35 feet tall on the end of Great Brewster Spit and helped guide ships clear of Harding's Ledge outside of Point Allerton. The lightkeepers at Boston, Narrows and the Lovell's Island Range Lights considered Hull their hometown, sending their children by boat to Hull schools.

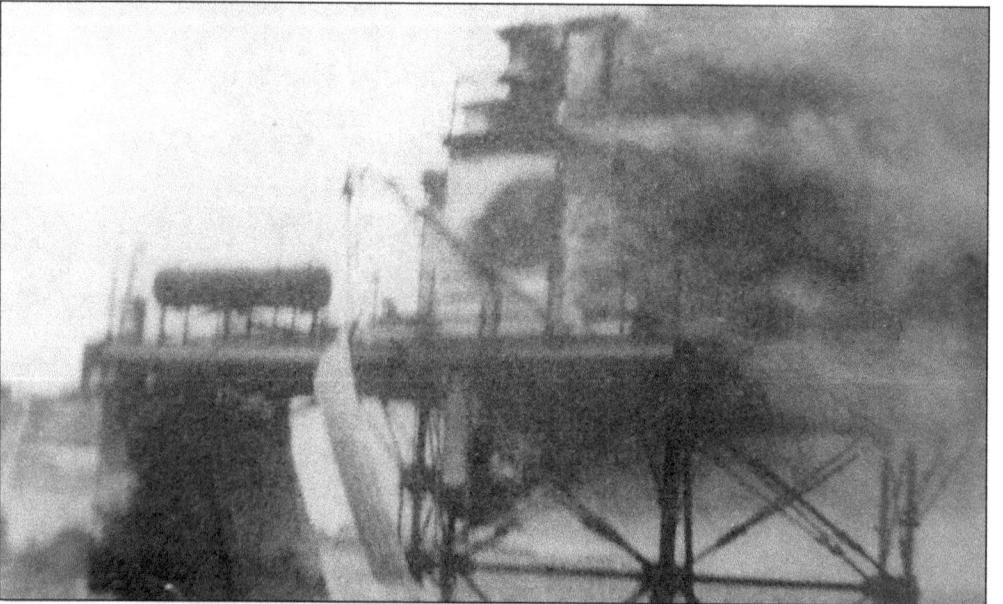

On June 7, 1929, Keeper Tom Small watched in horror as the flame from his paint-burning torch ignited a spot on the light above his head, and quickly turned his working home into a raging inferno. Within minutes, Bug Light burned completely. Today a small marker serves to steer mariners clear of the spit.

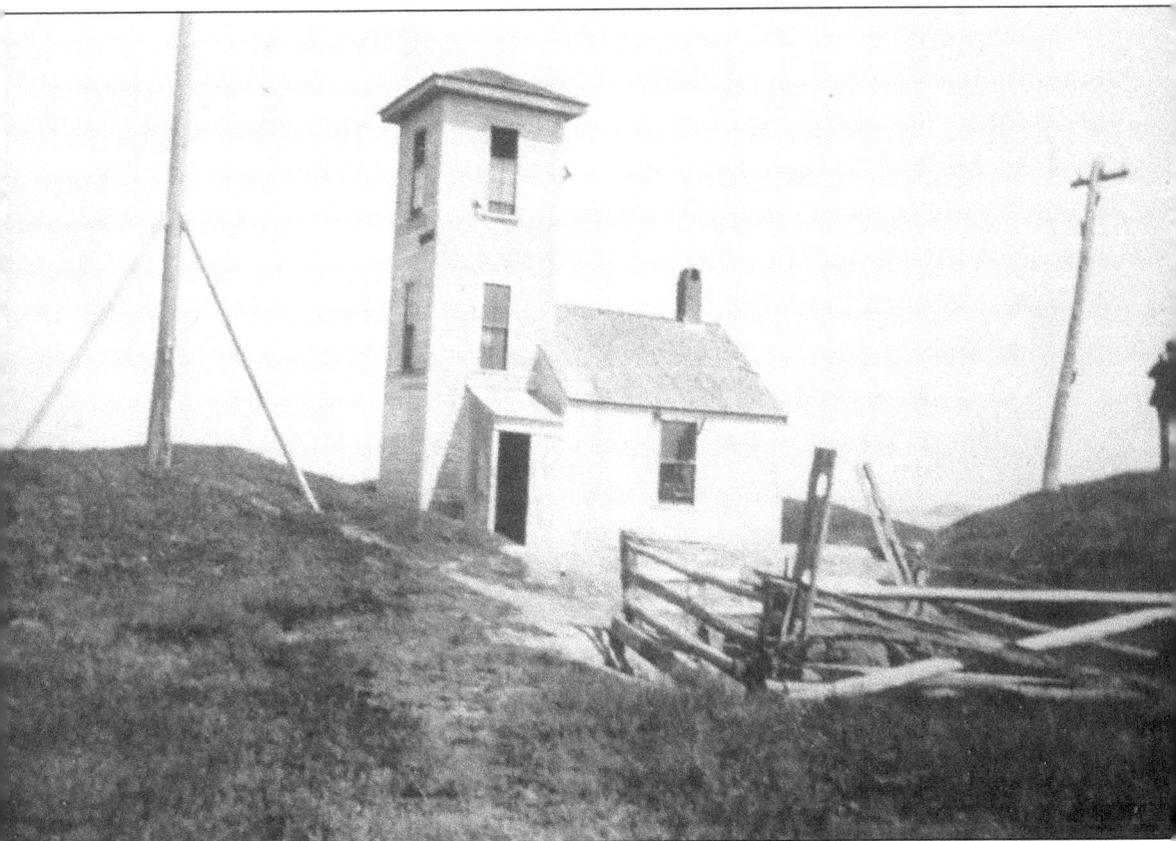

From the time of its earliest settlement, Hull's hills have provided grand panoramic views of naval activity in Boston Harbor. John Winthrop, governor of the Massachusetts Bay Colony, visited the peninsula in 1631, and acknowledged the military potential of the northernmost hills. He retreated into the harbor after two days of high winds, drenching rains, and eating raw mussels off the beach. The drumlin now known as Telegraph Hill possibly got its name as early as 1827 when John Rowe Parker extended the inner harbor's telegraph station to its apex. By mounting flags on three arms on a mast in different combinations, Hull's telegraph operators could send messages to Boston almost instantaneously. The first electrical telegraph came to Hull in 1853 and continued until at least the turn of the century.

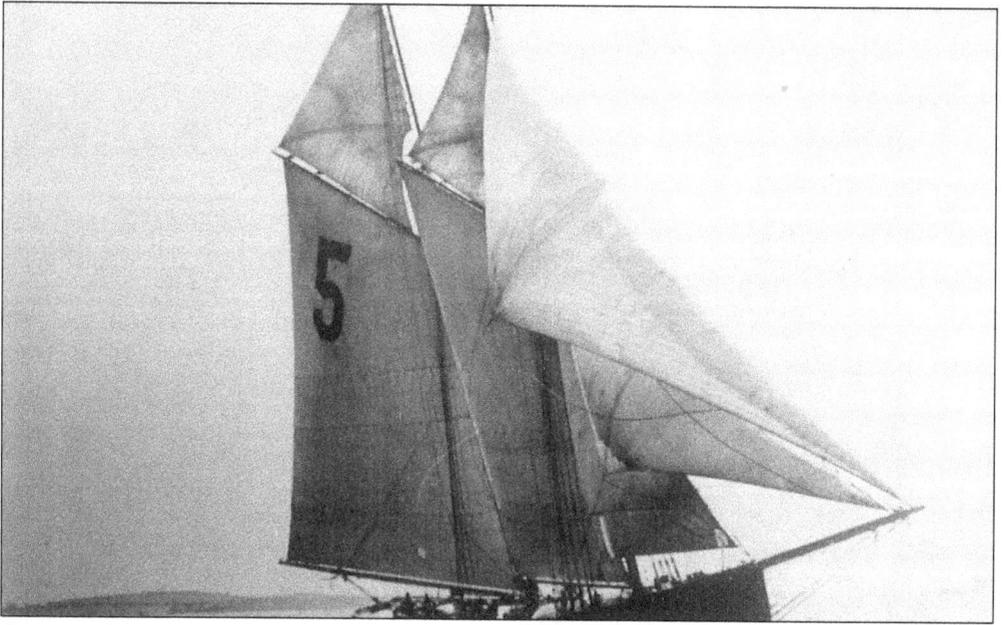

Once inside the harbor, sailors relied on pilots. Pilot boats, like the schooner *Hesper* above, met vessels at the mouth of Boston Harbor and placed an experienced pilot on board, one who knew the local waterways like no other man around. Taking the controls, the pilots brought the ships all the way into the port of Boston.

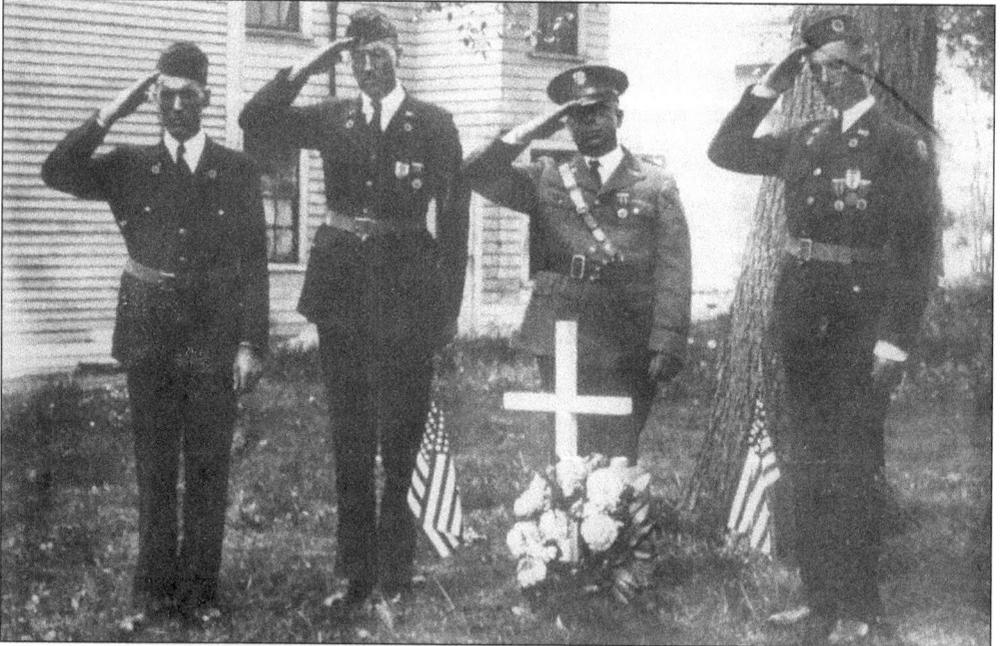

If lights, pilots, and lifesavers all failed, the town of Hull always remembered the dead left upon its shores by the sea. A mass burial site of approximately one hundred unknown shipwreck victims buried in the Hull cemetery today bears the name Strangers Corner. In a turn-of-the-century ceremony shown above, the town paid tribute to a British Royal Marine officer killed in a Revolutionary War raid at Boston Light and buried in Hull Village.

What good would a visit to Hull be without donning a risqué bathing costume and going for a swim? During the early 19th century, American social structure only allowed for leaves of absence from daily toil on the farm for reasons concerning health or religious revival. Oftentimes physicians recommended a dip in the ocean as the most salubrious of getaways.

Hull's very first settlers came to fish in 1621, and the tradition continues today. Fish stories abound in Hull, from the catching of a "squeegee" in 1897 (a fish with the head and bill of a duck, the body and shape of a fish, and wings and legs like a bird), to sightings of sea monsters, to the standard "big one that got away." Charters operate through the Nantasket Beach Saltwater Club, founded in 1961 by Hull's first fishing legend, Ollie Olsen.

The original Hull Yacht Club boasted a membership that included the most affluent and influential names in Boston: Melvin Ohio Adams, Lizzie Borden's defense attorney; Albert A. Pope, the father of American bicycling; Harry Converse, founder of the Boston Rubber Shoe Manufacturing Company; Charles Lauriat, the bookseller; Commodore William Weld, the

shipping magnate; Dr. Francis Brown II, the founder of Boston's Children's Hospital; Dr. Myles Standish, the ophthalmologist and direct descendant of the military leader of the Plymouth Colony; and Charles Francis Adams II.

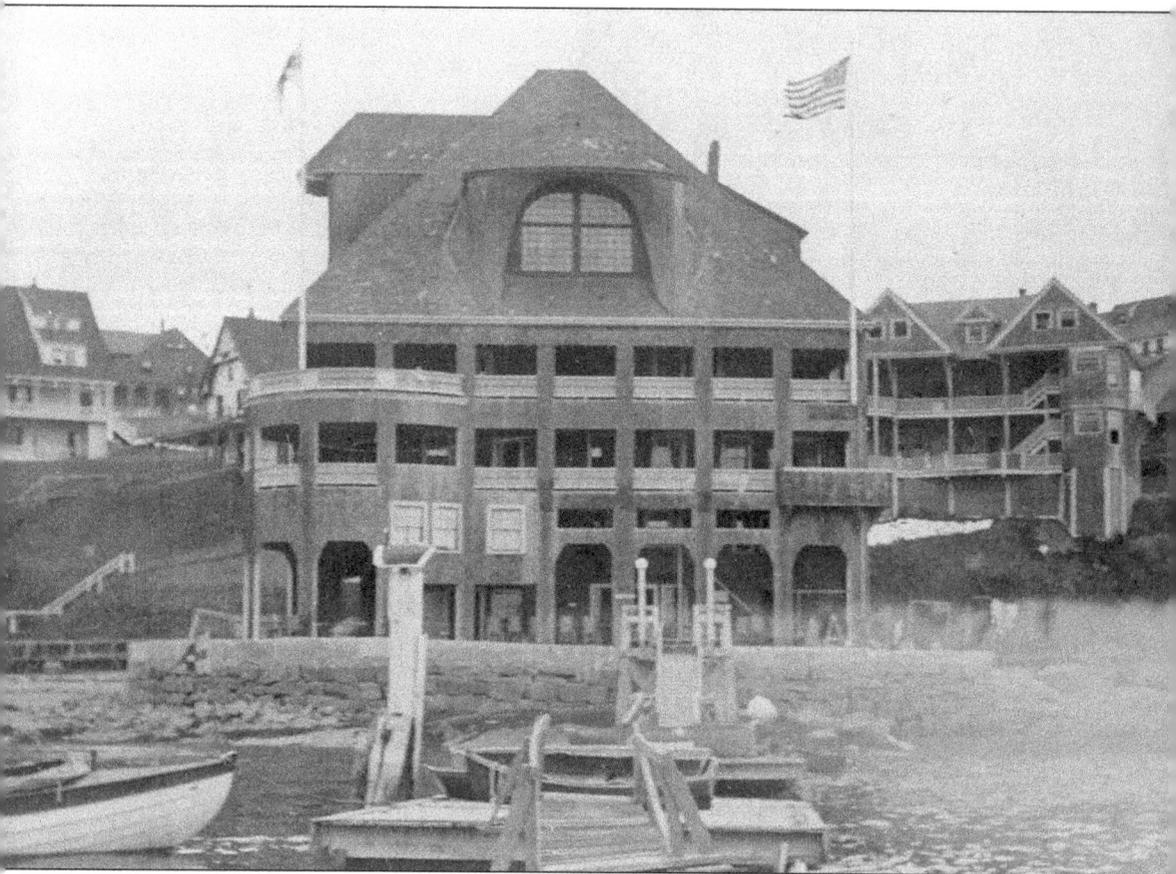

The four-floor Hull House of the Hull Yacht Club on Highland Avenue enticed new members with three bowling alleys, a billiard room, a dining room, and two reception rooms, not to mention easy access to the waters of Boston Harbor. In 1903 the club merged with the Boston Yacht Club, becoming the local station of that organization. The Hull Yacht Club admitted George G. Garraway, believed to be the first African American admitted to such a club, in 1881, while the smaller, short-lived Hull Mosquito Yacht Club boasted itself as the first organization of its kind in the world to admit women as members. Today's Hull Yacht Club formed in the 1930s after the demise of the first, and uses a building originally known as the Old Beacon Club, moved from Allerton Hill to the filled-in Windemere Basin. In August of 1998, the club hosted the Massachusetts Bay USA Junior Olympic Sailing Festival.

Three

GRAND HOTELS
AND THE BEACH
A VICTORIAN PARADISE

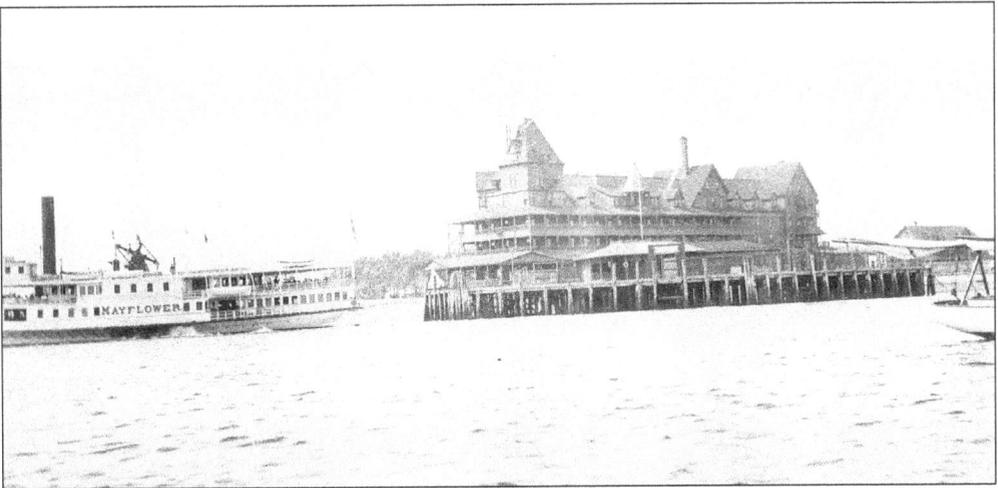

Nantasket's Long Beach has been a popular destination for out-of-town visitors since the 1780s when families from inland communities traveled in horse-drawn wagons to picnic by the sea. One hundred years later, people flocked from Boston and surrounding towns to enjoy the beach and the amusements built there by the Old Colony railroad. Among the 20 or more hotels in town, several larger resorts offered luxurious accommodations designed to appeal to the well-to-do. In its prime, the Hotel Pemberton, seen above, was described as one of the finest hotels in the world. As America prospered in the early 20th century, summer cottages became more fashionable and affordable. The decreased demand for summer resorts was the beginning of the end for Hull's large hotels, many of which were either boarded up or burned down before the start of the Second World War.

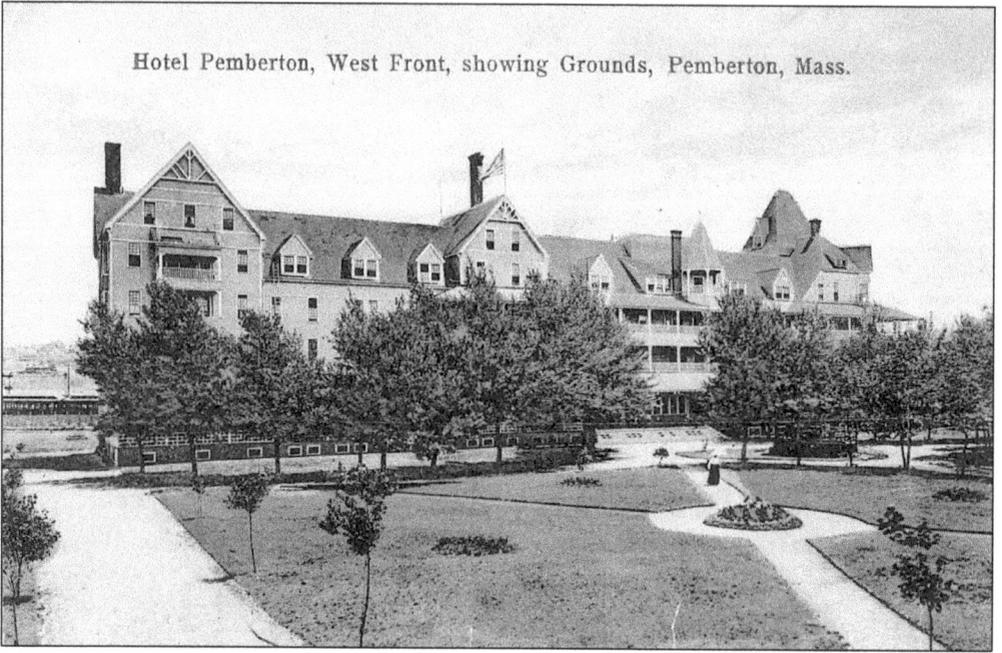

Hotel Pemberton, West Front, showing Grounds, Pemberton, Mass.

The Hotel Pemberton, built in 1880 on Windmill Point, was a luxurious Queen Anne–style hotel featuring one hundred richly furnished rooms, a billiard parlor, and an elevator. Seen here from Boston's outer harbor, the Pemberton was considered one of the finest hotels in the world in the late 19th century. After being boarded up for decades, this once magnificent hotel was demolished in the 1950s to make way for the construction of Hull High School.

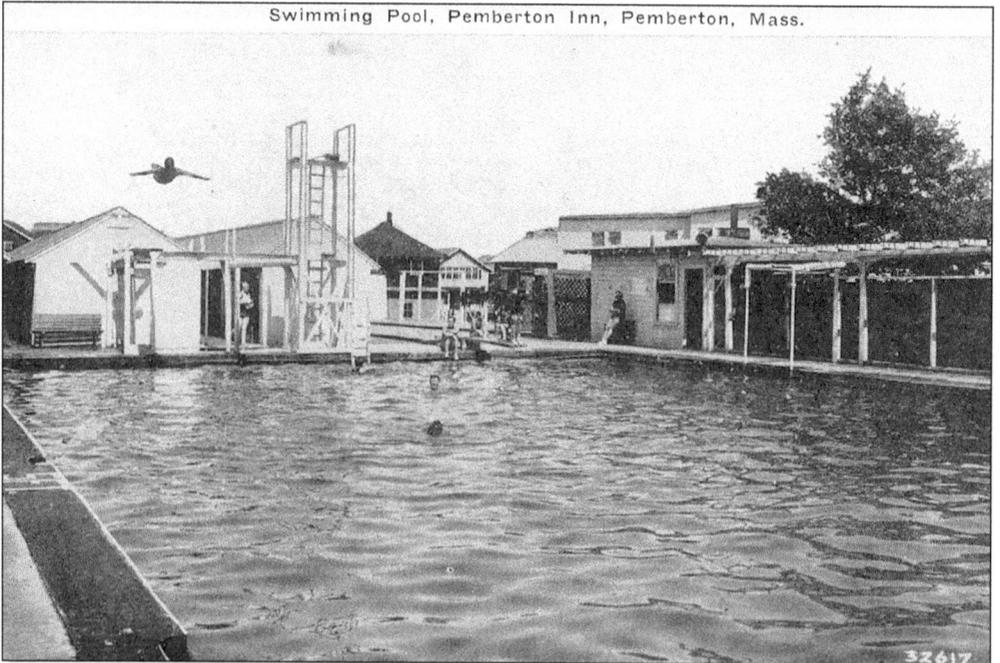

Swimming Pool, Pemberton Inn, Pemberton, Mass.

Among the Pemberton's many attractions was a steam-heated swimming pool filled with 50,000 gallons of ocean water.

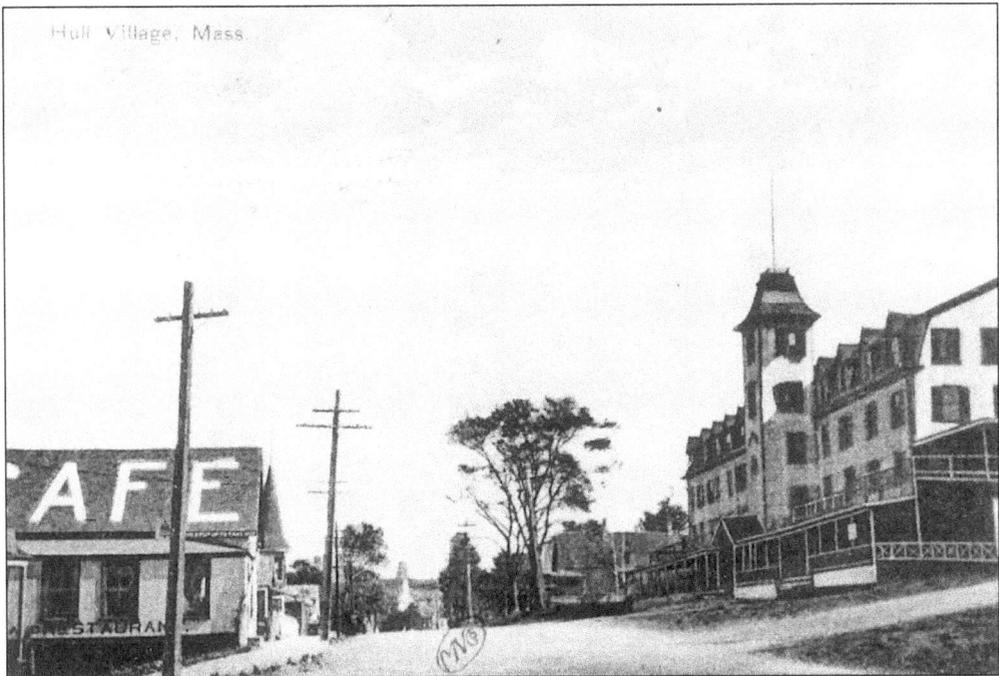

The Oregon House was built in 1848 on the corner of Highland and Nantasket Avenues using wood recycled from the Castle Island barracks. The Oregon was a favorite resort of fishermen, particularly smelters. After the hotel was demolished in 1926, St. Mary's of the Bay Catholic Church, now a private residence, occupied the site.

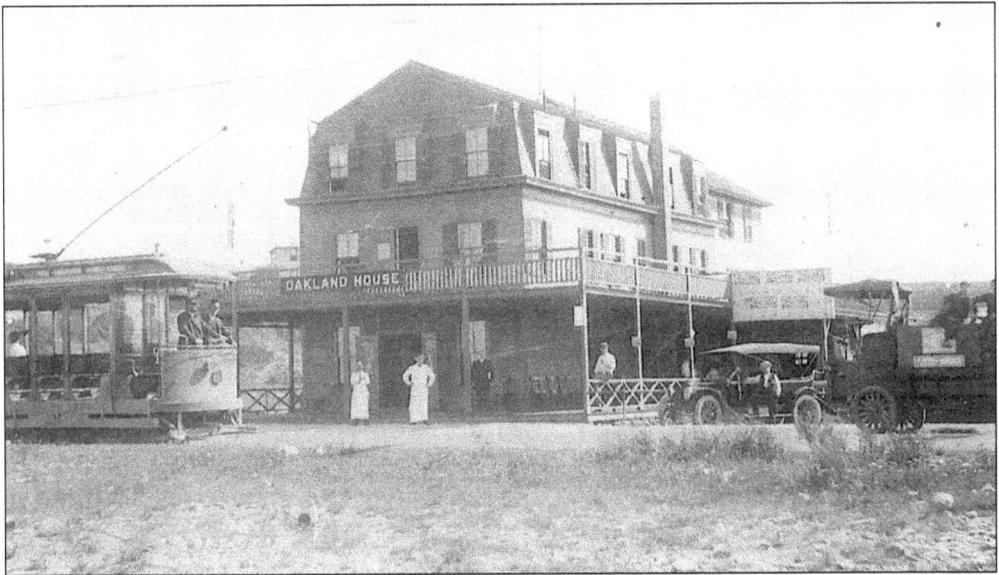

The Oakland House was located at Nantasket Avenue and Newport Road. It was taken over in 1914 by Mike Burns and later operated by his son Mike Burns Jr. For many years, the Oakland House was one of the nicer places on the beach, catering to wedding parties, church affairs, and social gatherings. It is scheduled to be converted into apartments.

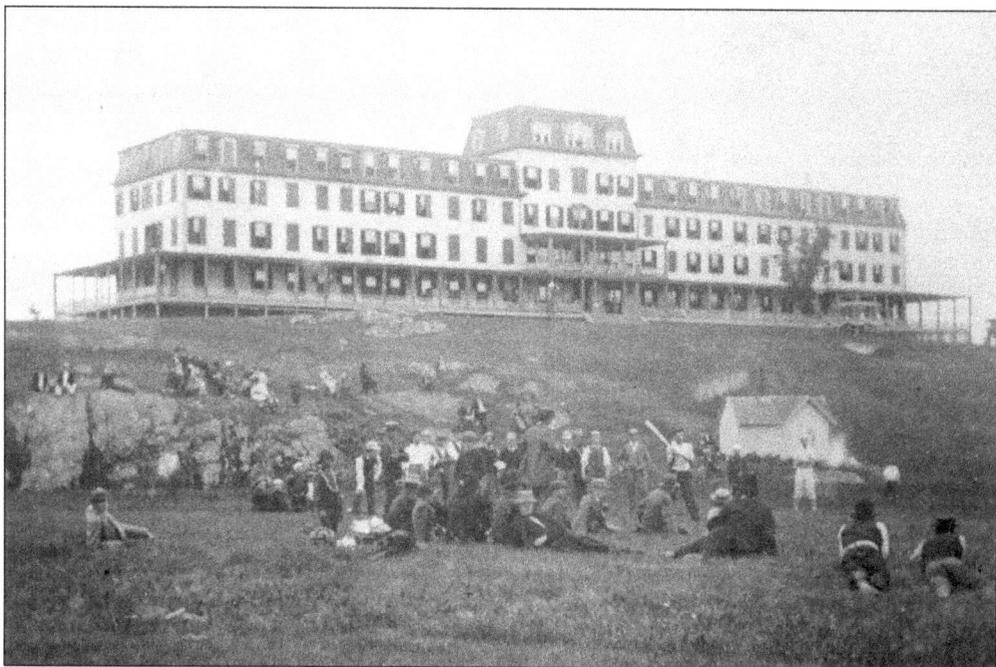

The Rockland House, built in 1854, burned down in 1916. At one time, it was the largest hotel in the United States, with 360 rooms. The Rockland's impressive facade was 275 feet long. President Grover Cleveland and future New York governor and presidential candidate Al Smith were among its many famous guests, as well as George M. Cohan, who also entertained there.

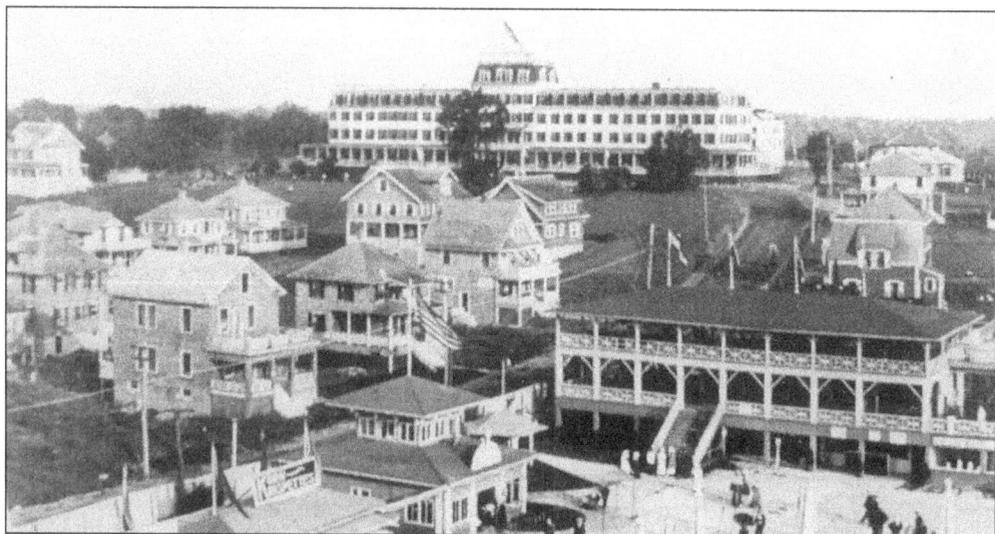

The Rockland House was located at the top of Park Avenue overlooking Paragon Park and the beach. Built in 1905, Paragon's Administration Building, bottom center, survived until the demolition of the Park in 1985.

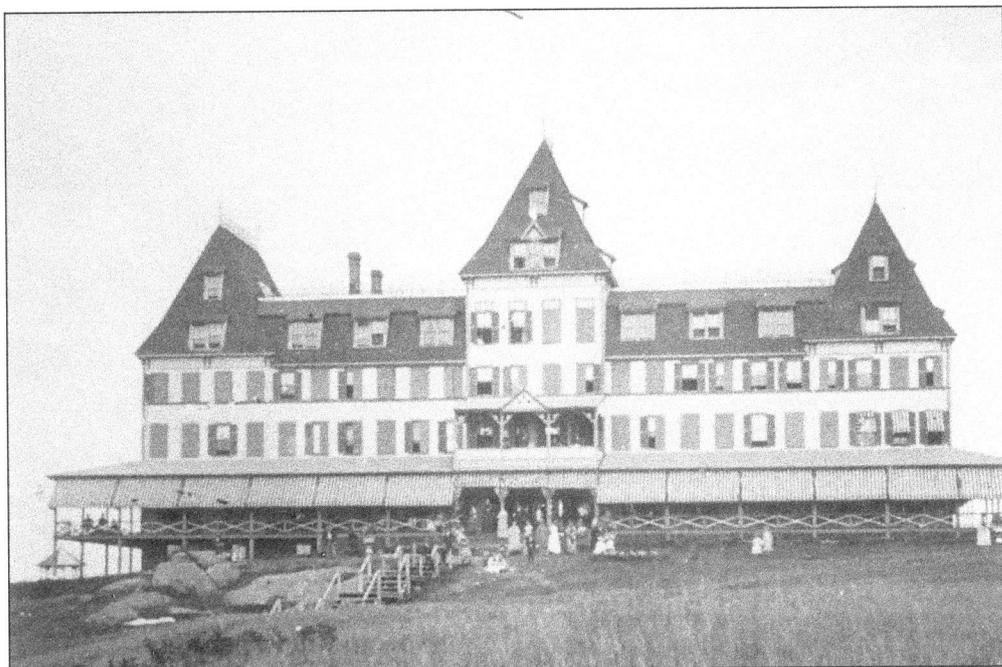

The original Atlantic House is shown here as built in 1877, before later additions. The wide verandas were famous for their commanding view of the beach. Legendary opera star Enrico Caruso gave two performances here shortly after the turn of the century. President William McKinley and world-famous actress Sarah Bernhardt also stayed at the Atlantic House.

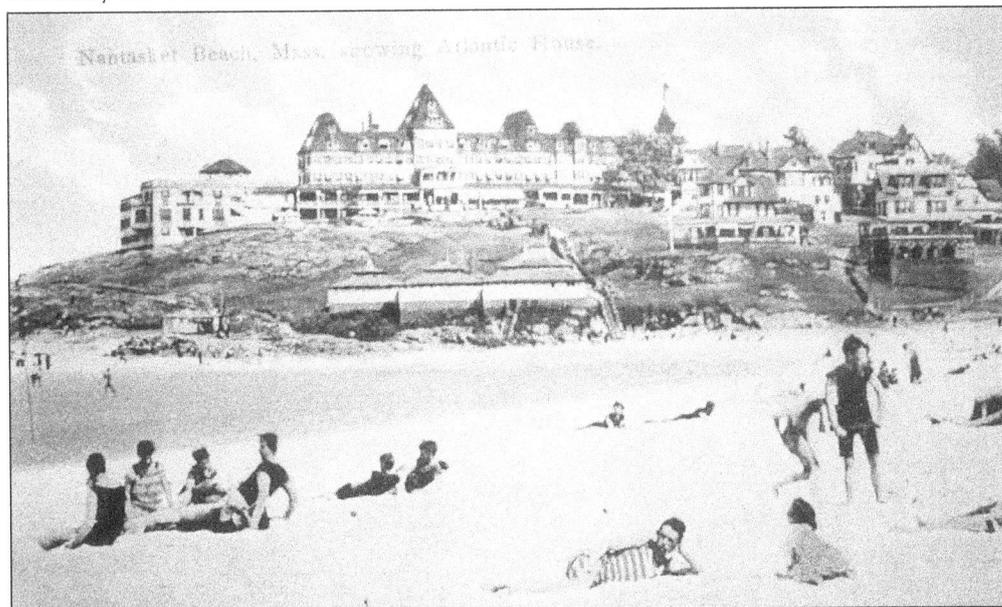

The Atlantic House was the most famous summer hotel in New England in the late 19th century. It encompassed a 174-room hotel and several cottages in a compound located atop Atlantic Hill. A stairway extended from the hotel to private bathhouses at the water's edge. Wallis Simpson, future Duchess of Windsor, occupied a cottage here one summer. The Atlantic was on the verge of bankruptcy when it burned to the ground during a 1927 blizzard.

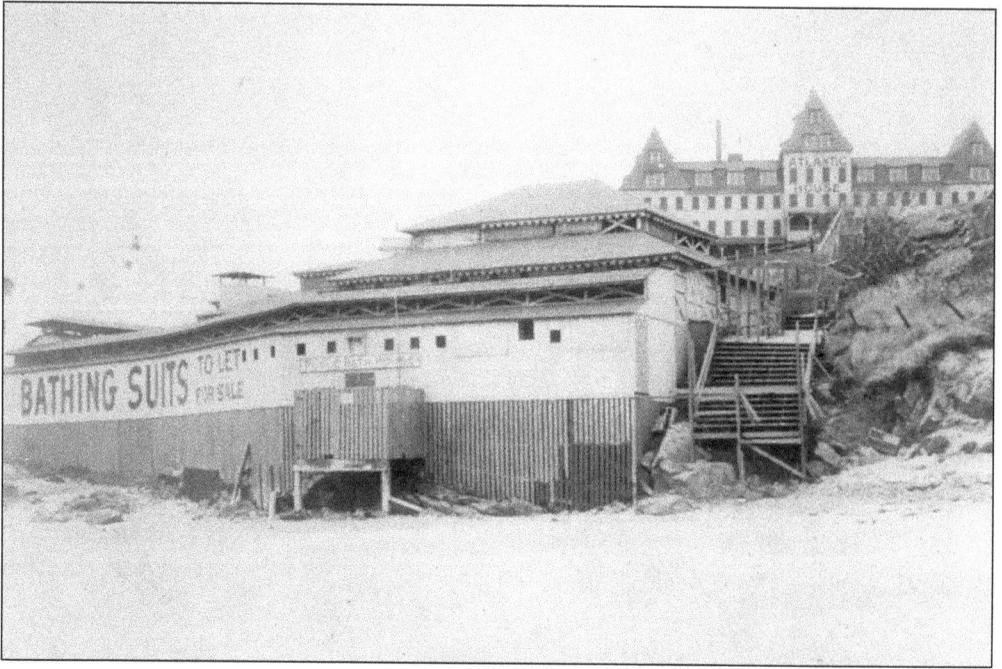

Public bathhouses at the base of Atlantic Hill sold or rented bathing suits to daily visitors. These bathhouses had been supplanted for years by Hurley's Bath House 100 yards inland, before they were condemned and torn down by the town of Hull in 1945.

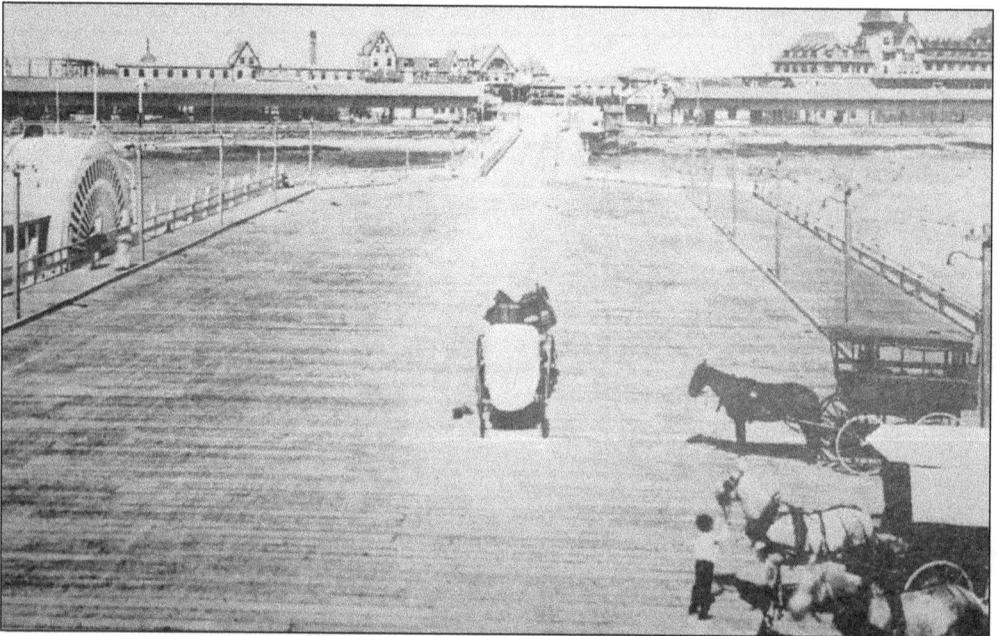

Horse-drawn carriages carried luggage as well as passengers from the steamboat landing at Nantasket Pier to the hotels on the southern end of town. The Old Colony's Nantasket Beach station is to the right, running parallel to the bay. The Hotel Nantasket is on the horizon in the far right-hand corner, the Rockland Café is in the center, and Grant's roller coaster is to the extreme left. Boat service continued to this location until the 1990s.

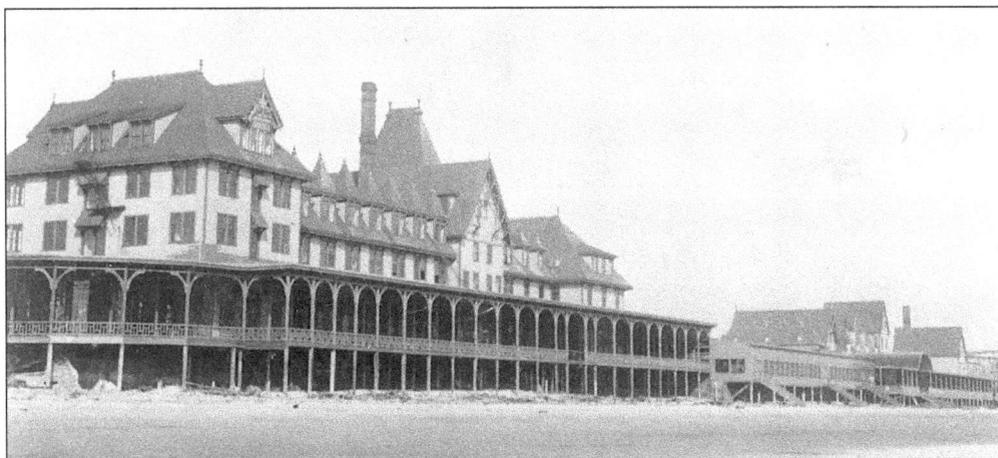

The Nantasket Hotel, built in 1879, was located at the center of Nantasket Beach, close to the steamboat landing and railroad station. Known as the "Aladdin's Palace" of the region due to its many towers, gables, and balconies, the Nantasket's wide verandas, totaling 1,000 feet in length, ran entirely around the hotel. All 100 guestrooms had outside exposure. The Rockland Café is visible to the right.

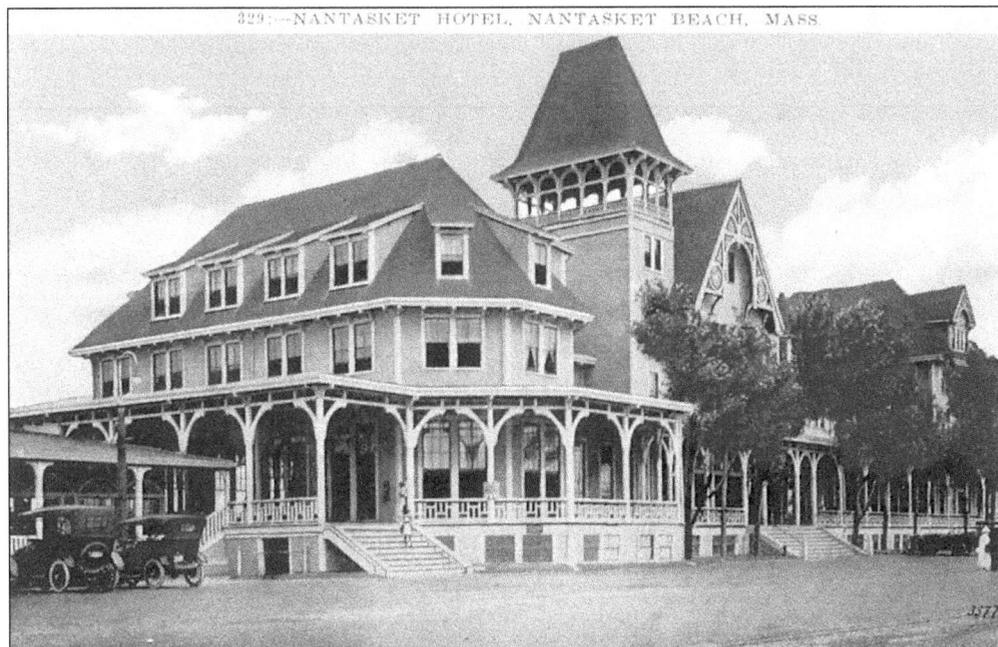

Half pavilion and half hotel, the Nantasket, seen here from the Avenue, was popular for its band concerts, metropolitan dining room featuring chefs from New York's Delmonico's restaurant, a small army of servants, and "the enchantment of electric lights." The building, long abandoned, was torn down in 1955 to make way for the parking lot to the right of the Bernie King Pavilion, where even today weekly concerts are held.

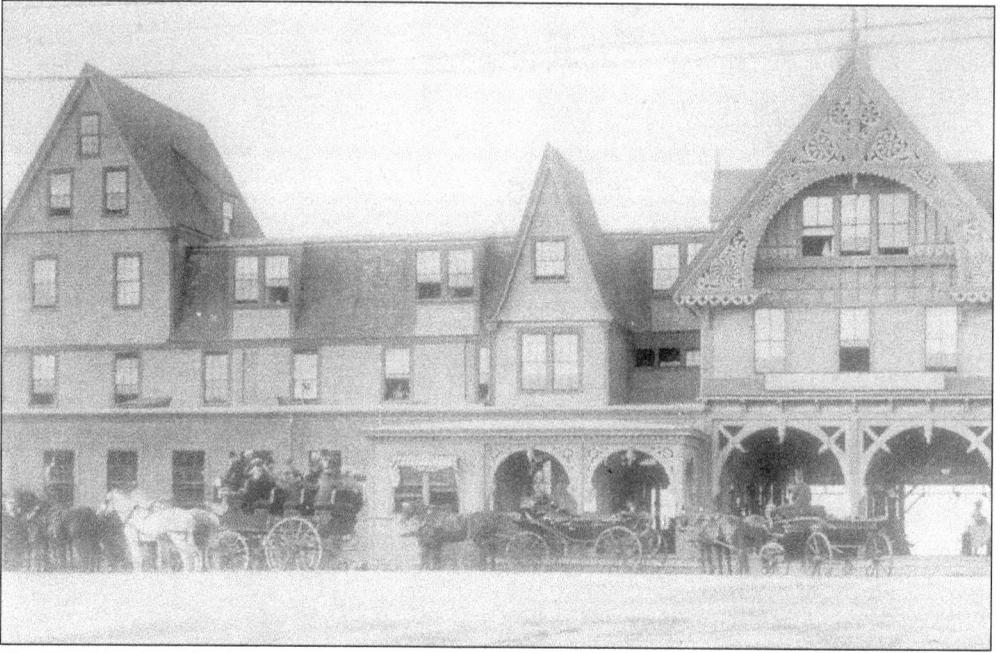

The Rockland Café's dance hall, shooting gallery, bowling alleys, and swings catered to day trip visitors. Located close to site of the Mary Jeanette Murray Bathhouse, the Café was also well known for its fish dinners and chowders.

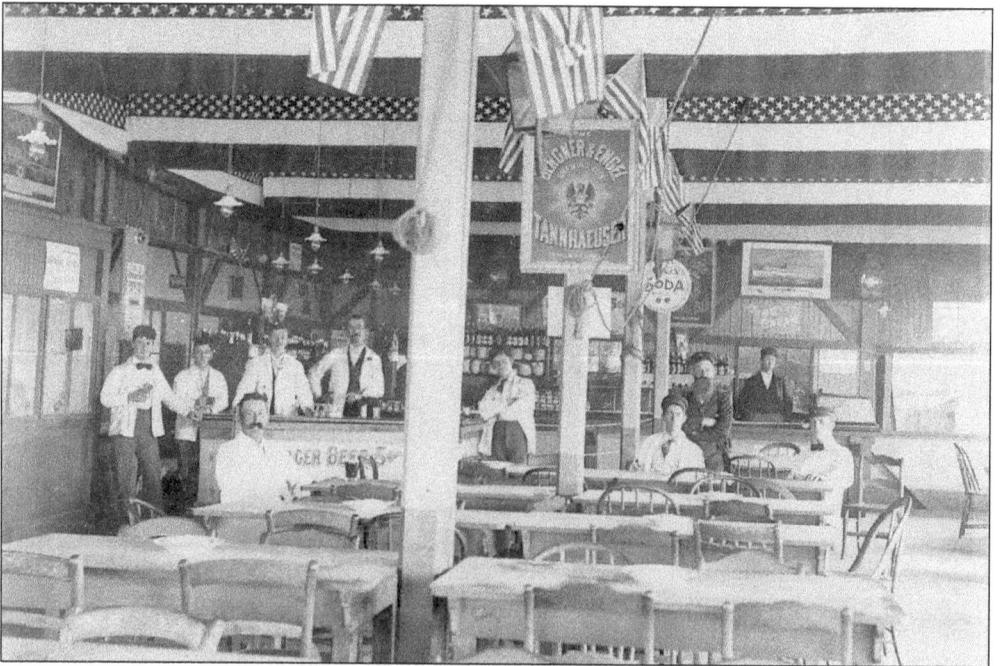

A typical hotel saloon featured ice cream and beer in the 1890s.

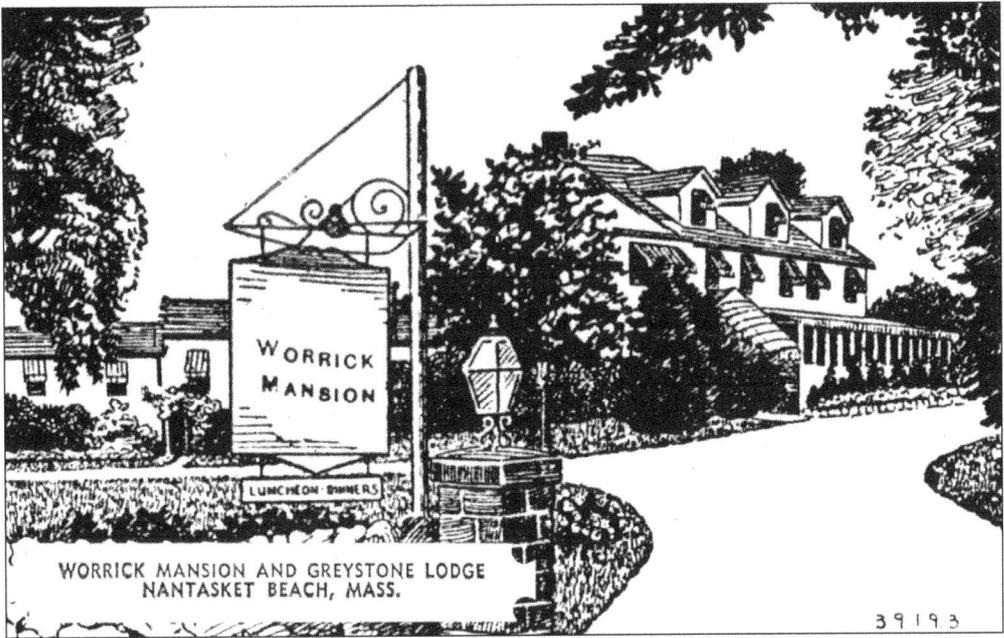

WORRICK MANSION AND GREYSTONE LODGE
NANTASKET BEACH, MASS.

The Worrick Mansion, built in 1826 by William Worrick at the beginning of Nantasket Avenue, was not only the first of Hull's famous hotels but also the most enduring, remaining in operation until destroyed by fire in the 1980s. Originally known as "The Sportsman," this resort was a favorite of Daniel Webster, one of the most renowned orators of the 19th century, who conceived of many of his famous speeches while fishing and bird hunting in the neighborhood.

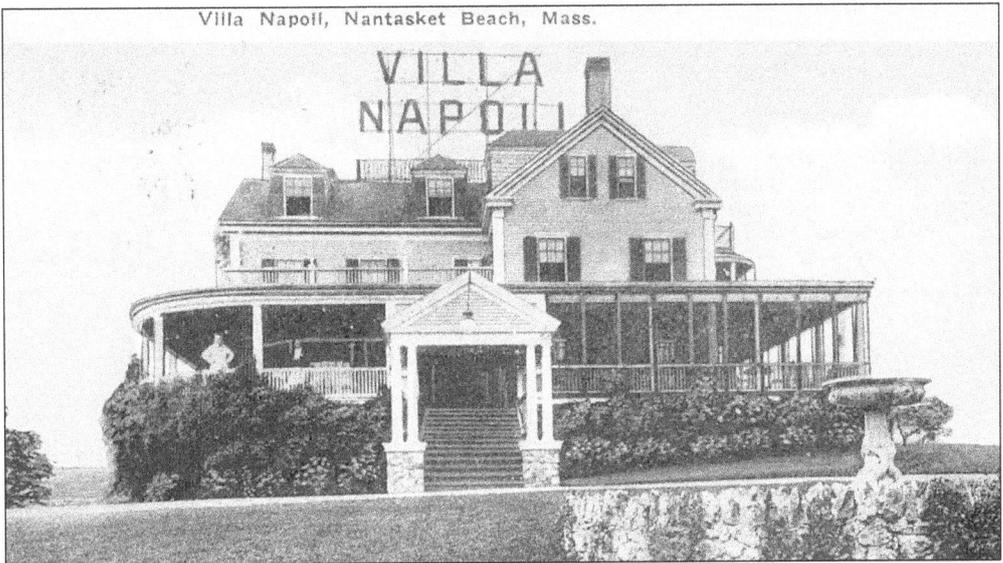

Villa Napoli, Nantasket Beach, Mass.

The Villa Napoli, the former summer estate of department store magnate R.H. Stearns, was built in the 1890s. Remodeled and enlarged into a spacious summer hotel on 14 acres of beautiful grounds, the Villa was noted for lobster and chicken dinners. This hotel was later known as McPeak's Shore Gardens before burning down in 1932. The entrance posts still exist at the end of Shore Gardens Road.

Swimsuit styles may change but summer fun at Nantasket is timeless. Had the gentleman on the right so desired, he could have rented a bathing suit at the bathhouse at the base of Atlantic Hill, rather than sweltering in the heat. To keep the shine on shoes, hotels built long boardwalks

on the beachfront for visitors to enjoy the breezes, sounds, and smells of the seashore without the discomfort of sand between their toes.

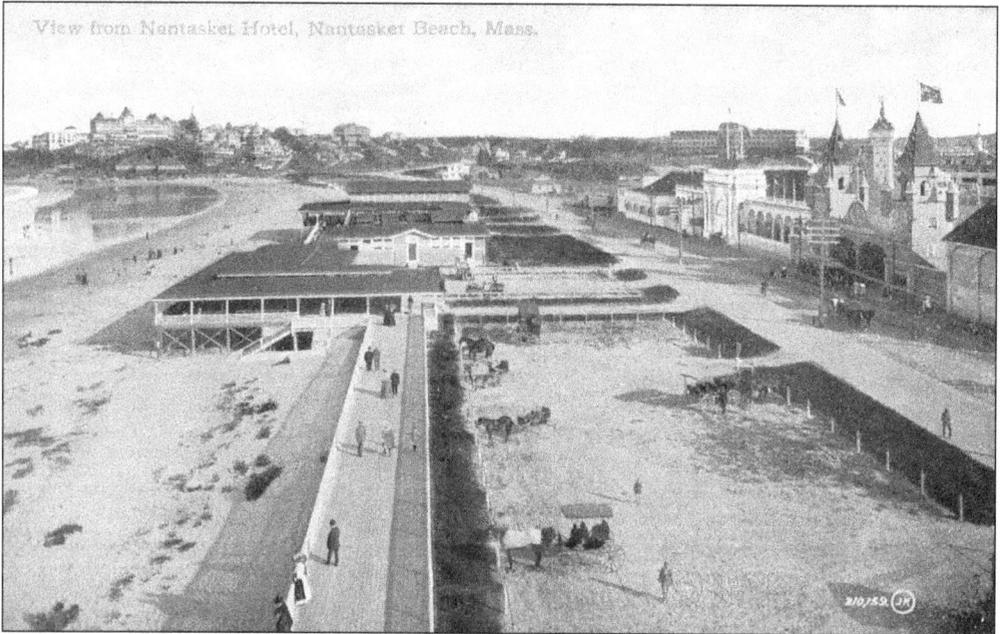

This view from the Nantasket Hotel, facing south in 1908, overlooks the boardwalk, Tivoli Gardens Restaurant, and Paragon Park. The steeplechase is to the left of Paragon's front entrance. The Atlantic and Rockland House Hotels are on the hills in the distance.

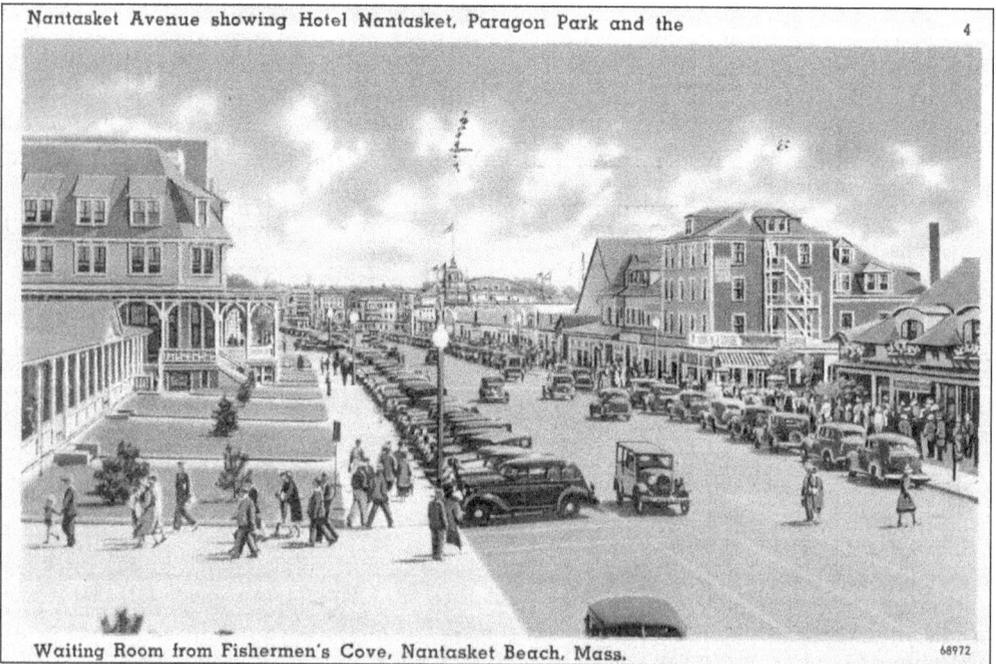

Nantasket Avenue is shown here in 1941. The Hotel Nantasket and the Clock Tower building are in the foreground. Paragon Park's Art Deco entrance and Hilarity Hall are in the distance.

A view in the 1940s shows Tivoli Pier, the Nantasket Hotel, and the Rockland Café along the beach. The Giant Coaster, Hilarity Hall, and the front half of Paragon Park are across the street.

A similar view of Nantasket Beach looks North from Atlantic Hill, 1993. The Horizon condominiums, on the left, are where the entrance to Paragon Park once was.

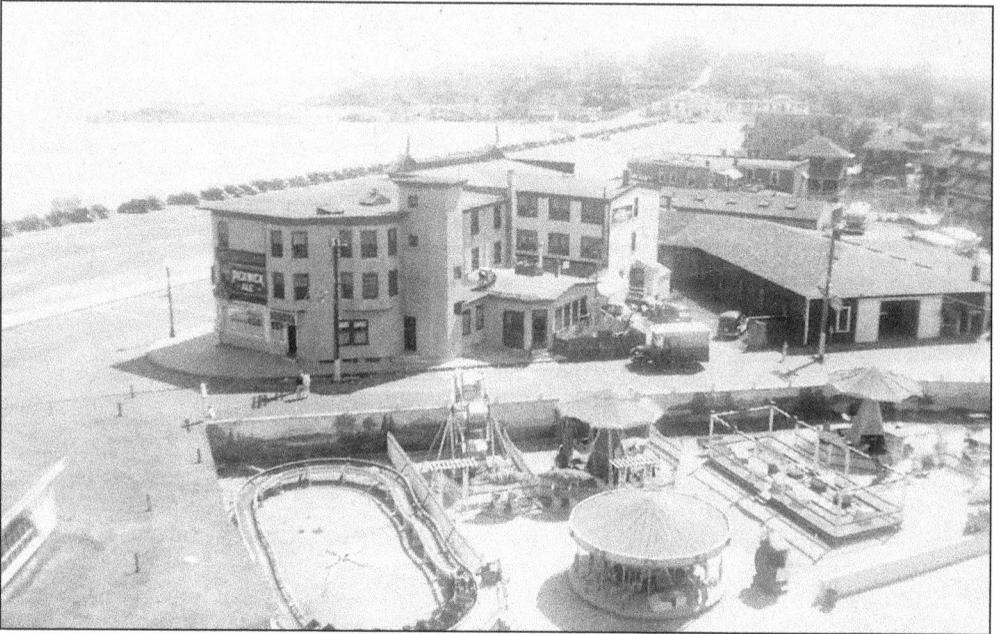

A unique mid-1930s view of the southern end of Hull from the top of the Giant Coaster shows Paragon's Kiddie Park rides in the foreground, Park Avenue, and Hurley's Bath House in the distance.

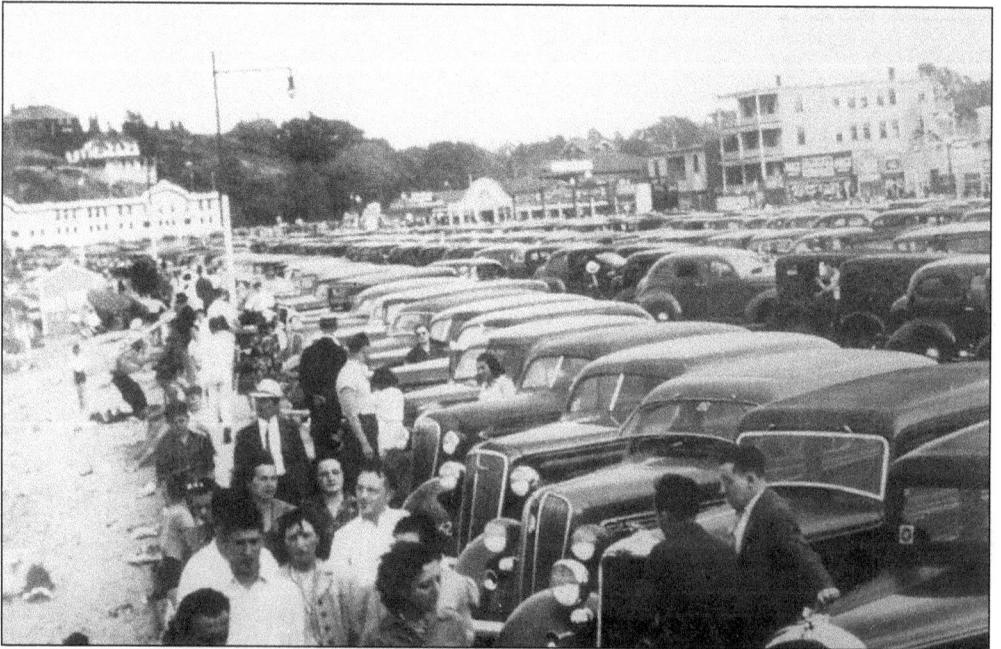

By the 1940s, the automobile had replaced the train and steamboats as the preferred mode of transportation to Nantasket Beach. Sheds on the beach, such as the one at left center, rented umbrellas until the 1950s. Prosperity made summer cottages both more fashionable and affordable, decreasing the demand for resort hotels, which gradually went out of business.

Four

STEAMBOATS AND TRAINS
GETTING THERE WAS HALF THE FUN!

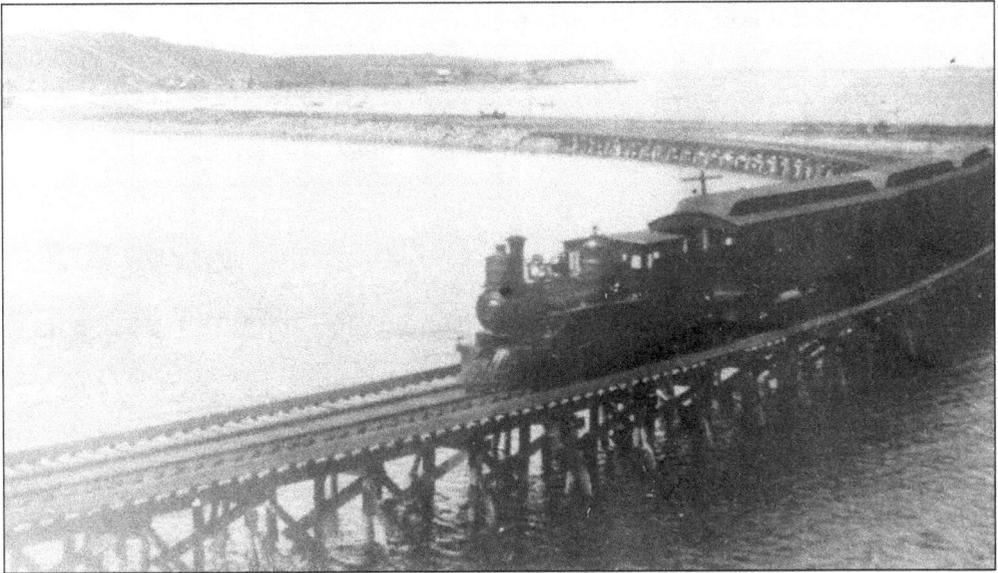

Long before the first passenger train ran the length of the peninsula in 1881, steamboats carried interested visitors to Hull's shores. Regular steamship service from Boston to Hull began with the *Eagle* in 1818 and continued uninterrupted until 1929. On July 10, 1880, the Nantasket Beach Rail Road Company began operating horse-drawn trolleys on a 3-mile stretch of Hull, from the Nantasket Pier to Allerton Hill, linking the town's steamboats and trolleys for the first time. In September, a second company ran standard gauge tracks from Allerton to Pemberton, and the following year a third group linked the entire line to Hingham. Above, an early Hull locomotive heads southeast along the trestle that later became Fitzpatrick Way.

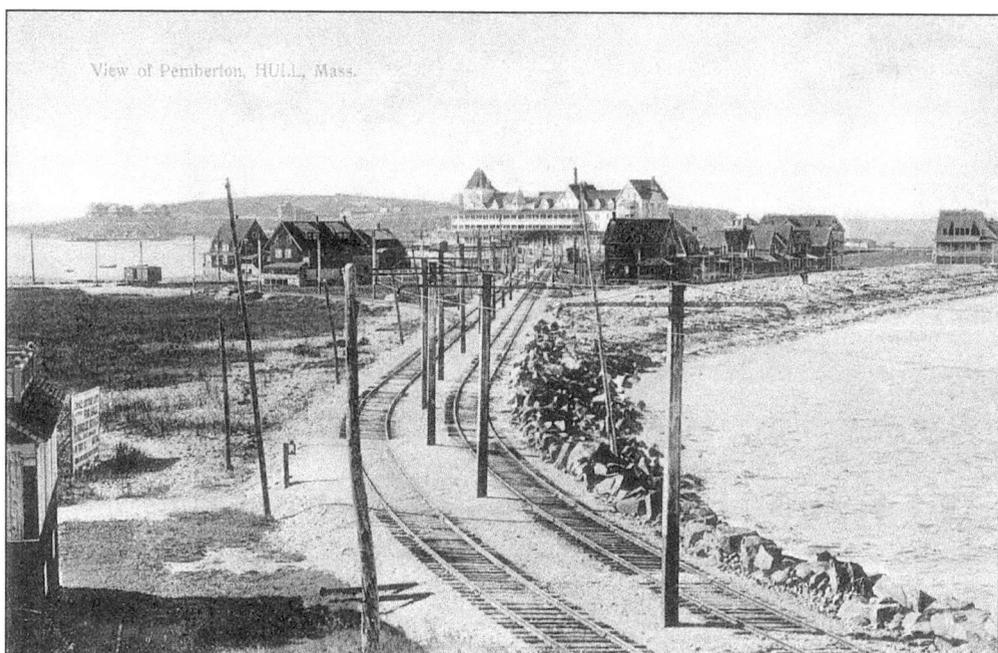

View of Pemberton, HULL, Mass.

By design, the trains carried passengers directly to the doors of Hull's grand hotels such as the Pemberton at Windmill Point. In 1895, the Old Colony Rail Road Company experimented with an overhead electrical line to power open-air cars at Nantasket Beach, figuring that enough cash flowed in Hull at least to break even in the attempt.

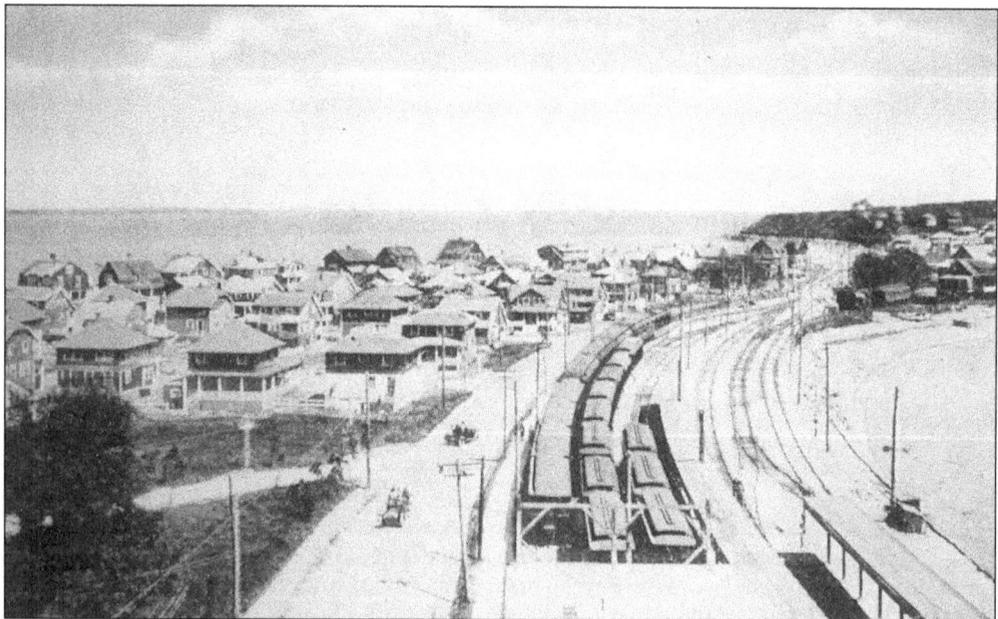

Looking east from the Pemberton Hotel, guests could see the tracks wind back around the base of Souther's Hill along Hull's northern shoreline. Oftentimes during the late 1800s waves lifted ships onto the tracks and stopped service altogether. Next to the trains their archenemy, cars, putter on by. The allure of personalized transportation provided by automobiles led to the downfall of trains in Hull.

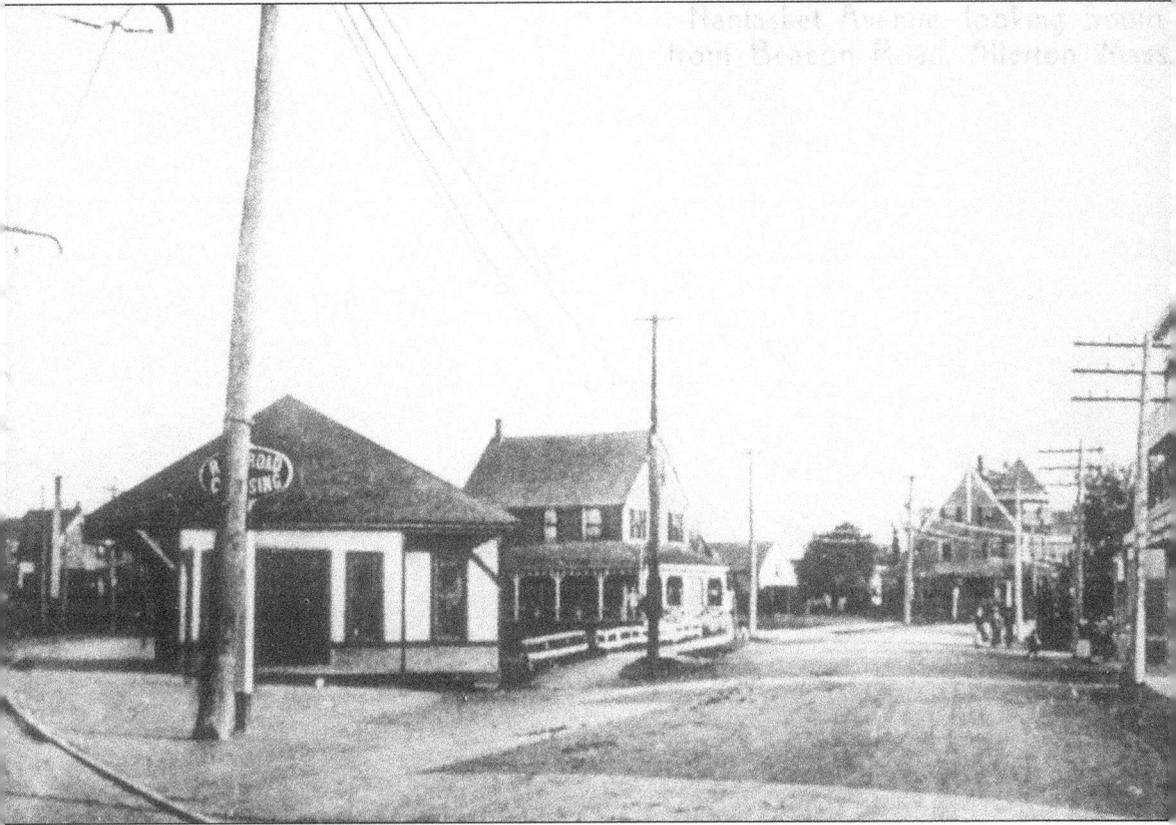

Moving from south to north after leaving Nantasket Junction, day trippers could choose from any of 11 stations: Nantasket Beach, at the Steamboat Wharf; Surfside, at Anastos Corner; Whitehead, by the Electric Light Department; Kenberma; Waveland, near A Street; Bayside, half way through the alphabet streets; Allerton, at the base of the hill by that name; Windemere, near the current Hull Yacht Club; Stony Beach, on the small isthmus between Allerton and Souther's Hill; Hull, on the far side of Souther's Hill; and Pemberton, the last stop on the line.

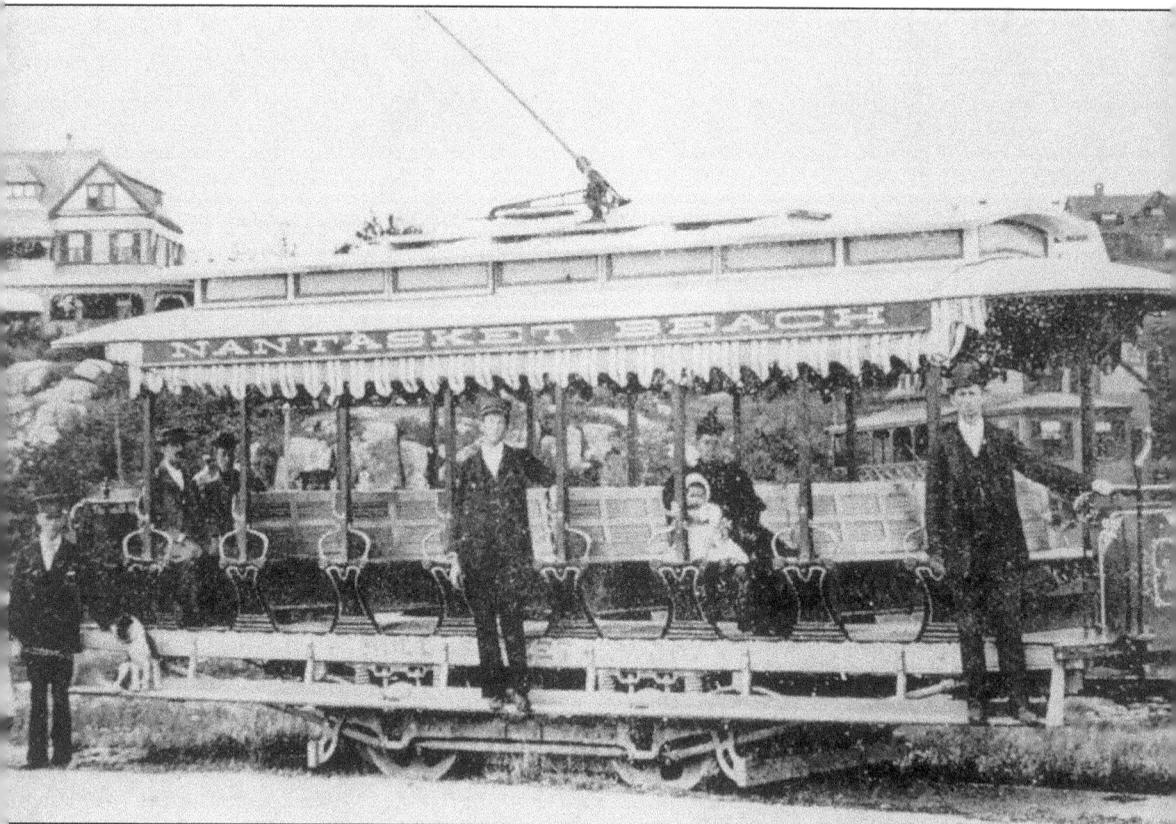

No soot, no steam—just clean open air tantalized the riders of the electric lines in Hull during the summers between 1895 and 1932, when the line shut down. Even without a final destination, folks hopped aboard to see the sights and let the cool rush of the breeze temper the sun's heat. Ready to go, this trolley and its conductors pause to pose for a photographer before leaving the base of Atlantic Hill.

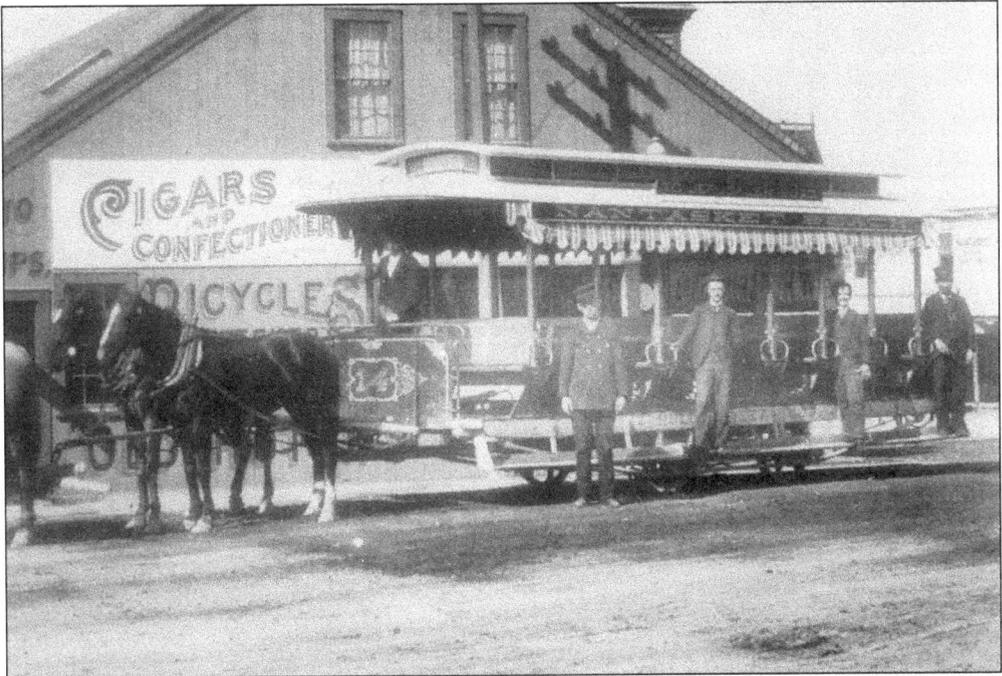

Early horse-drawn trolleys met steamboat passengers at Nantasket Wharf and Pemberton Pier to transport them directly to their destinations, that is, if they could first escape the barrage of enticing advertisements designed to lure them into a world of fattening foods, cigars, and other non-essential items.

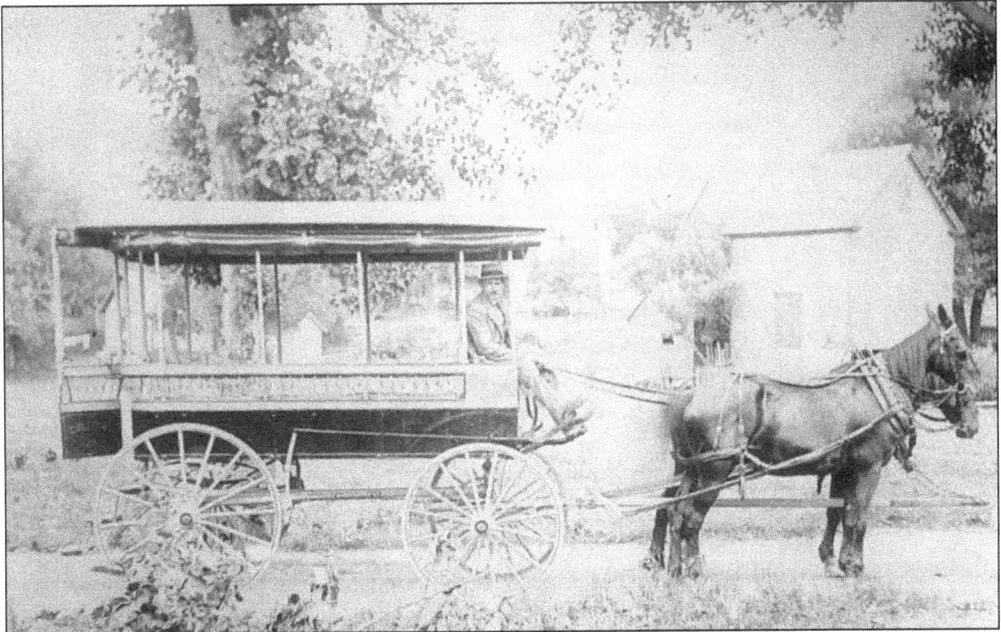

Off the tracks, local teams could be hired to transport people and goods through Hull's streets. Knight's Express, Daley and Wanzer, and Cullivan's Barge, here on Spring Street facing the Village Park, provided such services.

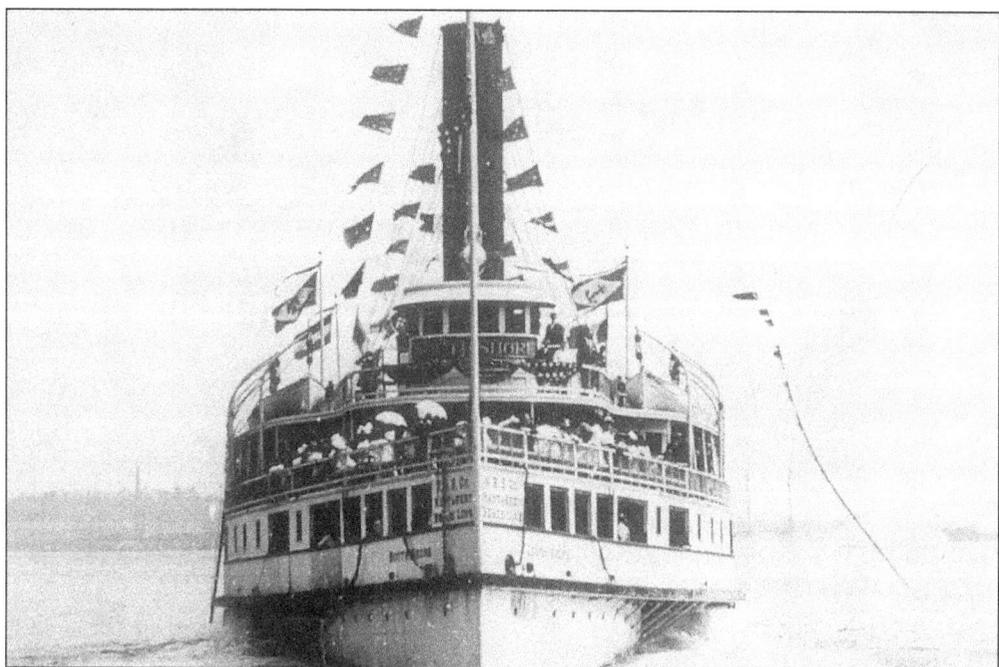

The steamer *South Shore* of the Nantasket Beach Steamboat Company plies her way through the water from Rowe's Wharf in Boston, heading for another summer adventure in Hull.

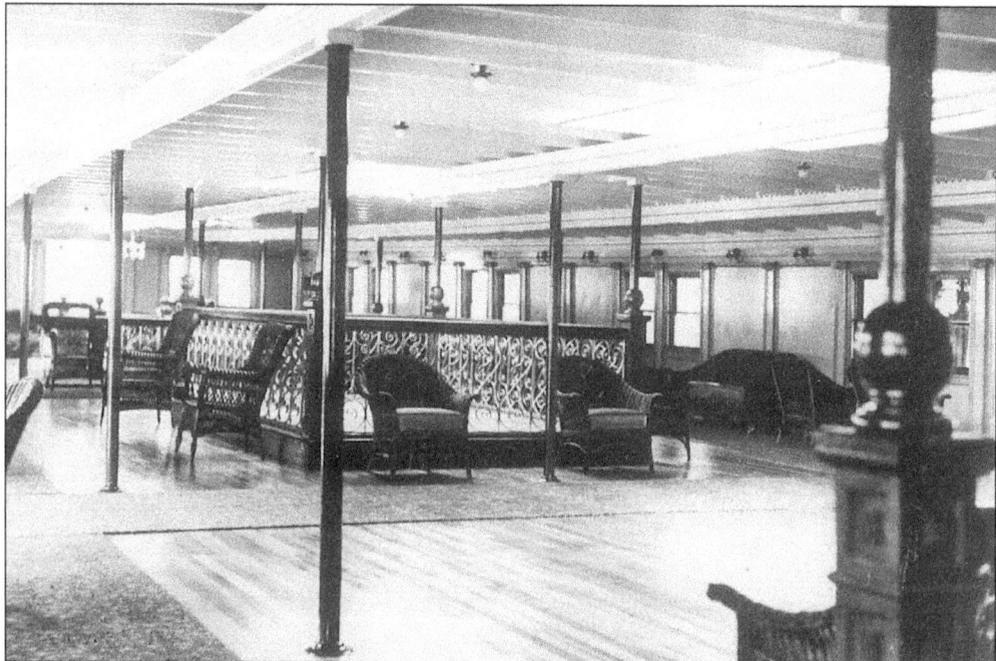

The exterior beauty of the stern-wheel and side-wheel steamboats could only be rivaled by their interior splendor. The main salon of the *Rose Standish* sported murals painted by artist S. Ward Stanton, who later perished aboard the White Star Liner *Titanic*.

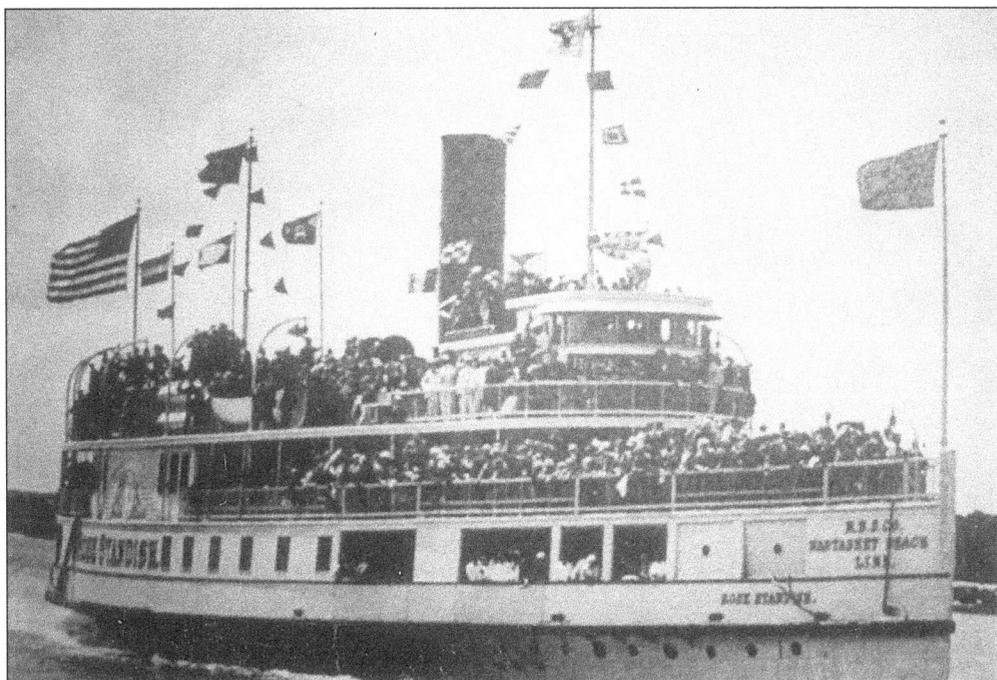

The second *Rose Standish*, on a diversion from her regular Hull and Nantasket Beach run, held the distinction of being the first passenger vessel to pass through the Cape Cod Canal on July 29, 1914. She was piloted that day by Captain Osceola James, son of the famous lifesaver Joshua James.

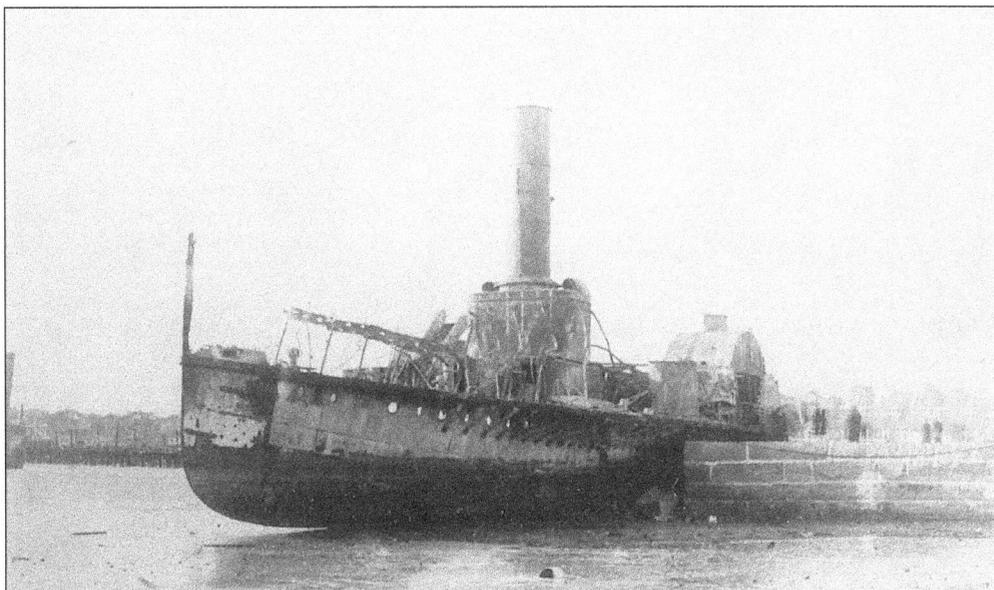

Fifteen years later, on Thanksgiving Day, 1929, the *Rose Standish* and four of the other five Hull to Boston steamboat fleet burned at their winter quarters at Nantasket Wharf. By strange coincidence, they caught fire on the only day of the year a fireman could not be found in Hull. The entire department, which doubled as the town football team, was in Scituate for the annual Thanksgiving Day Game.

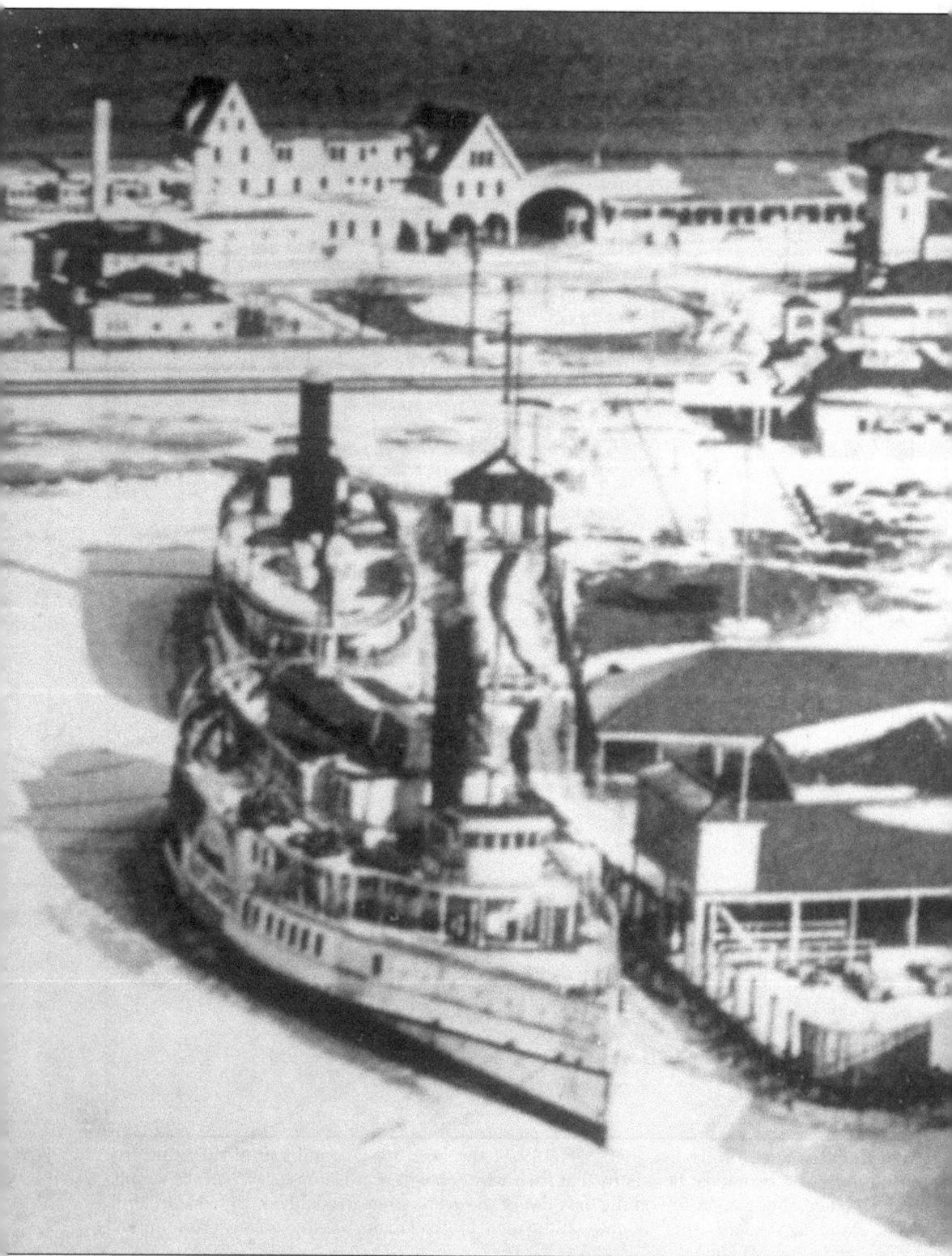

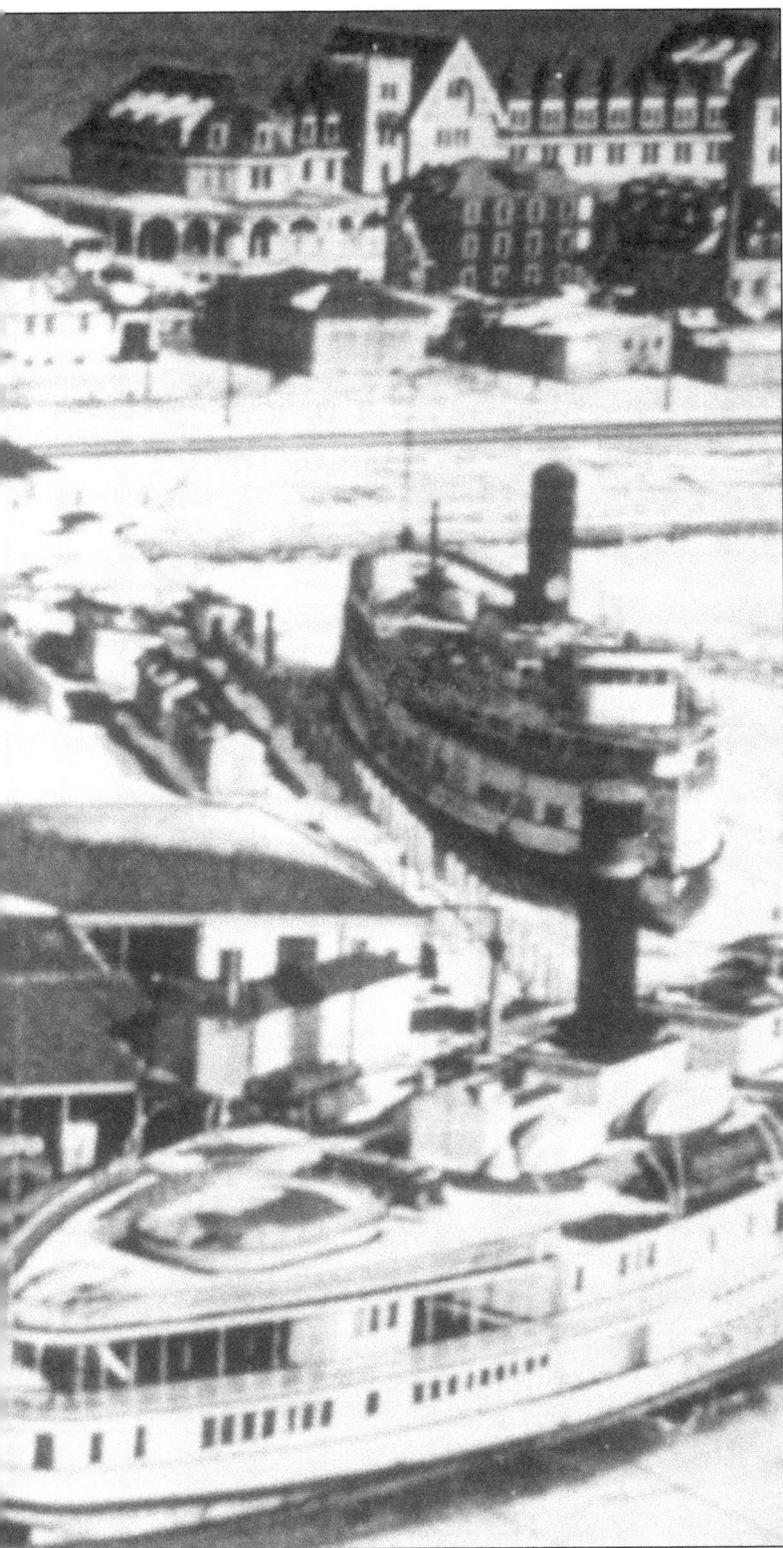

Socked in by the ice and happy to be in hibernation, four of the Hull steamers rest at their winter berths at Nantasket Wharf. From left to right in the background can be seen the Metropolitan District Commission Police Station, the Rockland Café, the Nantasket Beach Rail Road Station, and the Hotel Nantasket. Through more than 120 years of passenger service, nary a single accident claimed the life of a paying customer—leaving the proprietors room to boast of having one of the safest lines in the world.

49

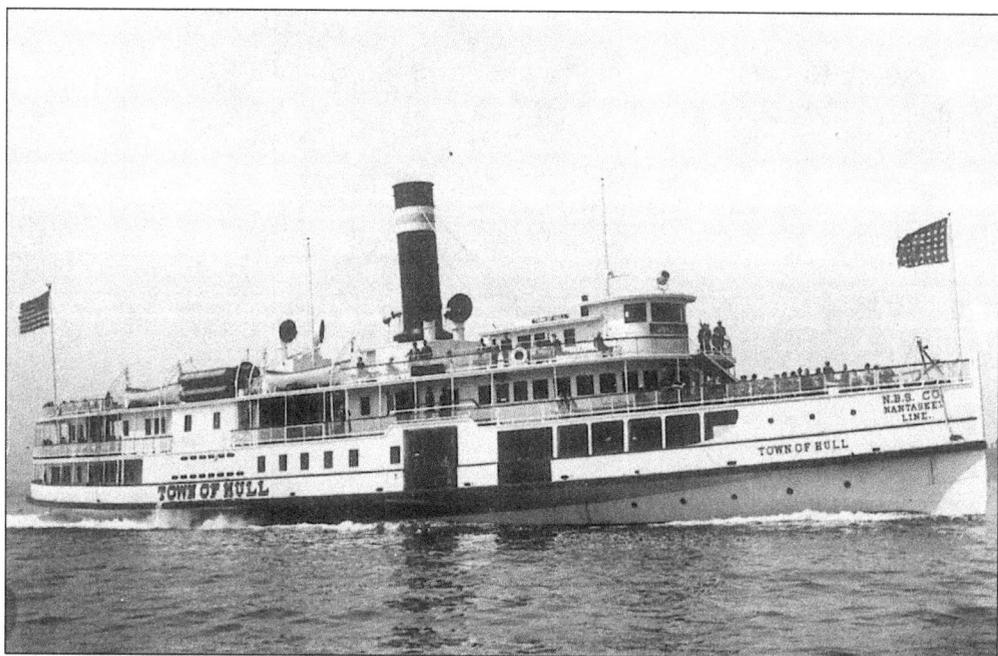

Other boats in the fleet of vessels servicing Hull and Nantasket Beach included the *Town of Hull*, above, and the *Pemberton*, below.

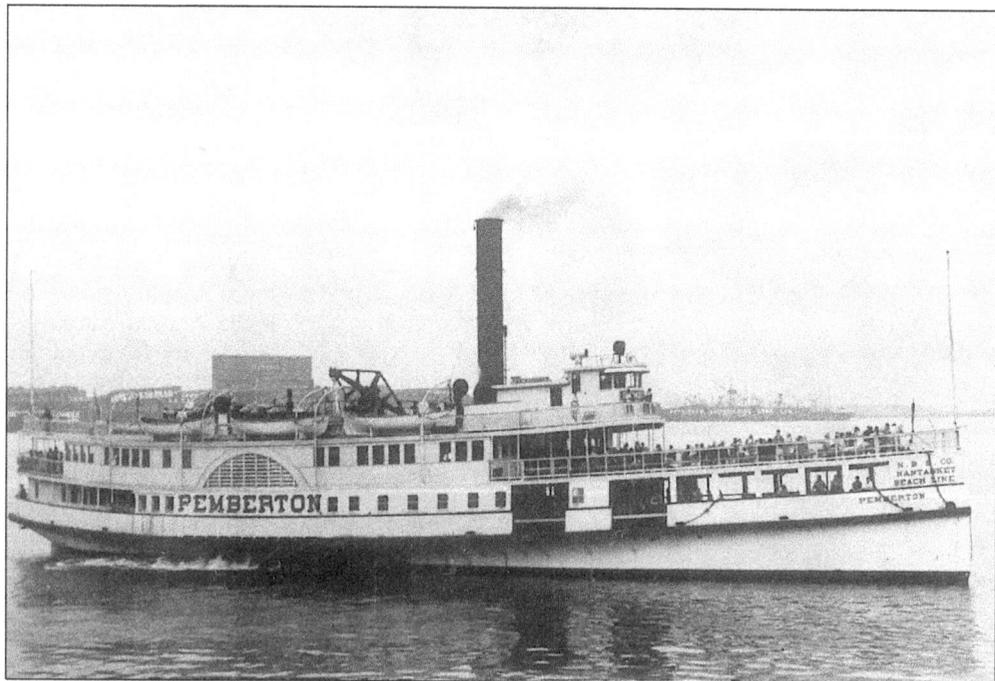

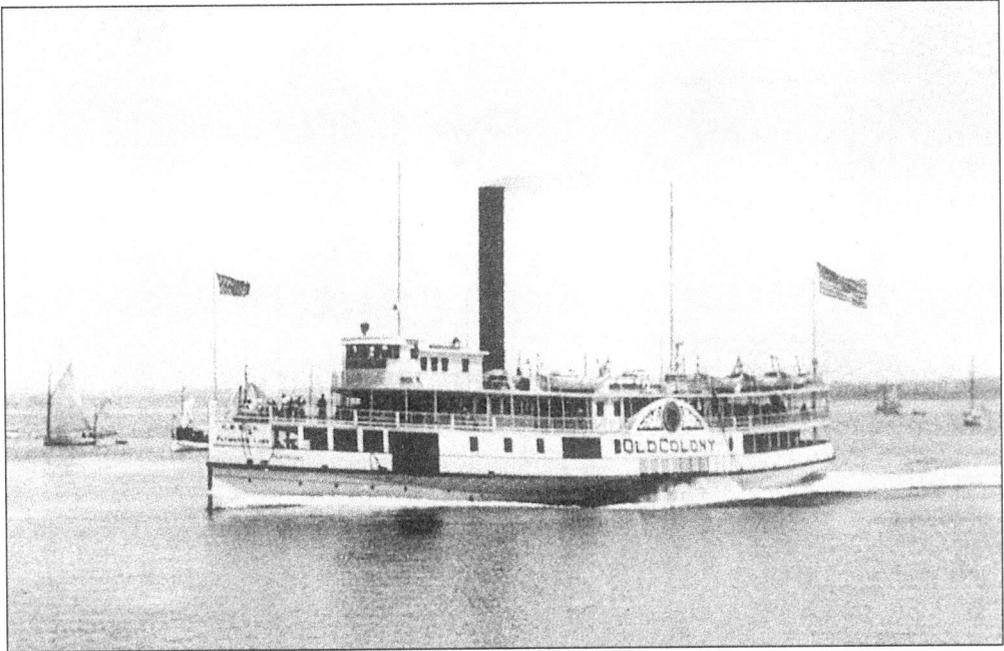

Pictured above is the *Old Colony*, and below is the *Nantasket*.

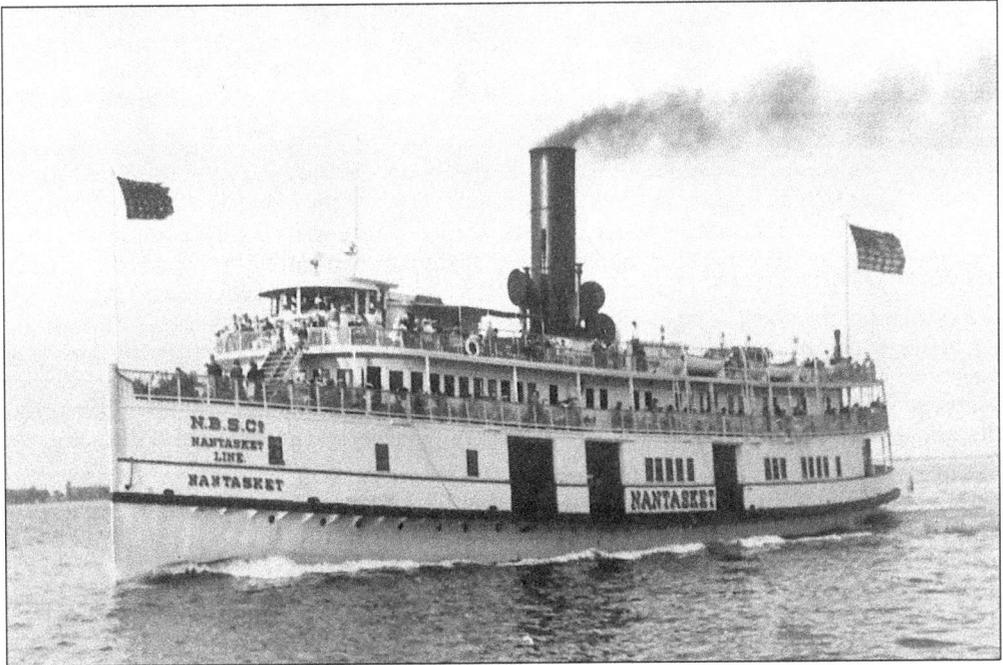

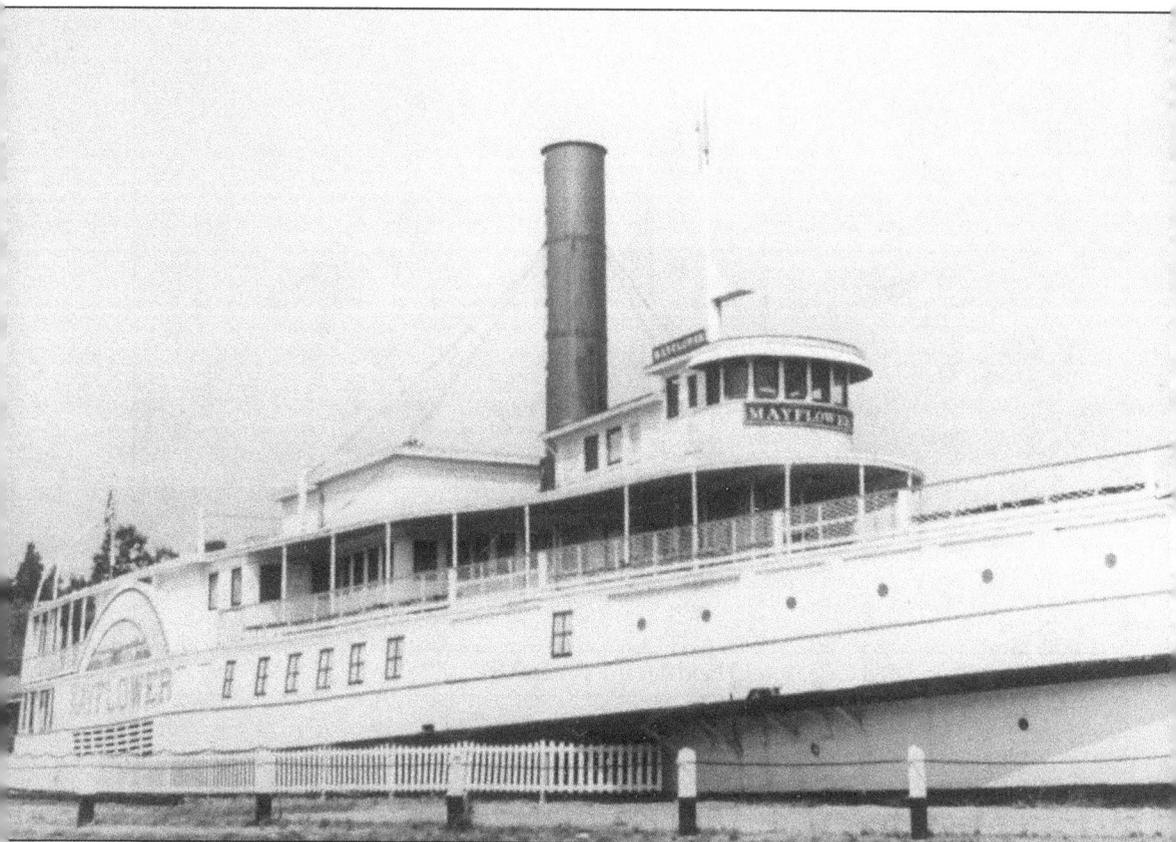

The only survivor of the 1929 steamboat fire, the *Mayflower* sailed on for nearly two more decades before local politician and dentist William M. "Doc" Bergan purchased her in 1948. He then had her grounded on a waters-edge parcel on George Washington Boulevard at the entrance to Hull. There she became the "Showboat," a nightclub frequented by hypnotists, singers, dancers, and other acts. On November 10, 1979, Hull's steamboat saga ended for good when the venerable "Showboat" caught fire during the night and burned to the ground. Although the era of the steamboat ended long ago, Hull today boasts one of the longest continually operating commuter boat runs, still bringing commuters to and from Hull and Boston year-round. Summer tourist service ended several years after the closing of Paragon Park, although there have been discussions for resuming such service due to the continued popularity of Nantasket Beach.

Five

NEIGHBORHOODS
THE HIDDEN BEAUTY OF HULL

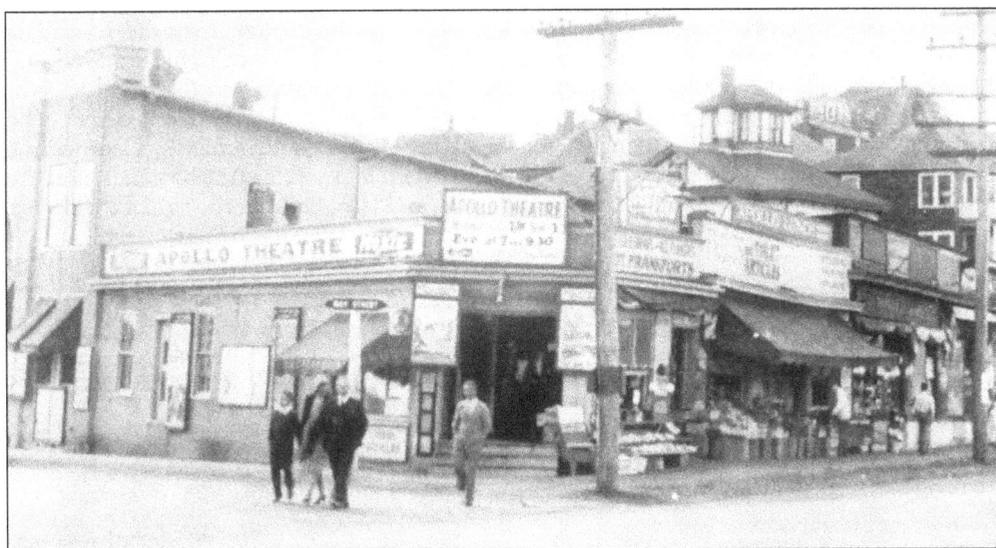

Although Hull is a small community by itself, it is made up of a number of neighborhoods that have a strong identity among the residents and visitors alike. Throughout the peninsula, in the neighborhoods of Stony Beach, Stoney Beach (yes, 2 different areas!), Sunset Point, Surfside, Pemberton, Rockaway, Rockaway Annex, Sagamore Hill, Strawberry Hill, Waveland, West Corner, Whitehead, Gun Rock, Hampton Circle, Hull Village, Allerton, Allerton Hill, Bayside, Fort Revere, Green Hill, Kenberma, The Alphabets, and Nantasket Beach, the spirit and excitement of the town as shown in this chapter is forever present. Even in the early 1910s, Anastos Corner, seen in this early-century photo, was a busy spot at Nantasket Avenue and Bay Street in the Surfside-Sagamore Hill area. The Apollo Theatre was one of the two movie theaters in Hull. Although substantially renovated over the years, the basic block of buildings still exists. The Corner Cafe, Anastos Hardware, Sea Side Kites, and Mezzo Mare (an Italian restaurant) are some of the current businesses.

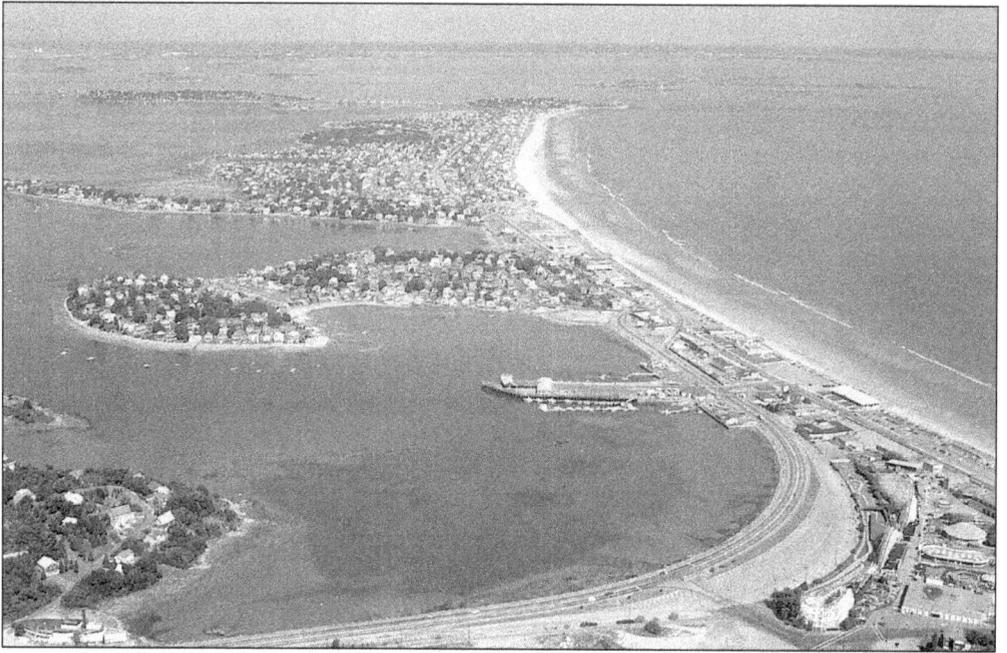

These two aerial views of the Hull peninsula show some of the changes over the years. The photo above shows the town before the close of Paragon Park (lower right) in 1985 and the construction of the high-rise condominiums. The old steamboat *Mayflower*, which was floated onto land and became the Showboat Nightclub, is seen at the lower left corner. The photo below shows the visual changes brought about by the condominiums. Ocean Place Condominiums, built on the site of one of the first Howard Johnson Ice Cream stands, is at the lower left. Horizons Condominiums is seen above Ocean Place, built on the site of the former Paragon Park.

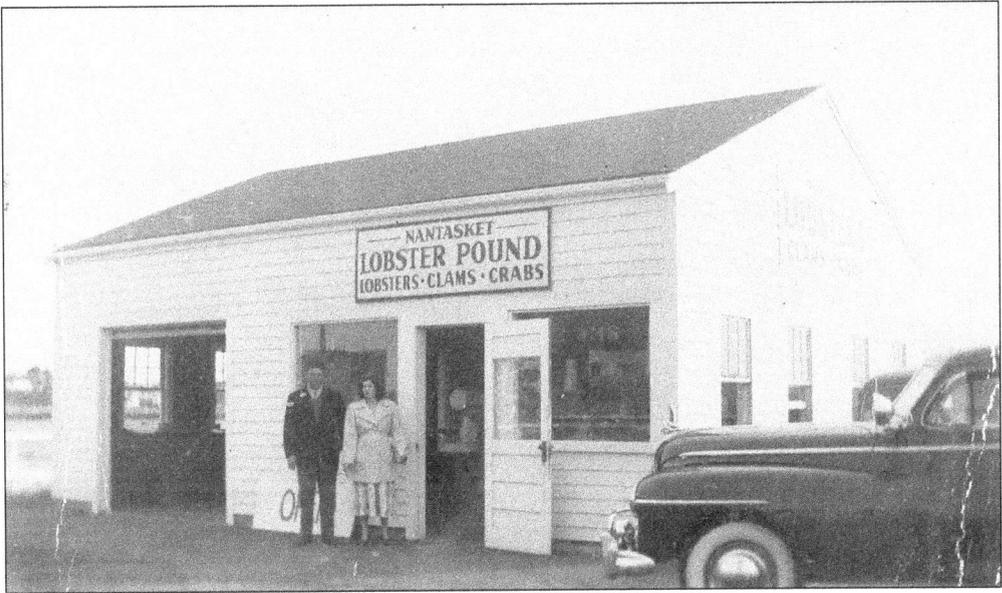

Hull still features many fine restaurants, including the well-known Jake's Seafood at the old Steamboat Wharf at Nantasket Pier, across from the Paragon Carousel. Begun in 1949 as the small take-out Nantasket Lobster Pound, Jake's has expanded several times over the past half century to its present layout of a popular full service restaurant and fresh seafood market. It celebrated its 50th year in 1999. Pictured above are members of the Jacobson family, who operated it until 1985 when the O'Brien family, the current operators, took it over.

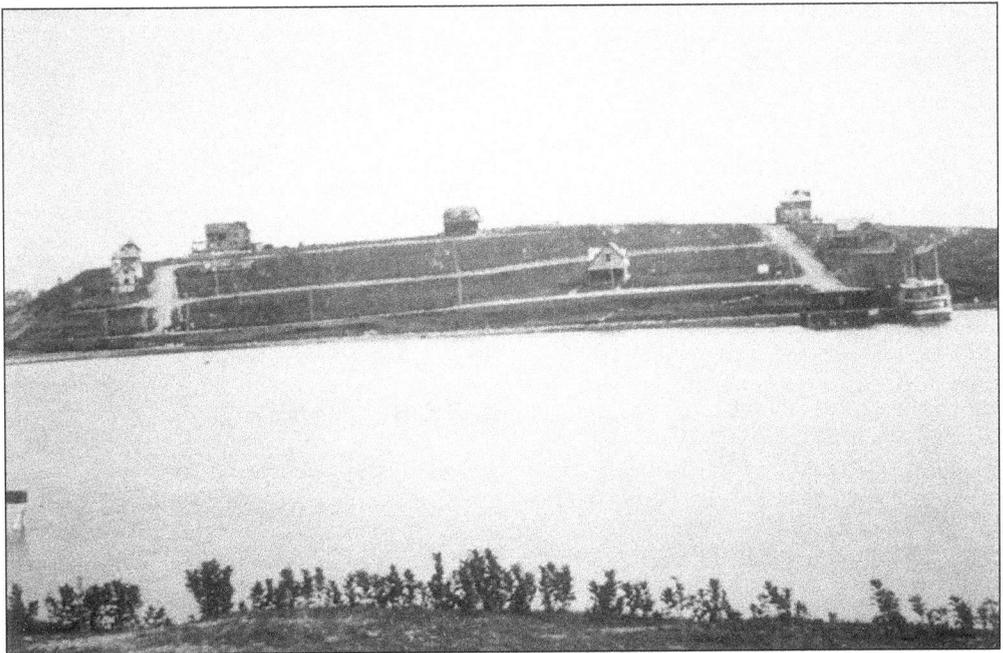

The view above is of Sagamore Hill, from Sunset Point (Edgewater Road) across the bay. Now fully developed with houses, at the time of this photo in the late 1800s only a handful of houses existed. Note the steamboat (the People's Line's *City of Quincy*) docked at the bottom of what is now Island View Road.

Centre Hill & Gun Rock, Nantasket Beach, Mass.

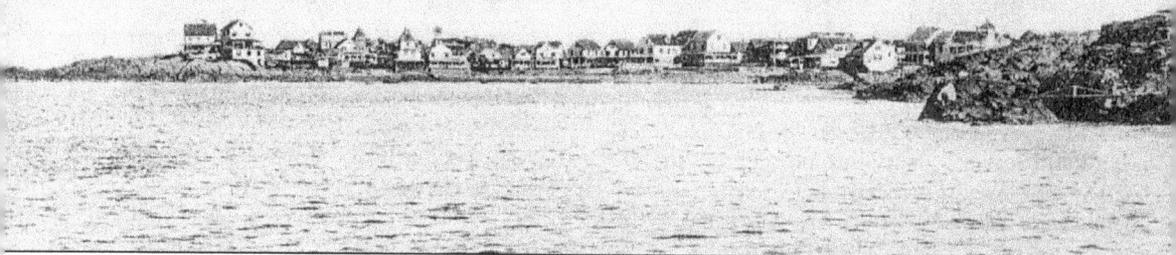

These panoramic real photo-postcard views of Centre Hill (also known as Green Hill), Gun Rock, Bayside, Waveland, and Point Allerton, show the vistas residents and visitors alike

Point Allerton, Mass. View from Strawberry

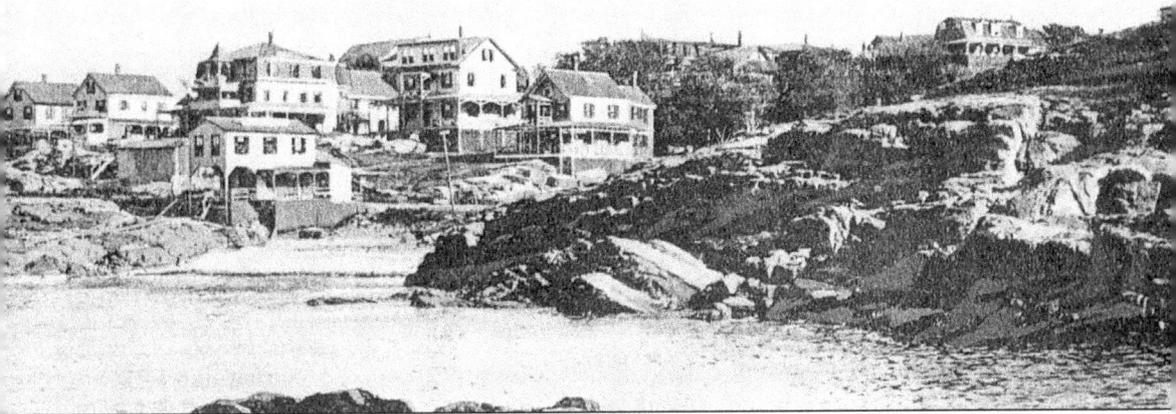

enjoyed. These areas have been substantially developed with private residences. They remain a popular spot for people to live in as well as visit.

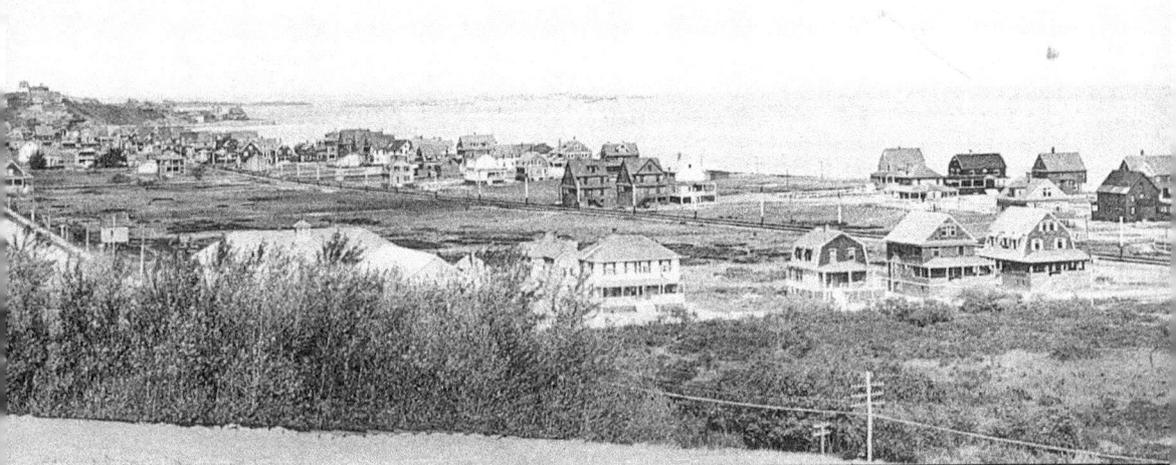

Allerton Bayside & Waveland, Mass.

Telegraph Hill offered unparalleled panoramic views of the town. The top view shows Isle Vista (center), which became known as Park Island, Hog Island, and eventually Spinnaker Island. Before becoming a military base, there were several private residences on the island primarily owned by A.J. West. A causeway was built in 1944 connecting the island to the mainland.

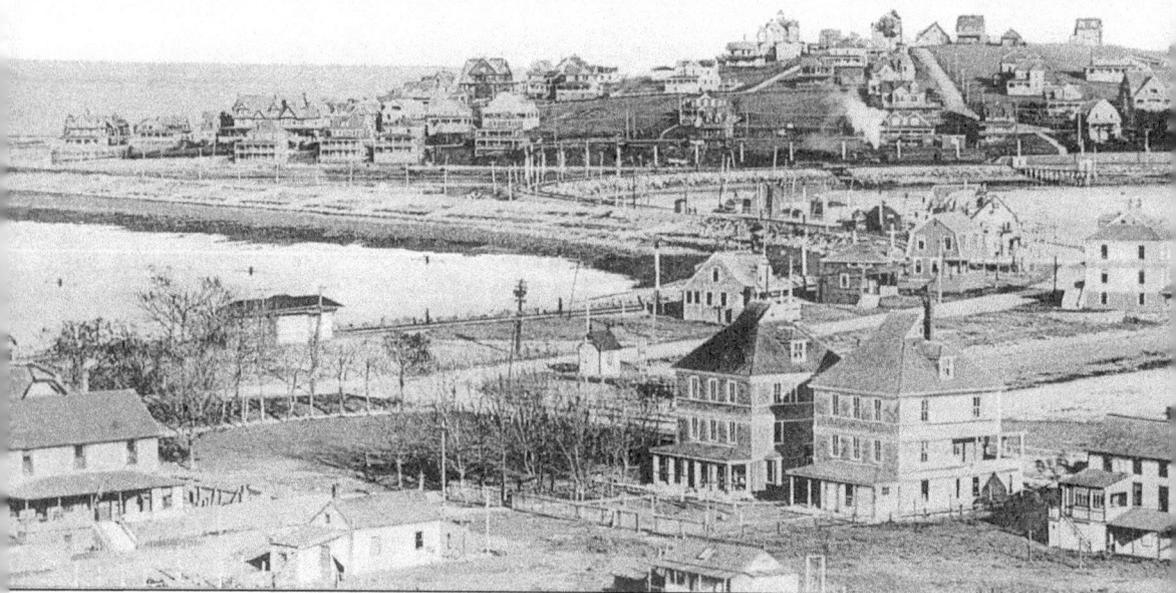

Below, Allerton Hill is shown in the background before development, but still showing the large homes. The bottom of the photo shows the then St. Catherine's Church and area homes. This is now the town's wastewater treatment plant and cemetery. Note the railroad tracks along the ocean side of the narrow causeway and bayside of Allerton Hill.

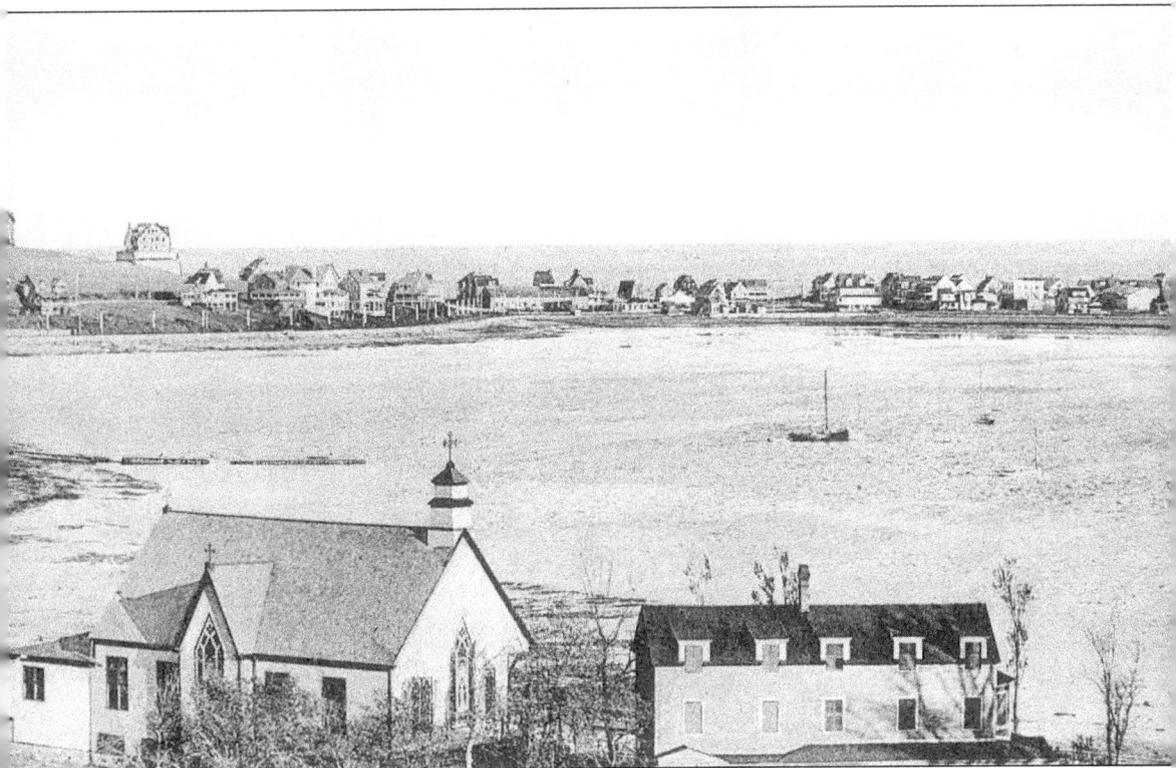

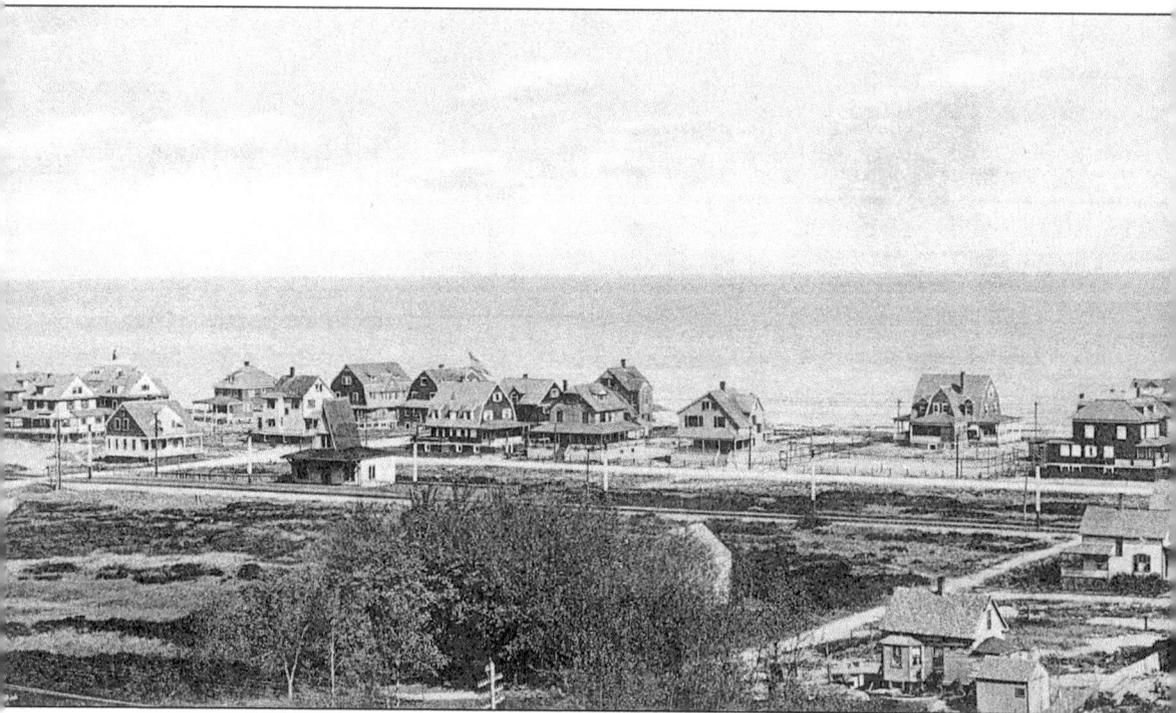

These views from Strawberry Hill, located in the middle of Hull, show the Waveland and Kenberma areas at a time when the beach area was sparsely populated. The proximity of the ocean became a natural draw to developers, who constructed a wide variety of homes there. Seen above, on the left, is the Waveland Train Station, near what is now St. Ann's Church on

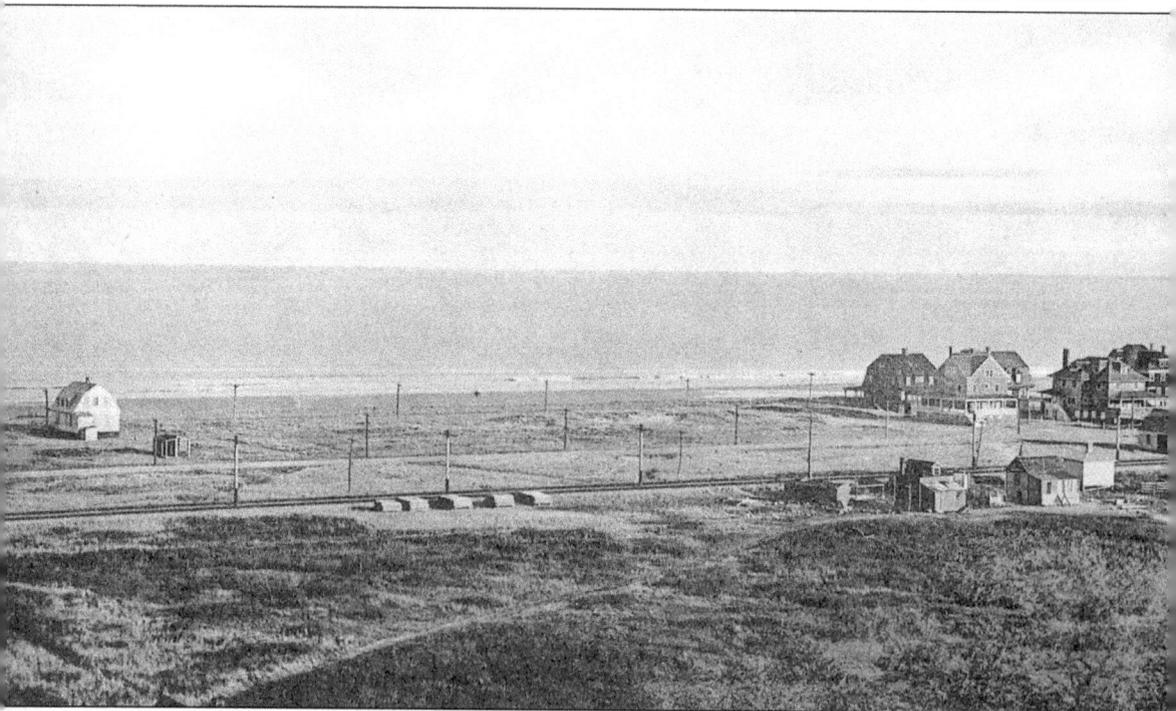

Samoset Avenue, near A Street. The railroad tracks can be seen in both views, running through the middle of town. One of the early businesses, selling "clothing on credit," can be seen in the lower right, below.

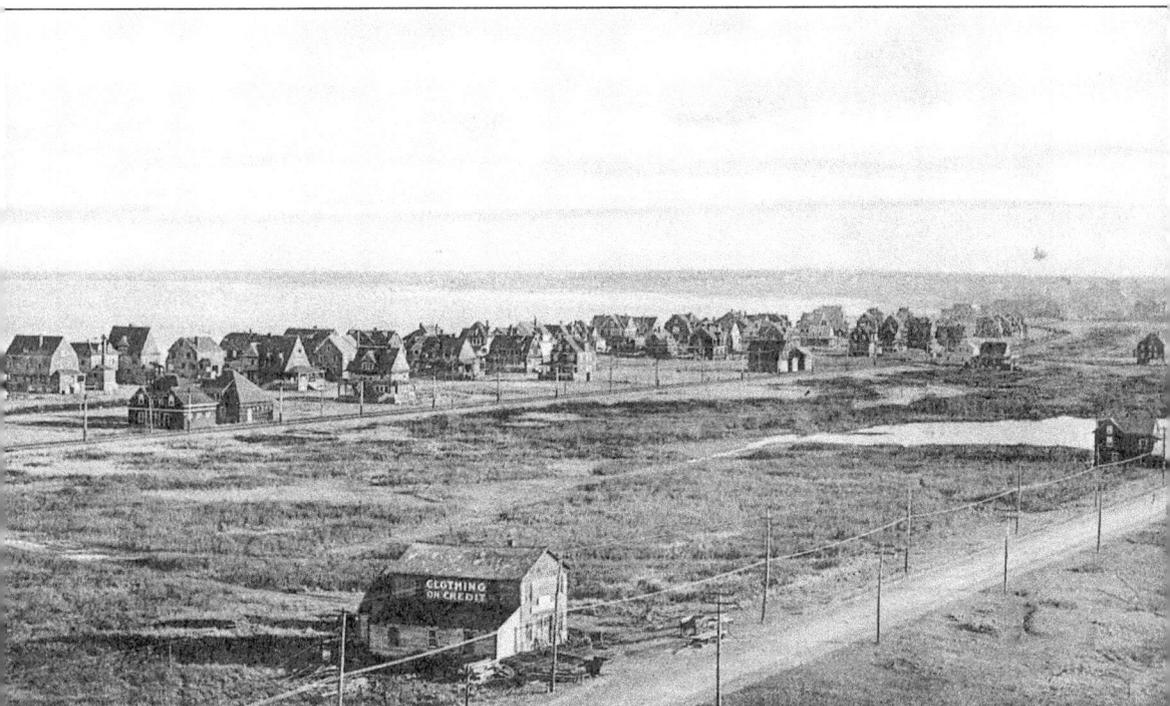

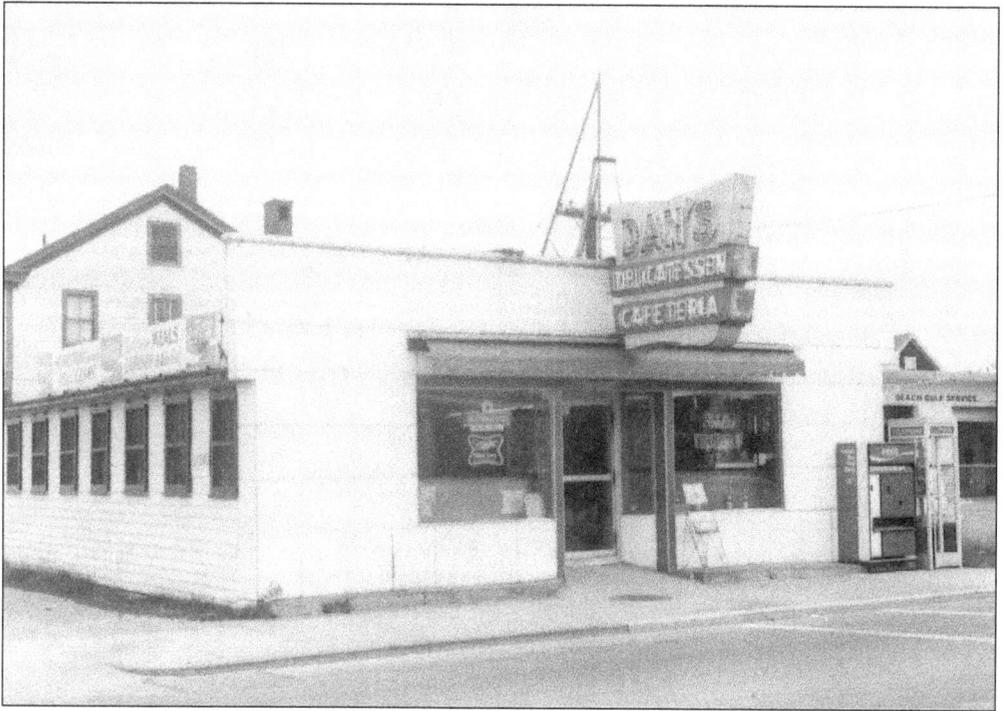

Dan's Delicatessen, which was located on Nantasket Avenue in what is now the Hull Redevelopment Authority, was a New York–style deli popular with residents and visitors alike. It also operated a rooming house, seen behind the deli. Both properties were razed as part of the land clearance for the Hull Redevelopment Authority urban renewal project.

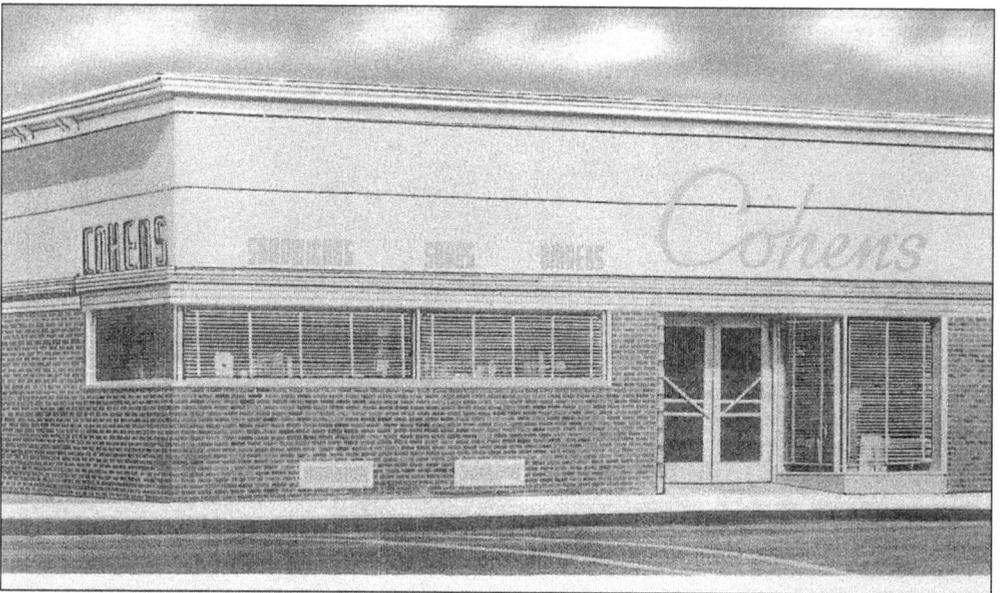

Cohen's Restaurant, located at the corner of A Street and Nantasket Avenue, was the beach's answer to a New York deli. It was even better to most visitors! Run by Harold and Elizabeth Cohen, along with their children, the Cutler and Berman families, this summer hot spot drew long lines of people at night longing for a "mile high" sandwich with an egg cream soda.

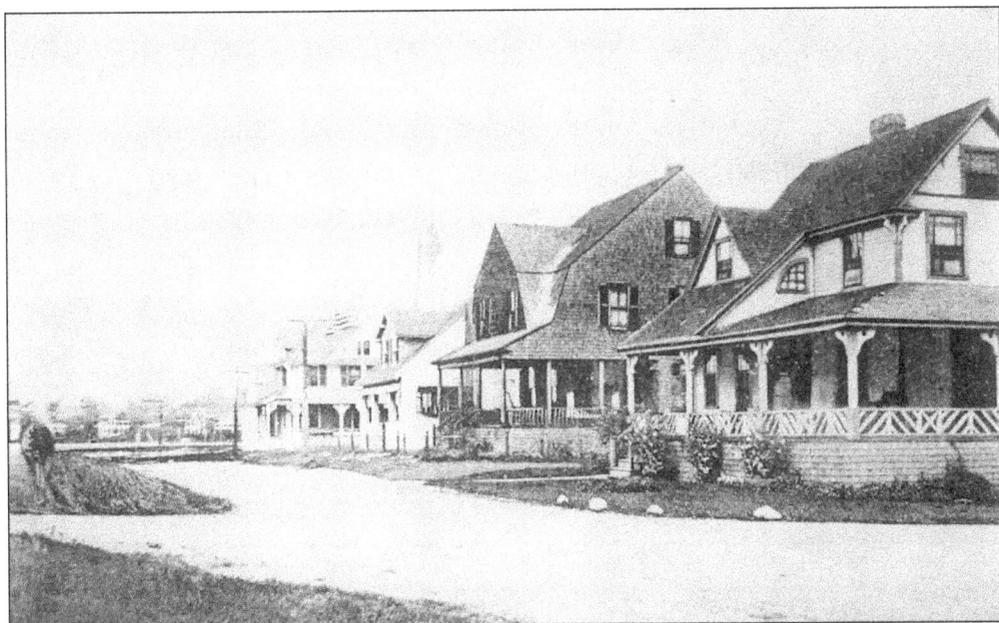

Many of Hull's neighborhoods featured quaint summer houses, which were eventually converted to year-round residences. The scene above is between P Street and Q Street along Central Avenue in what is part of the Allerton section of Hull and is typical of the homes in the area. Several of the homes still exist today, and their Victorian charm has little changed.

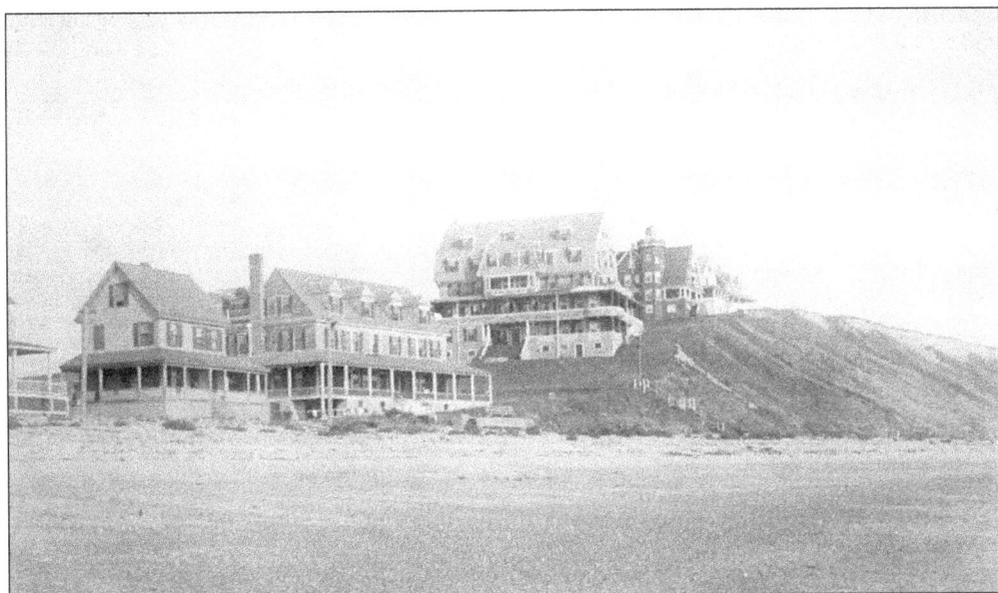

This late 1800s, early 1900s beach side view of lower Allerton Hill shows some of the large homes typical of that era. The Nautilus Inn was located behind the two houses on the left. The bluff had a long and wide slope at that time. As the hill became more developed and mother nature took its effects, the hill became densely populated and the slope eroded to a steep precipice. Under a public works project, the slope has been reinforced with stonework, saving the hill and many homes from certain collapse.

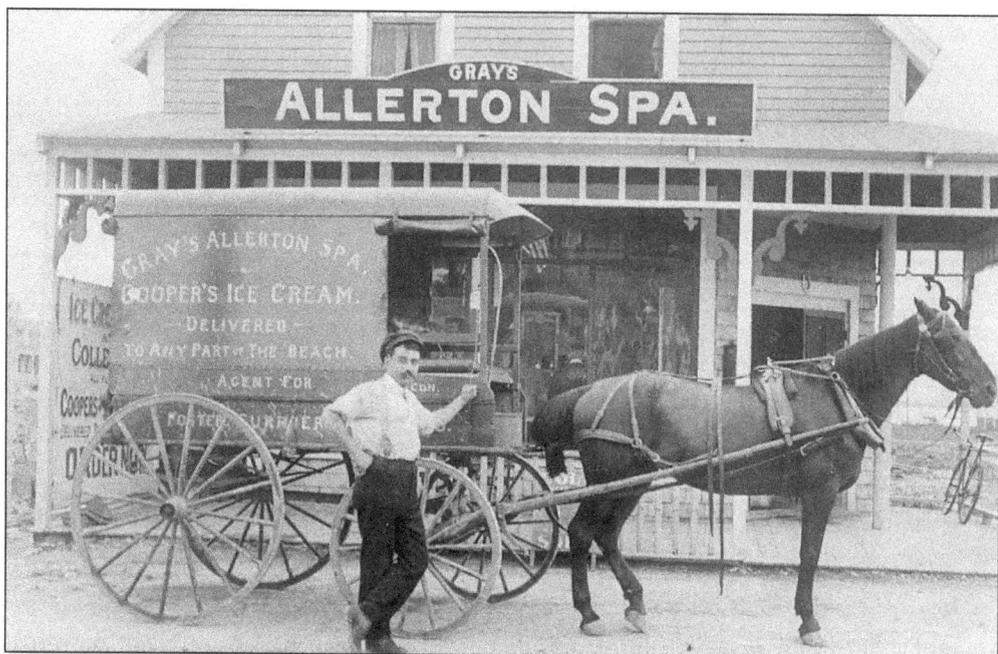

Located in the Allerton neighborhood were several stores that serviced the town. Gray's Allerton Spa, located at the R Street and S Street area of Nantasket Avenue, carried a wide range of items for residents and visitors. In what appears to be an early version of the popular ice cream truck, Gray's offered deliveries of ice cream treats by this horse-drawn wagon. Other stores in the area included Rudderham & Crowley, which sold groceries and provisions, and also served as the post office. It too had a team of horse-drawn wagons for delivering goods to customers.

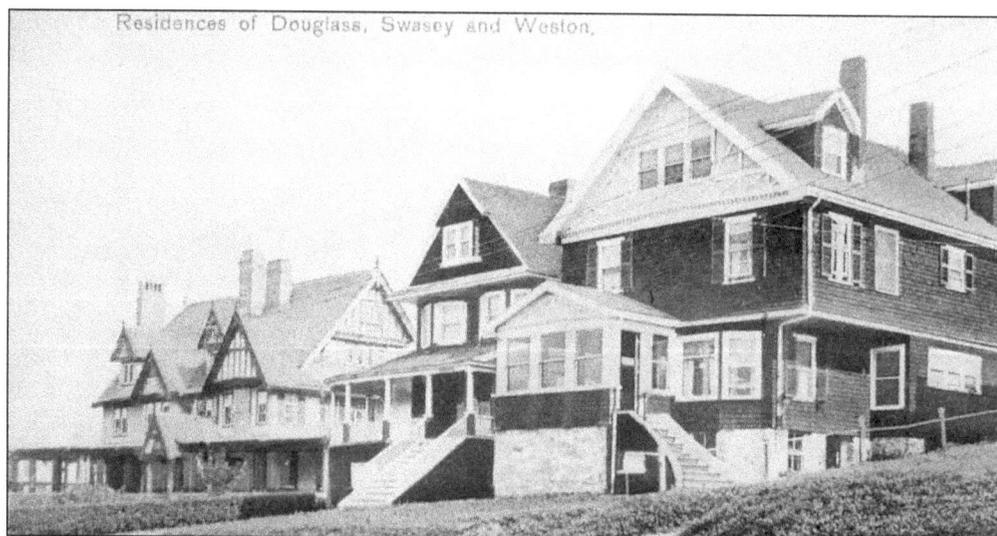

Even years ago, Allerton Hill featured large stately homes, having magnificent views of the beach and ocean. The Douglass house above (left) became the summer home of the Fitzgerald and Kennedy families. The Weston house (right) was the residence of Cora Weston and family, a woman who was a prominent builder of many houses in Hull—a rare vocation for a woman in the first half of the 20th century.

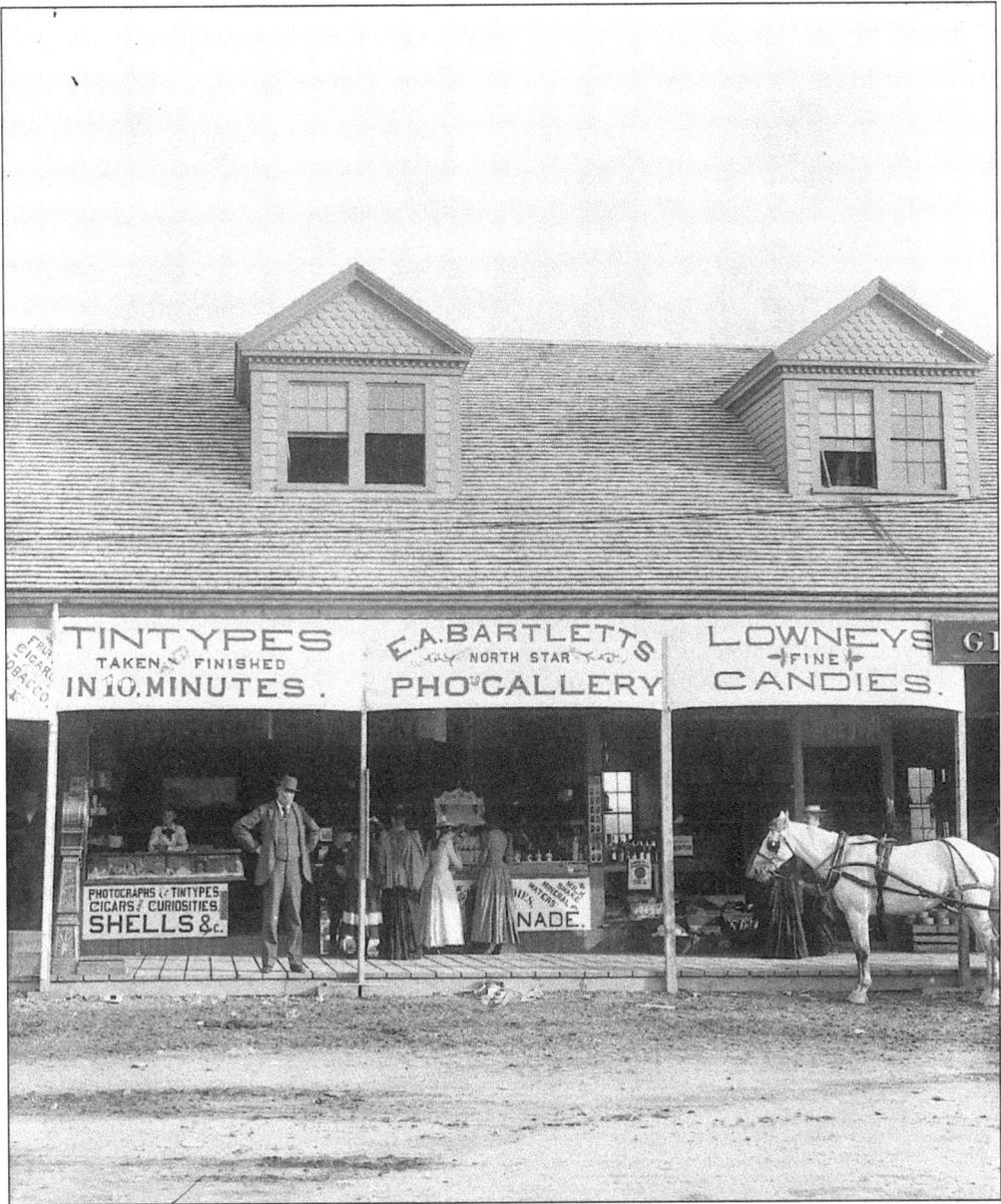

When national marketing was in its infancy, seaside resorts like Nantasket Beach were rendezvous for new ideas, products, and fads of all types. Edrick A. Bartlett was selling cola in Hull before it became a nationwide beverage. He also holds the distinction of buying the first paid advertisement using the phrase "hot dog!" In promoting the frankfurter, Bartlett ran an ad in the *Hull Beacon* edition for July 9–August 6, 1898, that read, "NO FOOLING! Don't Fail to See Bartlett's—Hot Dog—Factory." This use of "hot dog" makes Hull and Nantasket Beach the home to the original Bartlett Hot Dog, and this particular dog was the first to be named. By comparison, the first recorded use of the term "hot dog" at Coney Island did not occur until 1906. Bartlett operated a shop across from Nantasket Pier, behind the present-day Paragon Carousel site, selling souvenirs, and snacks such as roasted nuts, candy, and of course hot dogs. Bartlett also ran a photography studio.

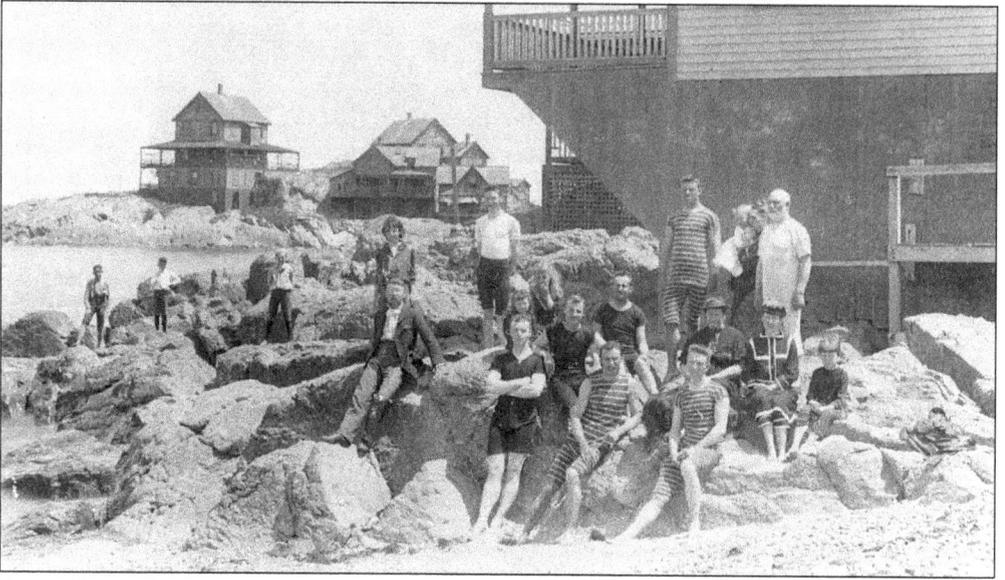

Gunrock Beach, located in the south section of Hull, has always been a small but cohesive neighborhood. Many summer families have returned here for generations and many more have become year-round residents. Gunrock Beach, pictured above, has always remained a popular spot. Note the variety of beachwear worn by the bathers.

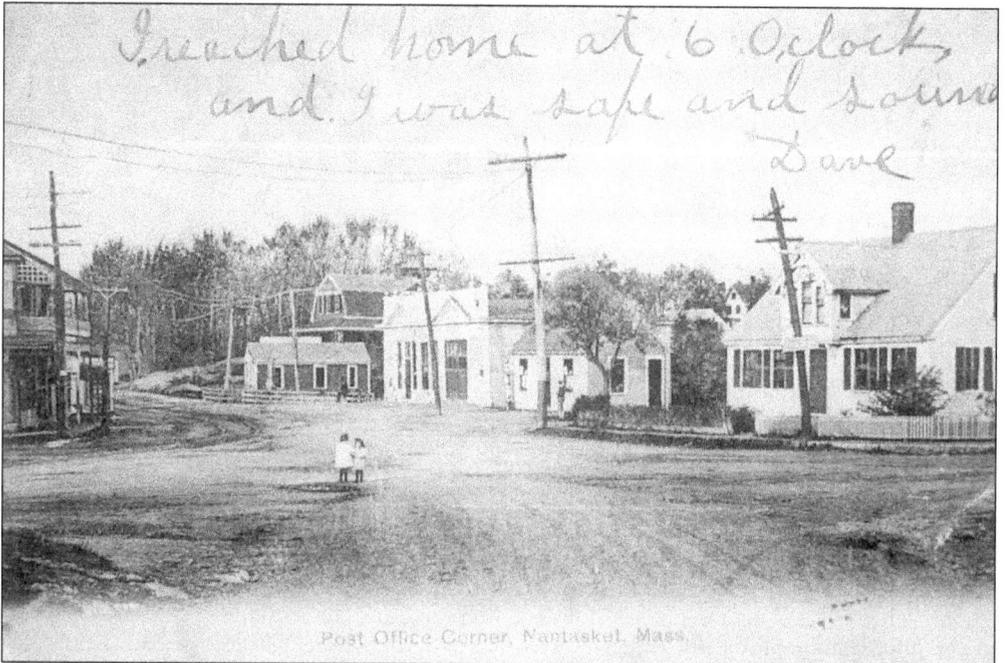

West's Corner, once known as Post Office Corner, is at the end of Route 228 where Hingham and Cohasset intersect with Hull. The area has not changed much since this early-20th-century real photo postcard was made. The private home at the right and the small building next to it, the West Corner Men's Club, still exist today. The third building from the right was recently torn down. The small shop on the other side of the bridge is currently Pasquale's Prints and Custom Framing Shop, while the house behind it is still a private residence.

Six

MUNICIPAL AND COMMUNITY BUILDINGS
WHERE WE ALL COME TOGETHER

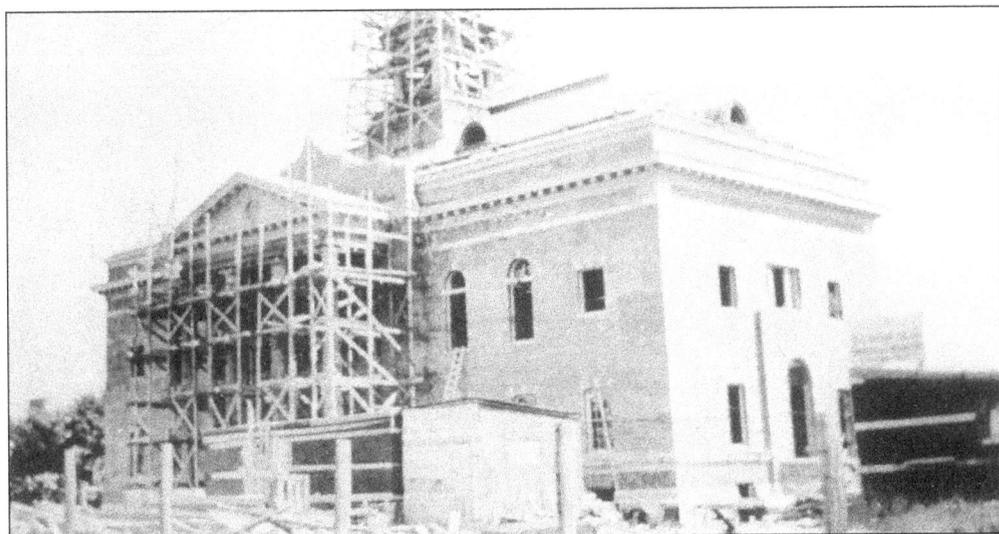

This chapter explores several of the town's municipal and community buildings, including Town Hall. The original Town Hall, located in Hull Village is still in use as a fire department sub-station and historical museum. The current Town Hall, located in the Green Hill section was constructed in 1921 as one of the largest buildings in town other than the hotels. Constructed mainly of brick, with impressive 40-foot-tall columns in front, the building initially had offices on the first floor, and an auditorium for town meetings and events and gymnasium on the second floor. After one renovation, the ceilings of the auditorium and gymnasium were lowered, and the space was used for offices. The new third floor was used for storage. A final renovation included an addition for the police department and was completed in 1978.

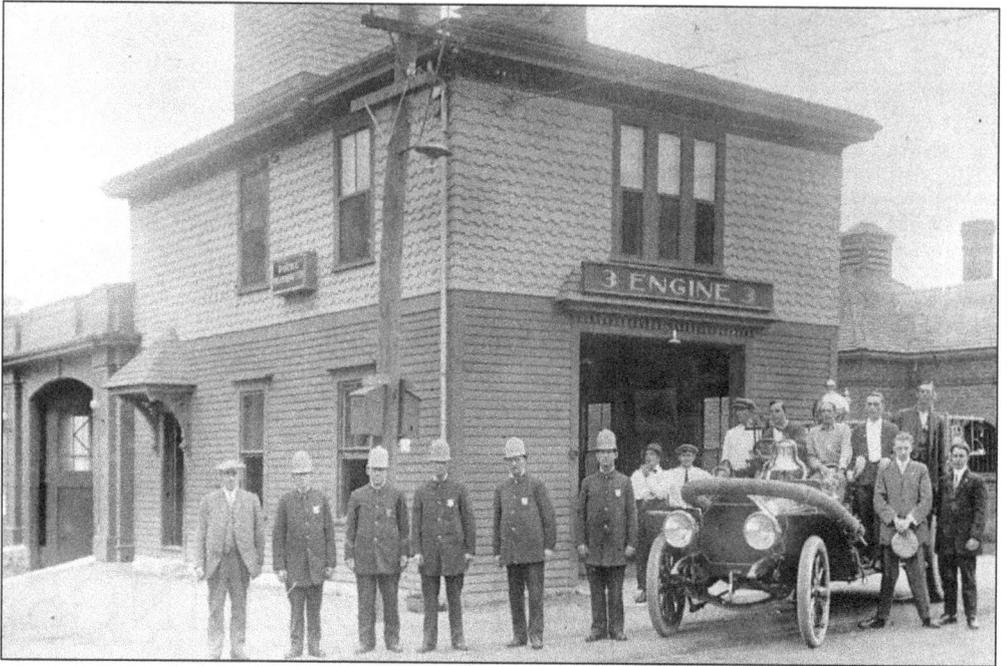

The original Hull Police Station and Fire Station, then located at School Street and Atlantic Avenue, Atlantic Hill, occupied different sides of the same building. A traffic island dedicated to World War II veteran Sergeant William E. Bowes, across from the present police station and Town Hall, marks the location today. The building was replaced in 1921 by the present Municipal Building on Atlantic Avenue.

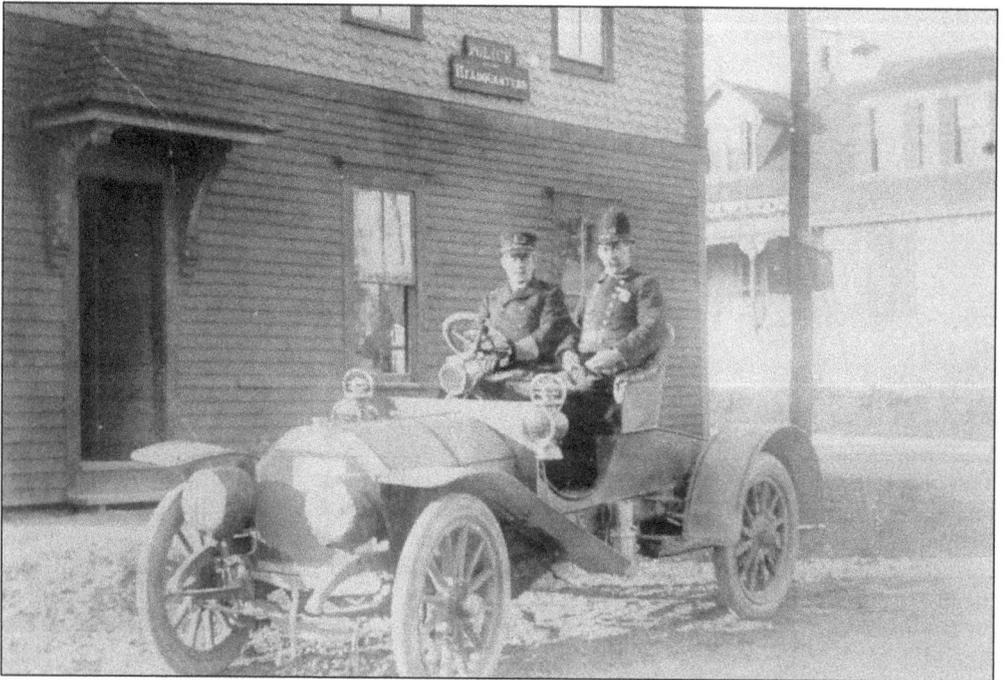

Believed to be the first Catholic church in Hull, St. Mary of the Assumption was dedicated in June of 1890. It was located in the Green Hill section of Hull, on Atlantic Avenue. In later years, following the consolidation of the Catholic churches, the local Episcopal church used St. Mary as its home. In 1998 the property was sold to private developers who plan to convert the property to other uses.

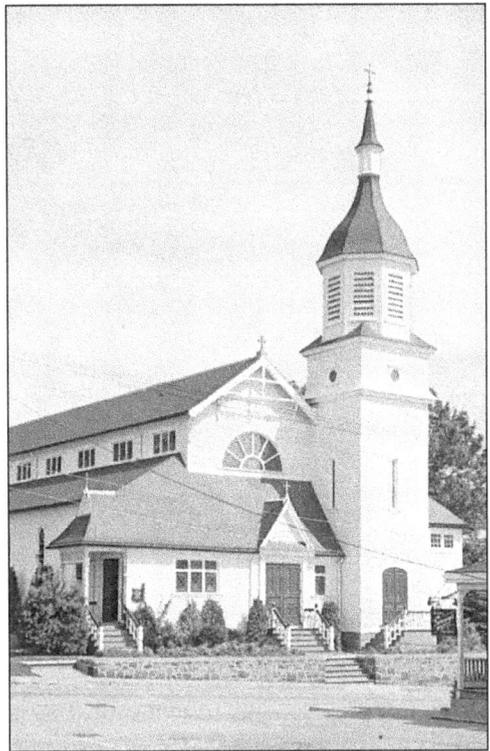

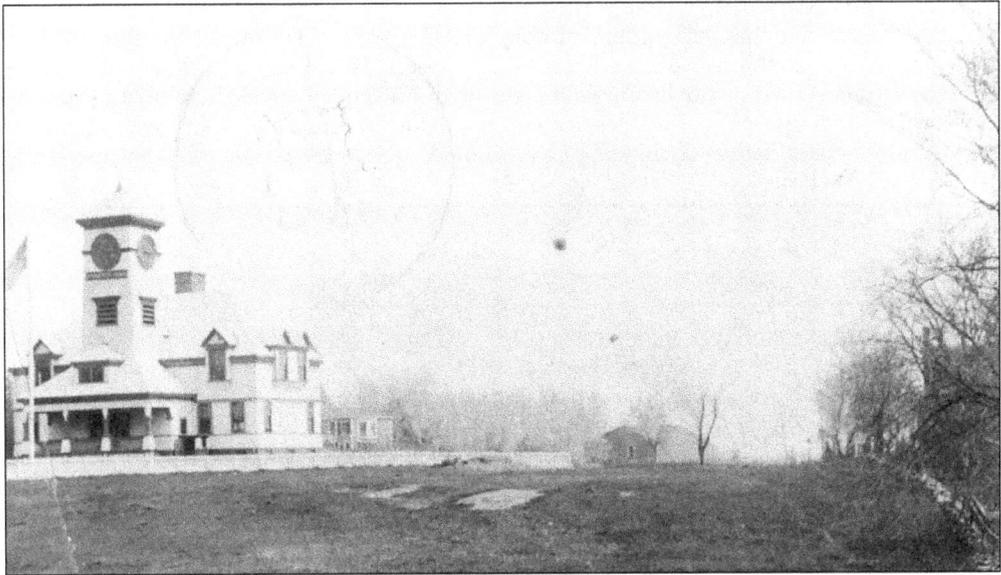

Atlantic School, off Atlantic Avenue and School Street, and one of Hull's earliest, was built in 1876 and opened in May of that year. It served the community until the original Damon school (above) replaced it after its construction in 1893, across from the current police department. This building served as one of the town's primary schools until a newer Damon School was completed in 1959. The "newer" Damon School served as an elementary school until 1981, when it was closed and eventually converted into the Damon Place Condominiums, where some of its former students are now its residents.

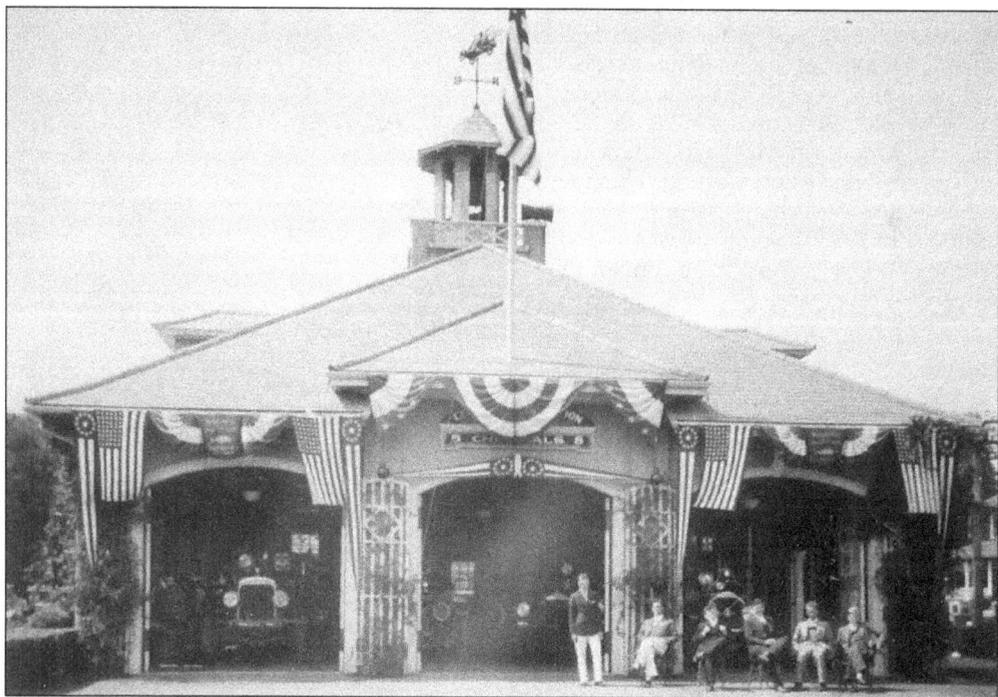

Hull's Fire Department, first organized as a permanent department in 1886, had to battle many fires that broke out in the wooden structures in town. The fire department headquarters at A Street and Nantasket Avenue is shown above c. 1930 decorated for the Fourth of July. The department also has sub-stations at the old Village Fire Station on Spring Street in Hull Village, and at the rear of the Town Hall in Green Hill. Pictured below is the Green Hill substation showing the first gasoline-powered fire engine in Massachusetts, costing the town $6,995 in 1909. The department has adopted the famous lifesaver and Hull native Joshua James, father of the U.S. Coast Guard, as its symbol. His face appears on the department's patches.

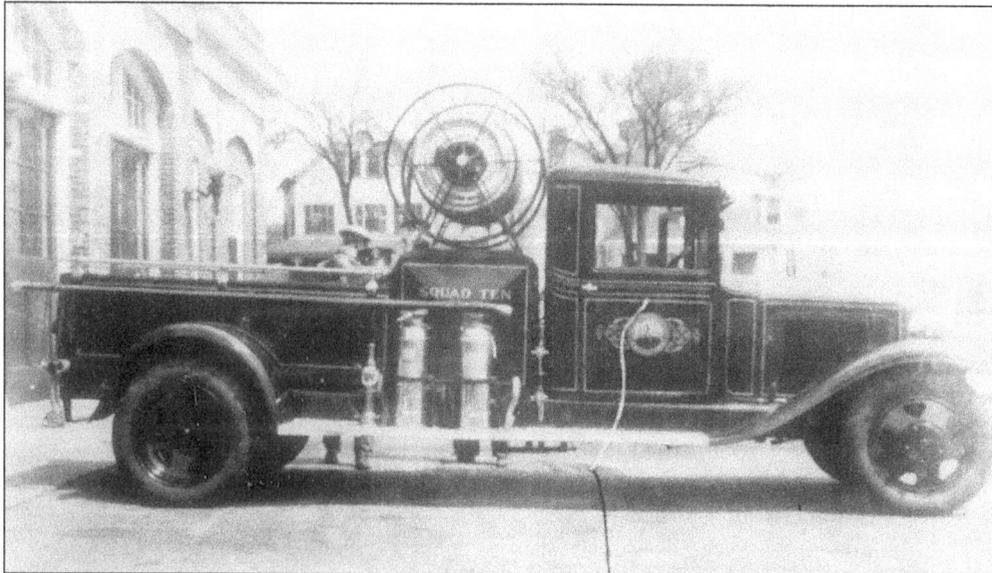

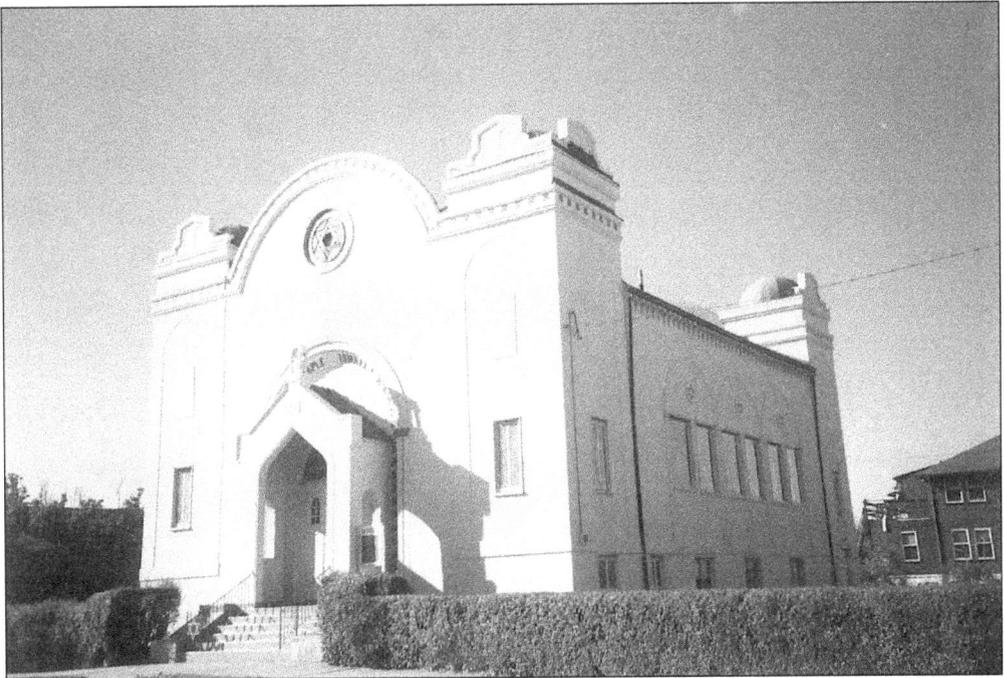

Temple Israel, located on Hadassah Way (formerly Wilson Street) was built in 1920 and is still used today by Temple Israel, mainly in the summer, and by Temple Beth Sholom, a year-round congregation. The Nantasket Youth Center was located between the two congregations and held non-sectarian summer recreational programs. It was also used as a religious school and community center prior to the construction of Temple Beth Sholom's School and Community Building on Nantasket Avenue. Hull also was the summer home of The Grand Rabbi of New England's Hasidic community, who maintained a summer retreat in Hull until the early 1990s at 4 Sunset Avenue (still a private residence).

St. Ann's Church, located on Samoset Avenue near A Street, in the Waveland section, features the Spanish mission–style roof seen on several local houses of worship. In response to the increased population in Hull, the Archdiocese built St. Ann's Church, which was dedicated on July 25, 1915. Still in active use, and having recently undergone an expansion following the consolidation of the local Catholic churches, the original cost of the building is believed to be $28,000.

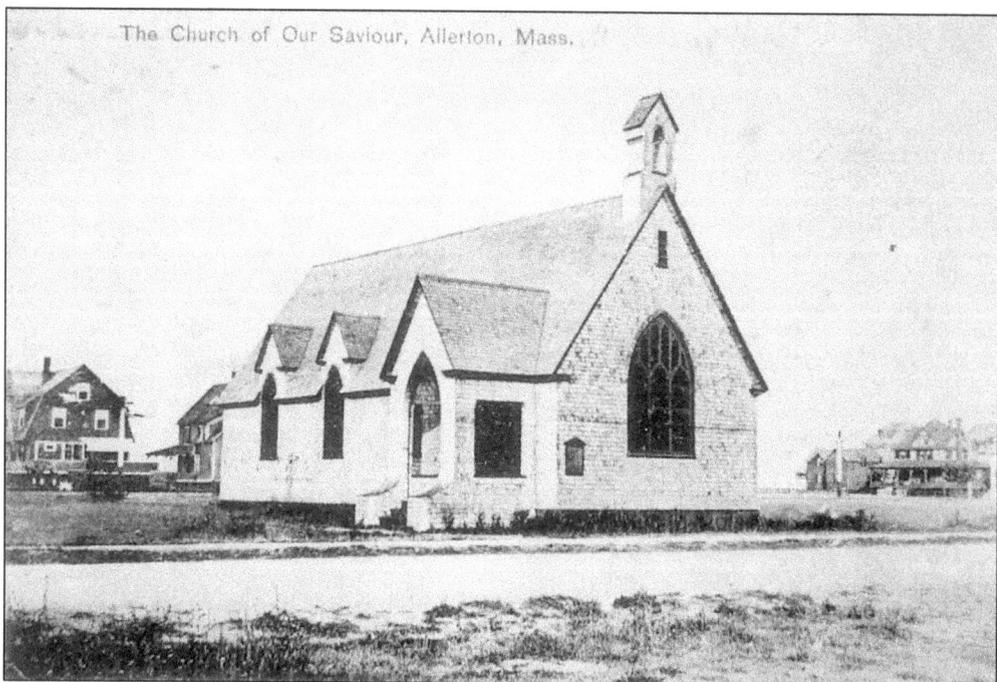
The Church of Our Saviour, Allerton, Mass.

The Church of Our Savior, an Episcopal church once located in the Allerton section of Hull at N Street and Nantasket Avenue, was built in 1902. In 1947 it sat unused in Hull, but soon became St. Peter's Church-on-the-Canal in Buzzards Bay. The then Episcopal minister from Buzzards Bay was told he could have the church building on the condition that he pay to have it removed. As shown below, all 70 tons of its 70-by-45-foot structure were placed on a barge on Nantasket Beach and hauled by the tugboat Bounty the 60 nautical miles to Buzzards Bay, where it is still in use. The church's former Hull location still has a religious connection. Across the street from its former location used to be the Bayside Movie Theater, which eventually became the Lighthouse Assembly of God church, a fitting name for a church located in the hometown of America's first lighthouse—Boston Light.

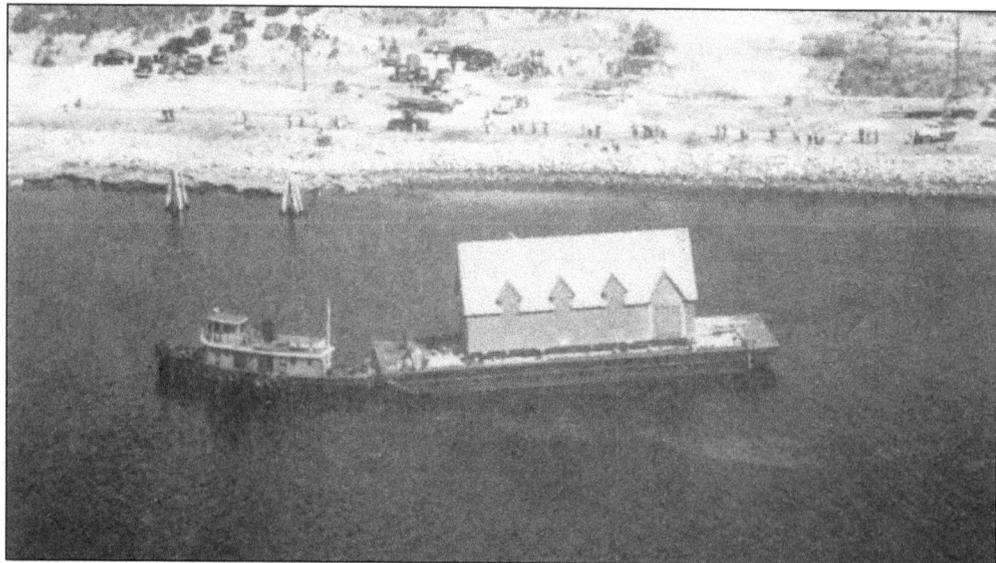

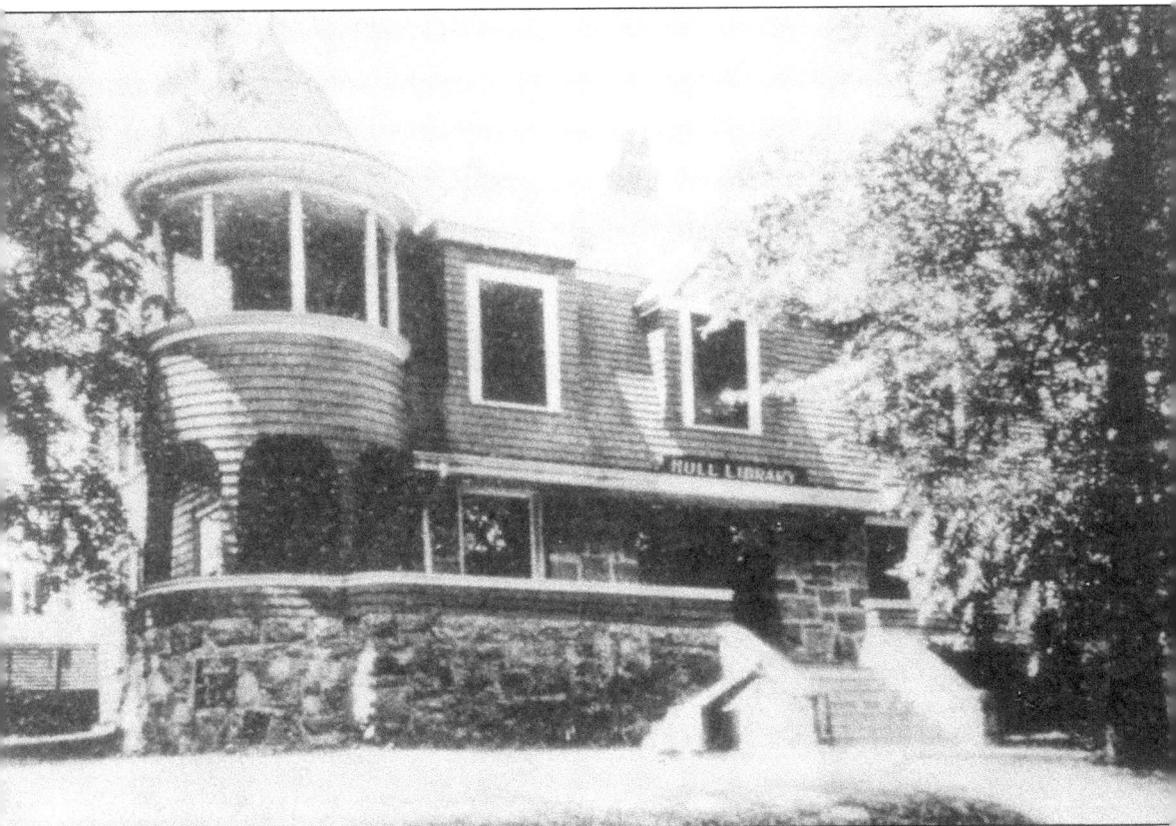

The summer home of John Boyle O'Reilly, the famous Irish patriot, poet, and editor of *The Pilot*, the newspaper of the Catholic Archdiocese of Boston, became the Hull Public Library in 1916. A raised image stone monument of O'Reilly graces the front yard. The cannon that appears in the photograph came from the wreck of the bark *Kadosh* in 1872. It sat in front of the public library until World War II, when maritime historian Edward Rowe Snow saved it from certain destruction when it was almost melted down for metal needed for the war effort. Plans are underway to restore it to its proud place in front of the library. Hull shared a library sub-station with Cohasset at West Corner for many years, until it was consolidated with the present library. An addition was added by community volunteers in the 1990s, and the library, located at Main Street, Elm Square, now also functions as central meeting spot in Historic Hull Village, and is the scene of numerous community events.

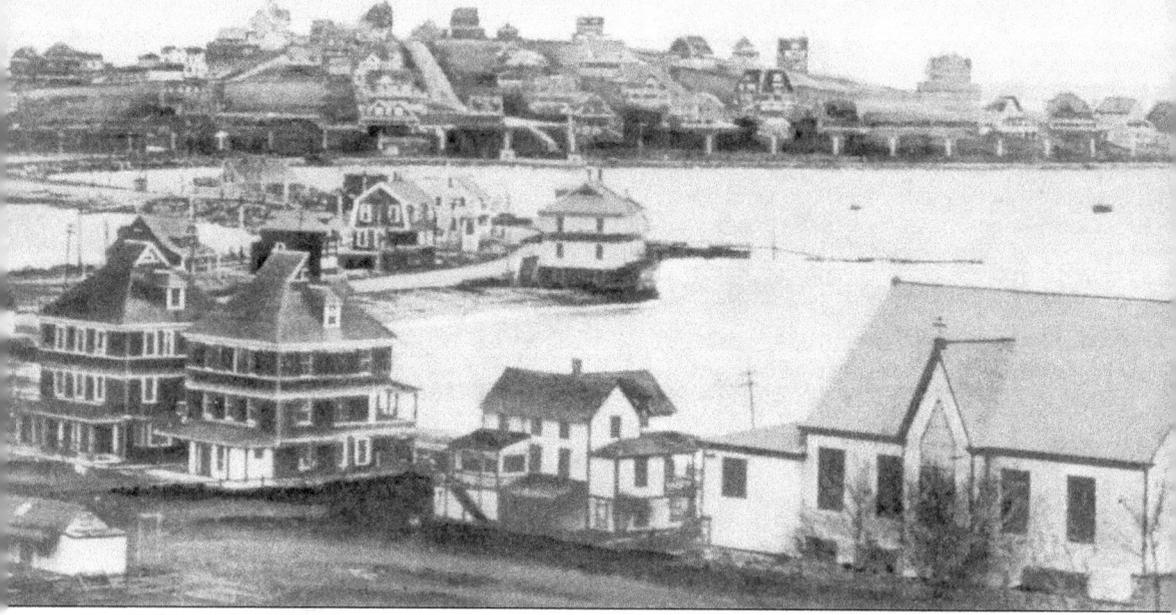

Before 1904, Catholics in the north end of town had to attend services at either St. Mary of the Assumption on Green Hill or travel to a neighboring town. To address their needs, first, services were conducted in Hull Village at the old Town Hall or the Corinthian Yacht Club. Finally this church, the original St. Mary's of the Bay, also known as the Church of St. Catherine, was constructed, and dedicated August 28, 1904. It was located at Stony Beach, approximately at what is today the site of the entrance to the Hull Cemetery. However, due to an increased Catholic population, St. Mary's of the Bay in Hull Village was built in 1928, and this beautiful building was razed. In the background is Allerton Hill at a time when there were few homes taking advantage of the beautiful views. Part of the bay area below Allerton Hill was later filled in and is now the home of Mariner's Park, the Hull Yacht Club, and Nantasket Beach Saltwater Club. The area between Allerton Hill and the Church is the narrowest spot in town, where one can literally kick a ball from the ocean to the bay.

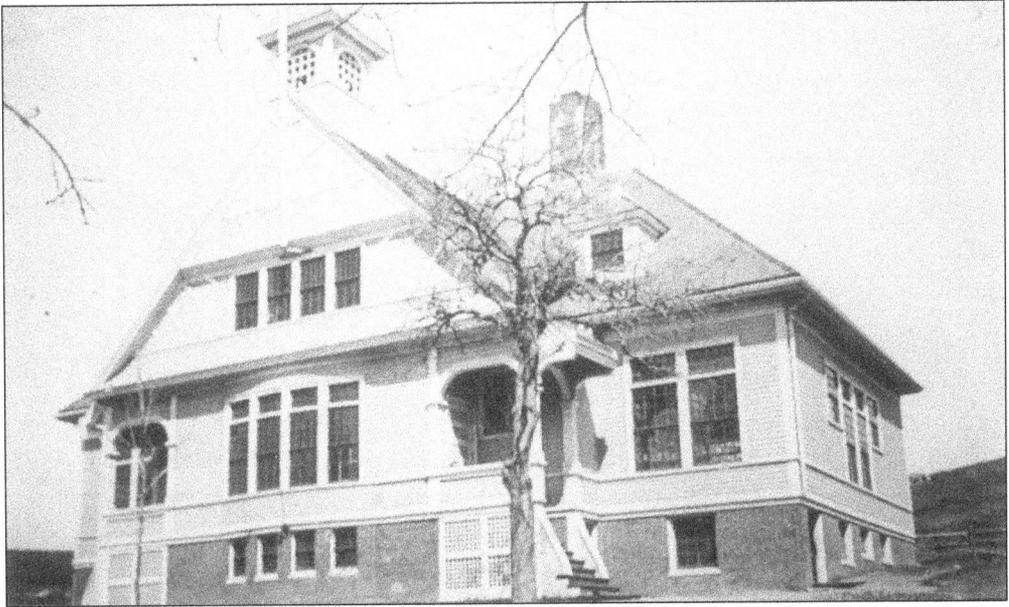

Hull's original Town Hall also served as the town's first schoolhouse and the Village Fire Station. Its school use was transferred to the Village School (above) in 1889. It housed grades one through eight until it was torn down in 1949 following the construction of the Memorial School. The former Village School House was located at the intersection of Nantasket Avenue and Spring Street, next to the St. Nicholas United Methodist Church and across from the old Town Hall.

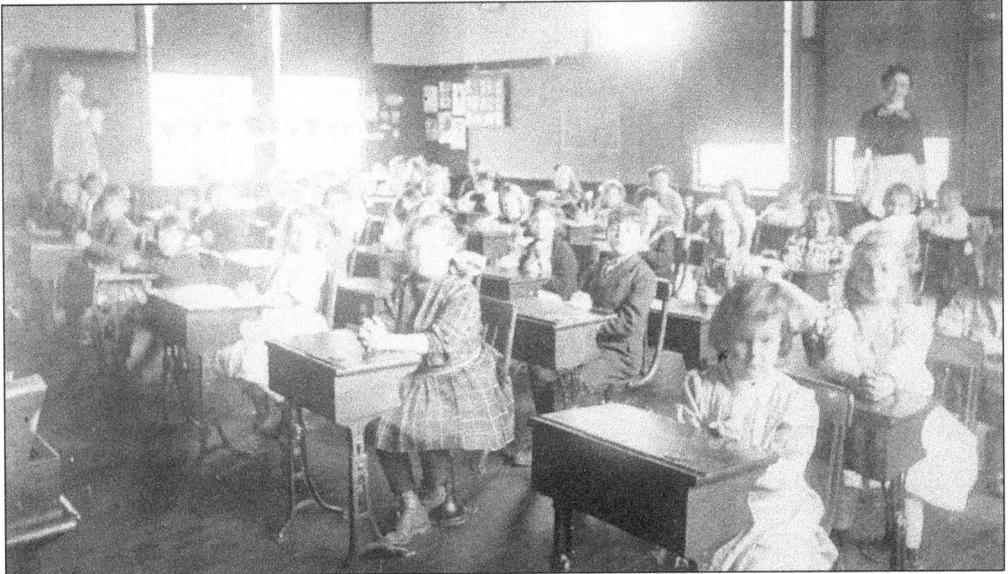

Classes in the Village School were full of children. As was common in that era, girls wore dresses and boys were neatly attired. The teacher, right rear of the photo, was dressed prim and proper. Although the school is long gone, the students' desks from the school remain popular collectors' items. During recess, the students played across the street in the Village Park, a quintessential New England village green still used today.

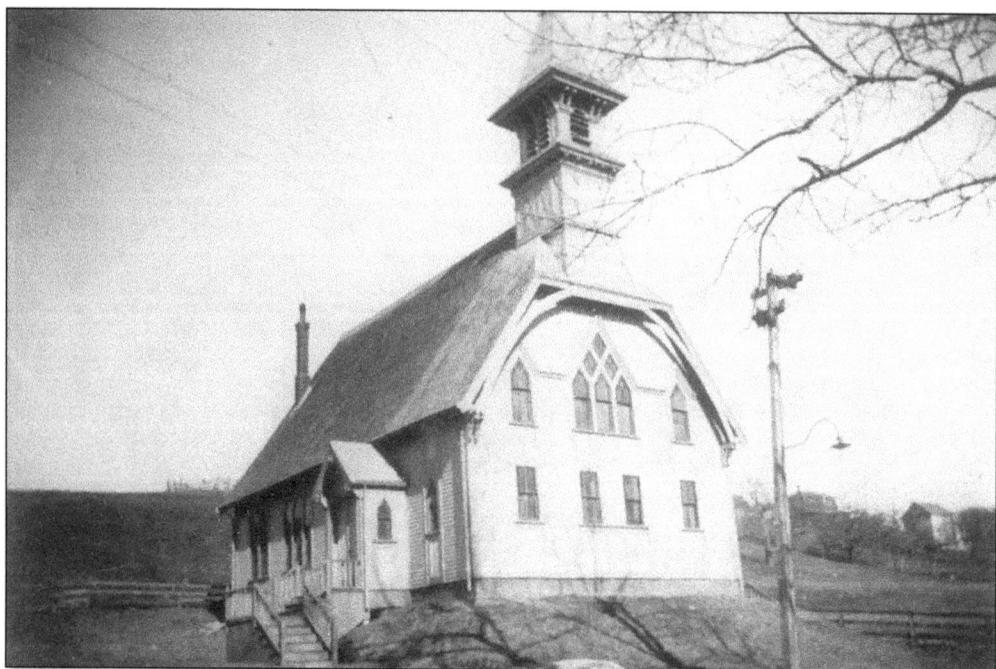

The St. Nicholas United Methodist Church is located on Spring Street in Hull Village, across from the Village Park. Built in 1882, it is still in use as a house of worship. The interior sports tin-plated walls, which were necessary to prevent damage to the walls when the military guns at the nearby Fort Revere were discharged. The church's minister performed all the burials at Strangers Corner in the Hull Village Cemetery—final resting place for those unidentified bodies washed up on Hull's shores from ships lost in the infamous storms.

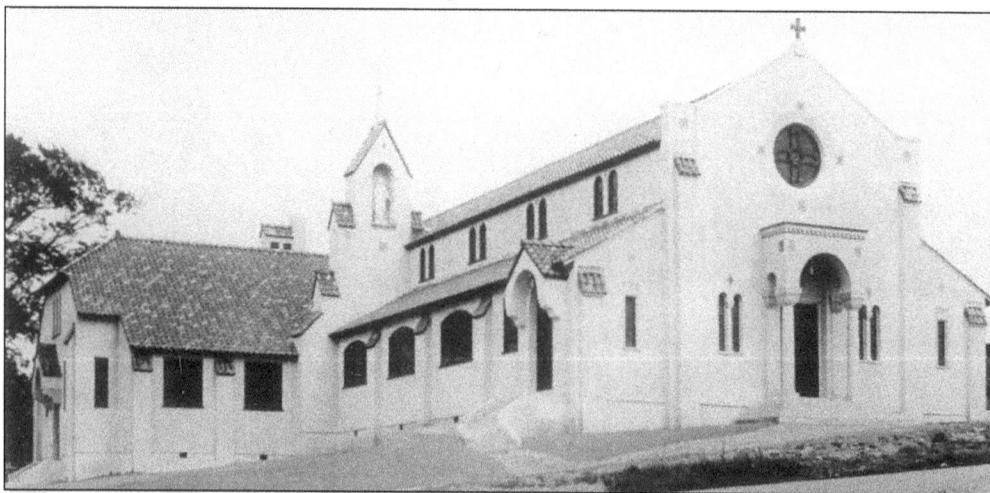

Built in 1928 of Italianate design, St. Mary's of the Bay in Hull Village was located on Highland Avenue across from the present site of the United States Coast Guard Station—Point Allerton. The Kennedy Family assisted in its construction and worshipped there during their summer stays in Hull. Dedicated on June 28, 1928, it replaced the former St. Mary's of the Bay at Stony Beach. The local Episcopalian church operated from part of St. Mary's until the building was sold in the late 1990s. It is now a private residence retaining many of the features of the "Church by the Bay."

76

Seven

MILITARY
DEFENDING BOSTON HARBOR

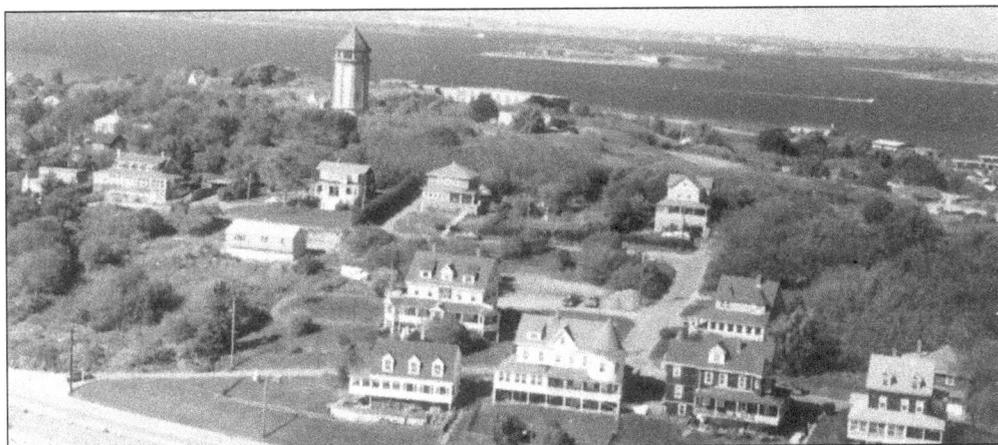

In 1632, Governor John Winthrop considered Hull as a site for a fort to defend Nantasket Roads, Boston Harbor's southern entrance. Later, instead of fortifications, Hull residents were directed to maintain warning beacons on Allerton and Telegraph Hills from 1673 to 1696. English and Colonial military expeditions against the French in Canada sailed from Nantasket Roads in 1690, 1692, 1704, 1711, 1745, and 1758.

During the American Revolution, Hull villagers were evacuated three times: 1775, 1778, and 1782. In July 1775, two American raids (Vose's and Tupper's) on Boston Light resulted in extensive damage to the light tower and heavy British casualties. A field gun placed on the shoreline of Telegraph Hill sank a barge carrying Royal Marine reinforcements to the lighthouse garrison during the second raid. In June 1776, local militia commanded by Benjamin Lincoln constructed and garrisoned the small, five-bastioned earthen Fort Independence and two detached batteries on Telegraph Hill. From July to November 1778, the Hull peninsula was turned over to D'Estaing's squadron for use as a fleet base. Bougainville, the famous South Sea explorer and circumnavigator, commanded the peninsula, and Major MacDonald commanded the French Marine garrison of Fort Independence. In the fall of 1782, Rochambeau's army marched from Yorktown to Boston and embarked at Hull for France over Christmas.

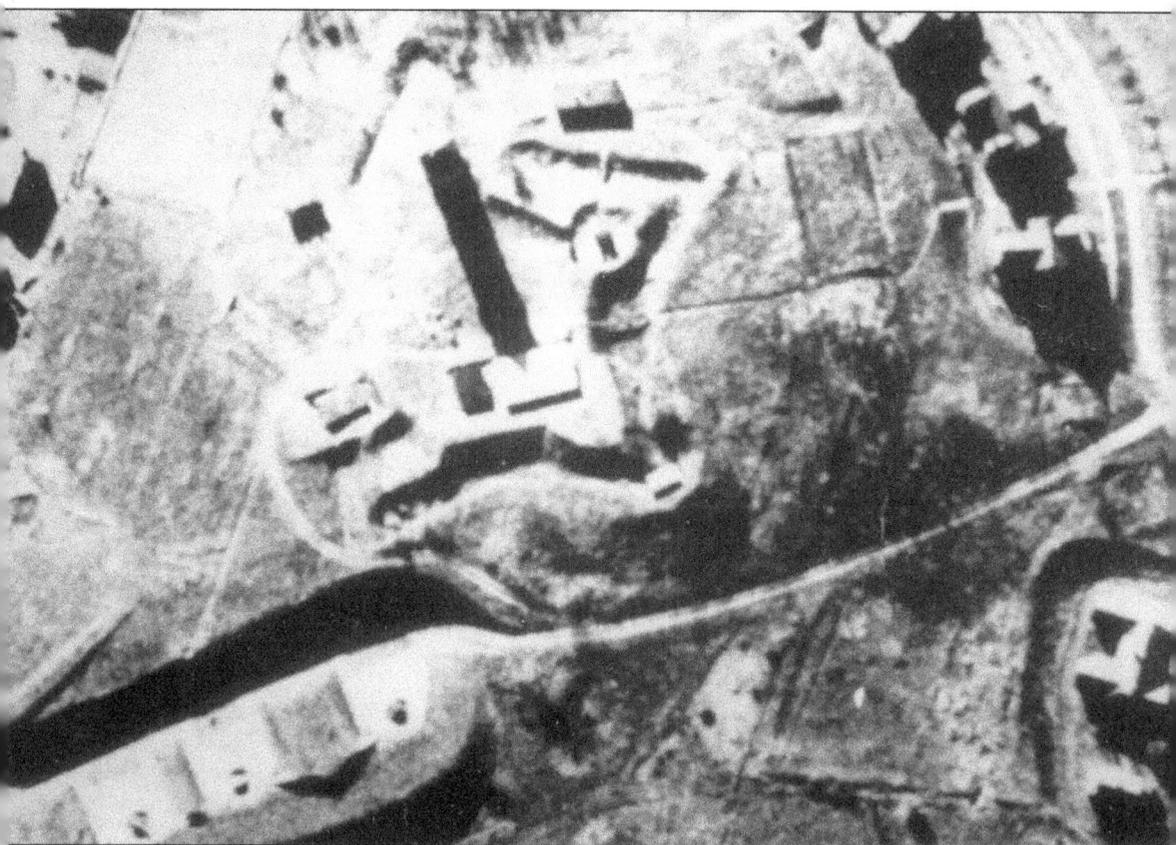

Only half of the evacuated families returned to Hull after the war. The exact location of the French graves on Telegraph Hill is still unknown. Memorial stones donated by the people of France during the 1976 American Bicentennial are located at the Fort Revere Park flagpole and on the observation deck of the water tower.

This 1933 aerial photograph covers the present Fort Revere Park, managed by the Metropolitan District Commission and the Fort Revere Park and Preservation Society. The shadow of the water tower bisects Ft. Independence. Battery Pope is visible in the lower left corner; the post infirmary in the lower right corner; and in the upper right corner, Officers' Row, of which the middle house alone survives and is the present Fort Revere Museum.

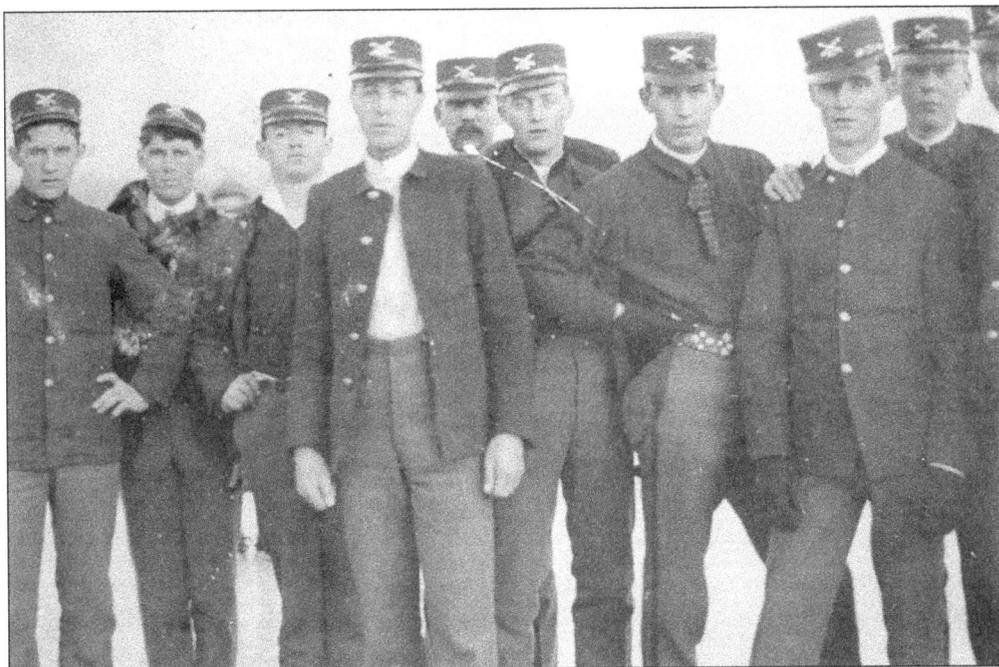

The Corps of Engineers and such notable military figures as Commodore Bainbridge and Colonel Sylvanus Thayer recommended various fortification schemes for Hull in the 19th century. However, nothing was approved until the 1885 Endicott Board designed two modern, dispersed-battery, coast artillery forts whose construction began in 1897 on Telegraph Hill and on Peddock's Island. In this photograph, *c.* 1862, Union artillerymen from the Fort Warren garrison on George's Island attend an ice skating party at Hull Village Park.

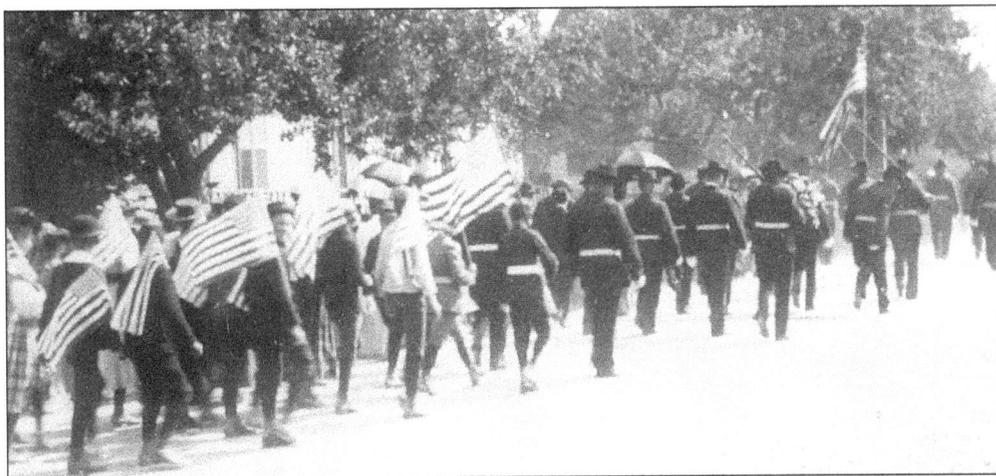

The hills and islands of Hull command the southern approach to Boston Harbor and the Nantasket Roads channel of the outer harbor. Perhaps the long awareness of defending the harbor accounts for Hull's quiet patriotism evidenced in the high proportion of veterans in a small population, and the number of youth who join the services. Further evidence is this photograph of a well-attended Memorial Day parade. The parade has followed the same route since these Union veterans of the Grand Army of the Republic marched down Main Street in the first Memorial Day parade in 1875.

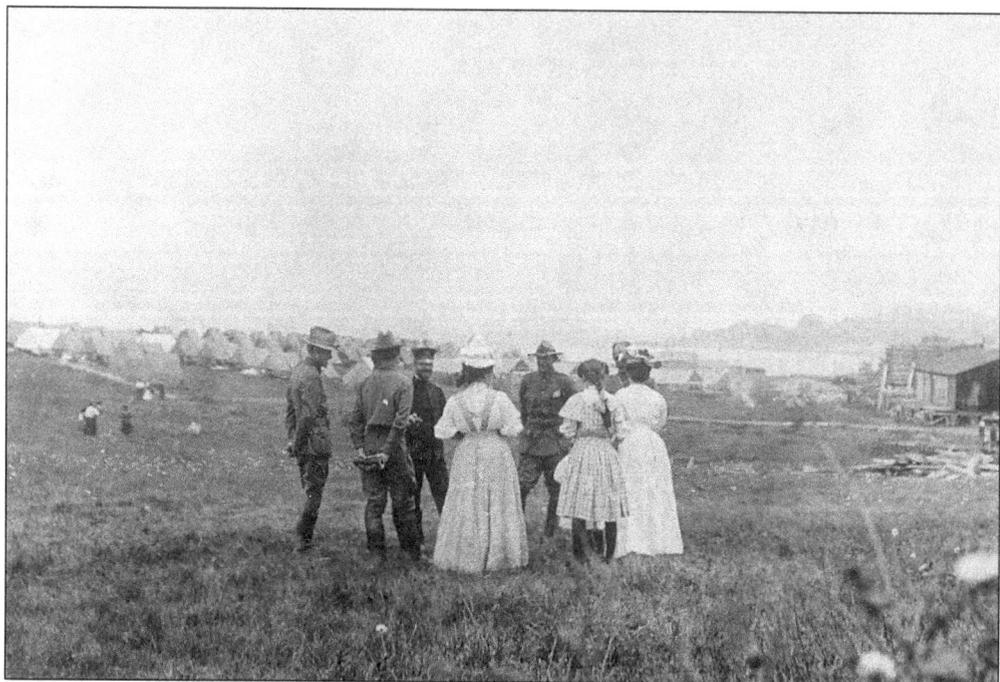

Construction of Battery Ripley (two 12-inch rifles on barbette carriages) and Battery Field (two 5-inch rapid-fire guns on pedestal mounts) began on Telegraph Hill in 1897. In the same year, construction of Fort Andrews began on Peddock's Island. The outbreak of the Spanish-American War in 1898 increased the rate of construction and required the stationing of companies from the Massachusetts Provisional Brigade at Telegraph Hill and Peddock's Island to protect the unfinished batteries. Summer visitors to the Telegraph Hill encampment were plentiful as this 1899 photograph shows.

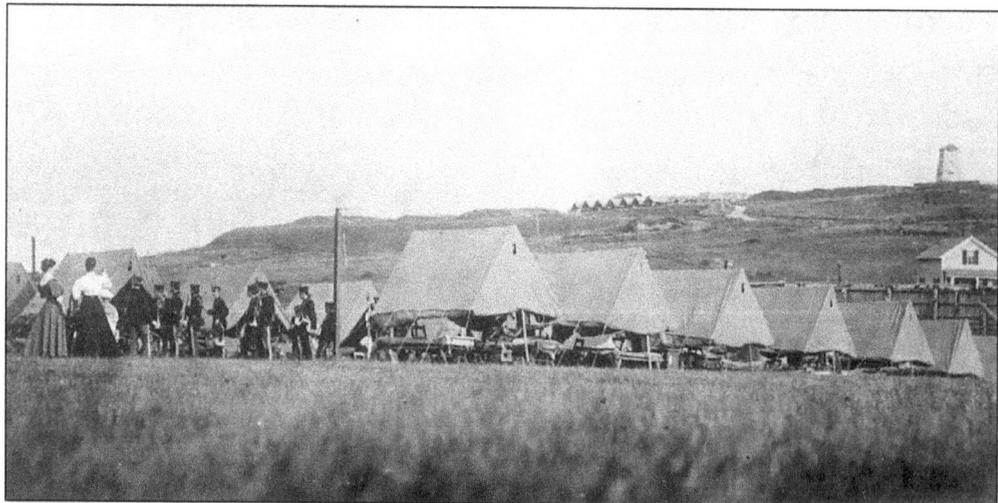

Battery Ripley is under construction on the right side of this 1899 photograph of the Massachusetts Provisional Brigade encampment on Telegraph Hill. Along the skyline, the small group of tents marks the approximate location of Batteries Sanders and Pope (6-inch rifles on disappearing carriages) built between 1903 and 1906. The ramparts of Fort Independence are visible at the base of the 1861 Marine Telegraph Tower.

80

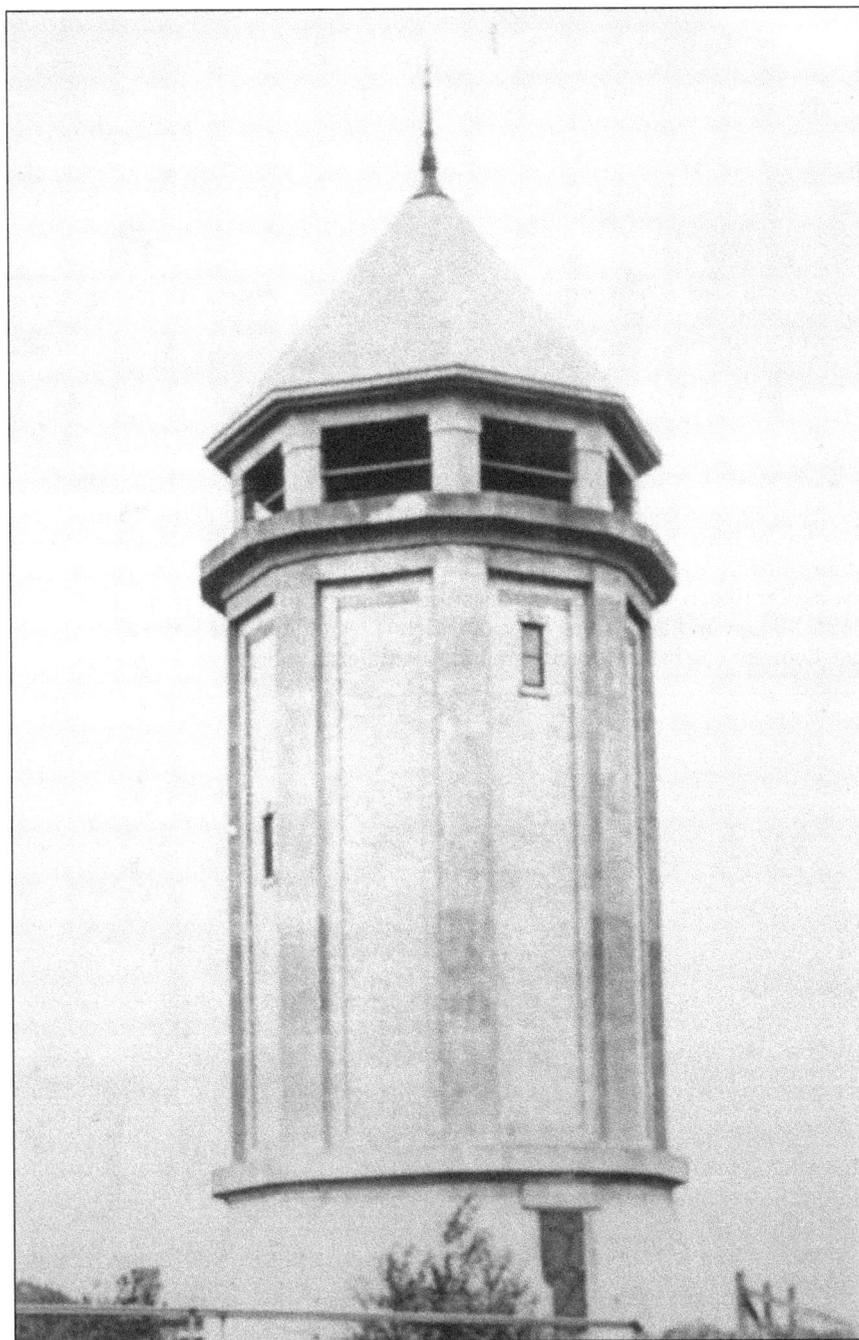

The Fort Revere Water Tower, built in 1903, held 118,000 gallons and is reputedly the first reinforced concrete water tower built in this country. This 1917 photograph shows part of the footbridge over the Ft. Independence ditch. The observation deck of the water tower held a 36-inch military searchlight from 1913 to 1923. It is now the high point of Fort Revere Park, with stunning views on a clear day of Massachusetts Bay from Cape Ann in the north to the Cape Cod Canal in the south. Twelve lighthouses and navigation beacons are visible from the tower along with most of the Boston Harbor Islands Recreation Area.

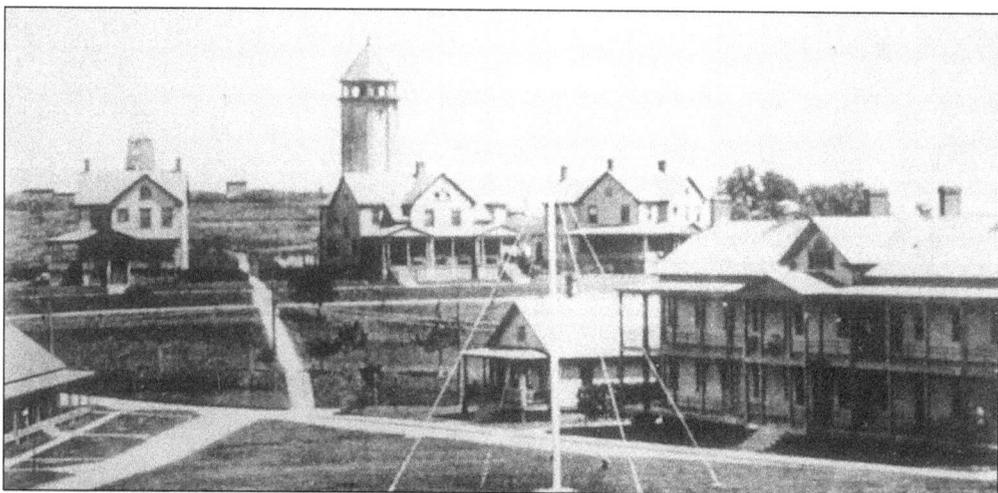

By 1907, Allerton and Strawberry Hills held combined observation/fire control stations to direct the guns of Forts Revere and Andrews. A seabed minefield in Nantasket Roads could also be controlled by a Mine Observation Casemate at Fort Revere. Along the skyline of this 1918 view of Fort Revere appear the 1861 Marine Telegraph tower, the mine casemate, and the water tower. Mid-ground is Officers' Row, of which the middle house is the only survivor. The foreground contains the bakery, parade ground, guardhouse, and one of the barracks.

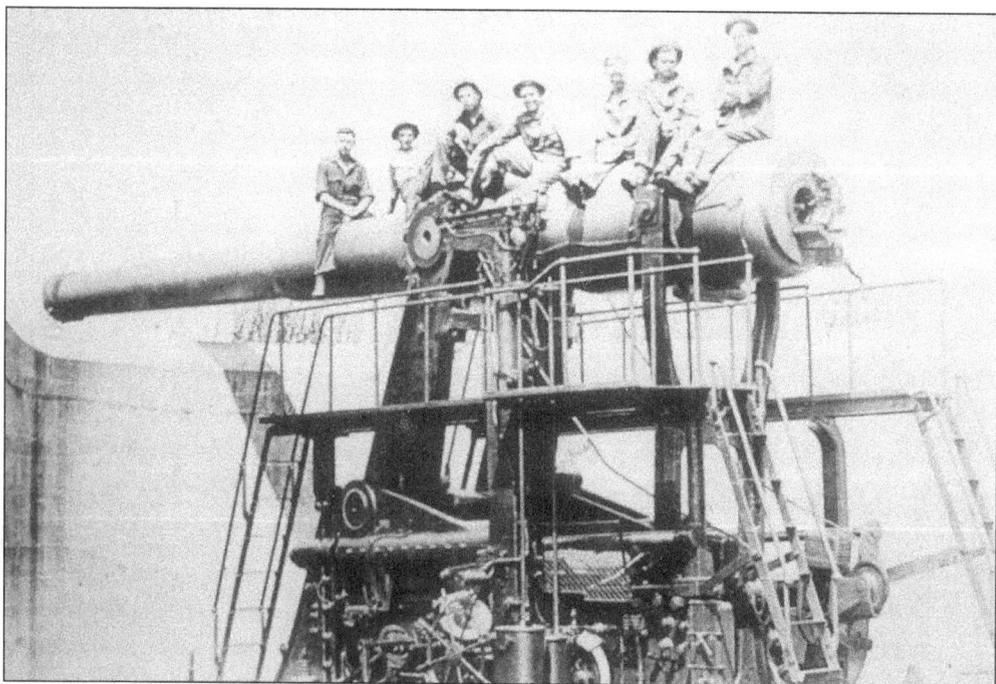

Federal and National Guard artillerymen were trained at the Boston Harbor forts in both World Wars, then were transferred for overseas service. In 1917, the garrisons of Fort Revere and Fort Andrews became part of the 55th Regiment, CAC, which included artillery companies from the other Boston Harbor forts and from Rhode Island. In this 1917 photograph, a 55th Regiment gun crew poses on a 12-inch disappearing rifle in Battery Stevenson at Fort Warren on George's Island.

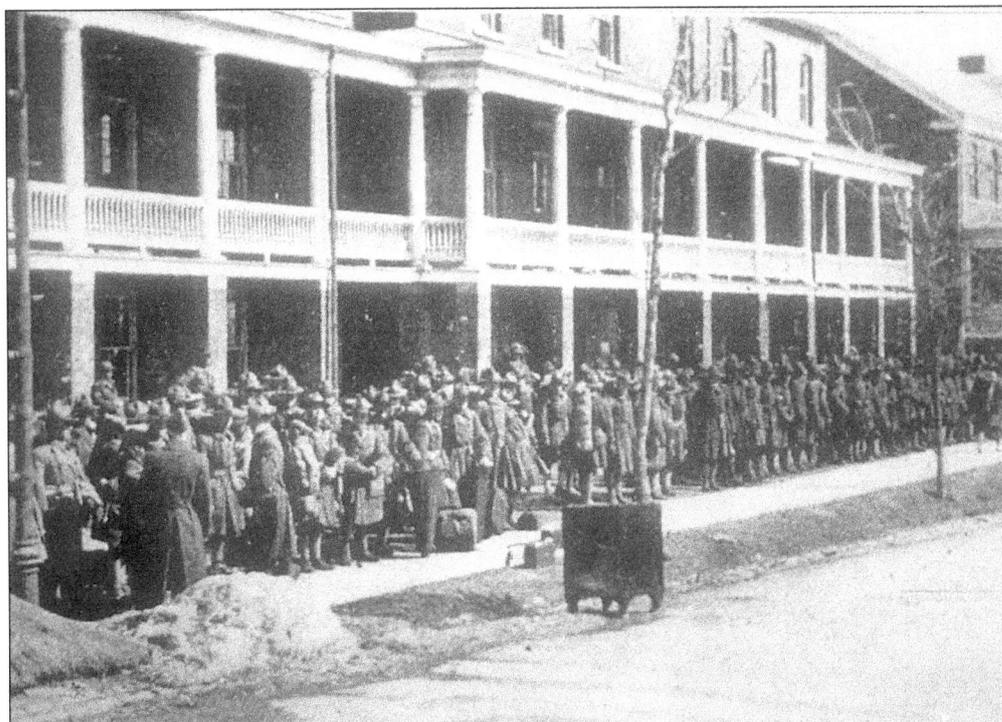

The 96th Company at Fort Revere became Battery A, 55th Regiment, in December 1917. The 55th, shown here embarking for France in March 1918, served in the campaigns of Aisne-Marne, Champagne, Oise-Aisne, and Meuse-Argonne, earning commendations on the accuracy of their shooting, as well as a Silver Star for Sergeant Mark Damon. Damon was a Hull resident, who "during rapid fire at Montfaucon closed the breech of his gun when the powder started to burn prematurely thereby saving his gun crew and an officer from certain injury or death."

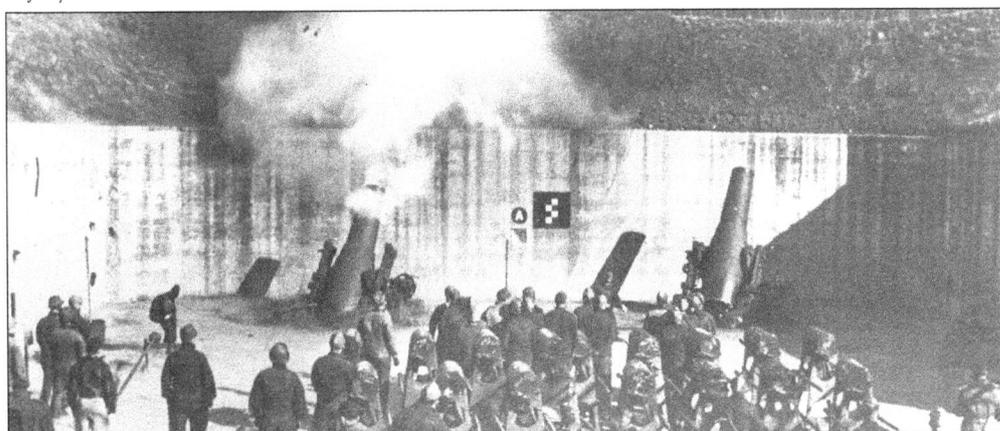

After World War I, the guns of Battery Sanders were remounted at Fort Revere, but Batteries Field and Pope were left vacant. By the late 1920s, Fort Revere had been reduced to caretaker status and Fort Andrews maintained only a skeleton garrison for training purposes. In the late 1930s, before the United States entered WW II, the Boston Harbor forts began a modernization program that emphasized antiaircraft defense. Here gun crews of the 9th Coast Artillery Regiment fire the 12-inch mortars of Fort Andrews, c. 1940–41.

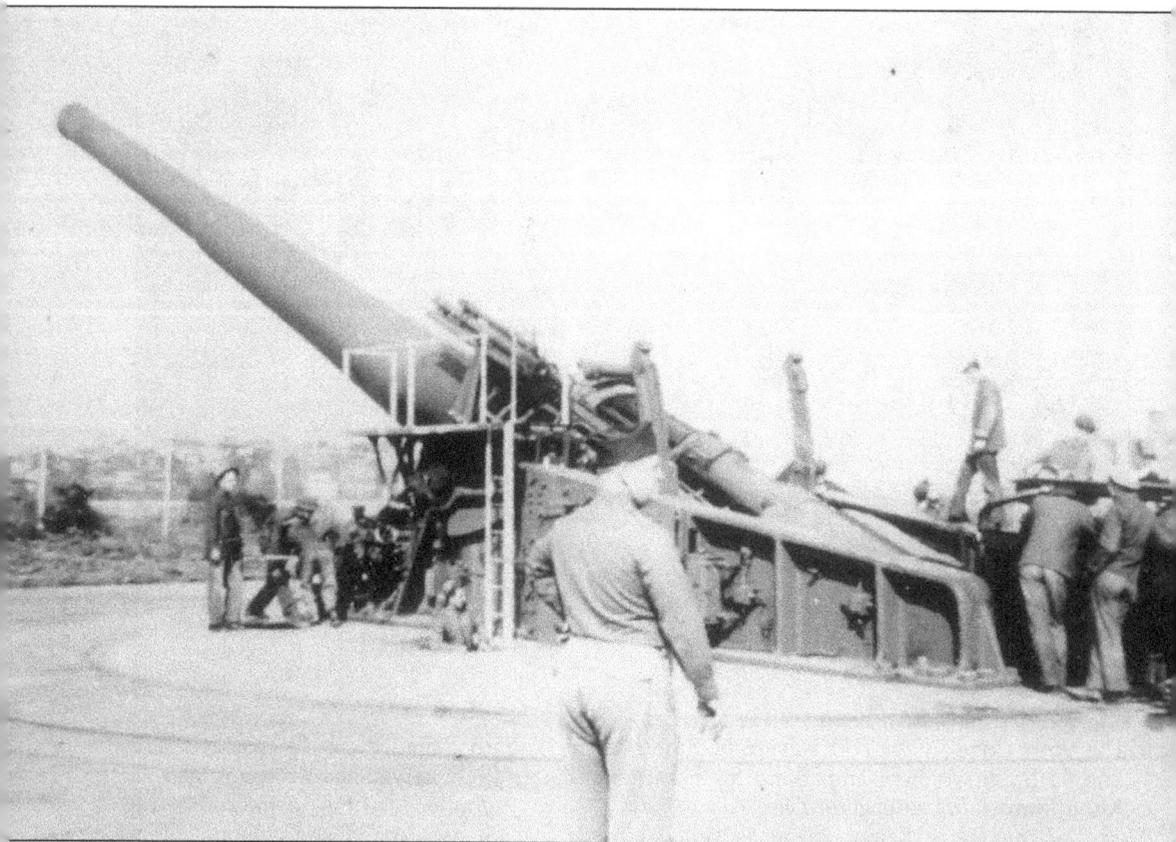

Fort Duvall, begun in the 1920s on Little Hog Island, mounted two 16-inch guns with an extreme range of 31 miles. Here, battery commander Tom O'Connor oversees the proof-firing of Battery Long in September 1941. By 1944, Fort Duvall was protected by massive reinforced concrete casemates and connected by a bridge to the peninsula. World War II brought radar-directed gunnery to the harbor forts, although the obsolescent batteries and seabed minefields were kept at readiness throughout the war. Fort Andrews received mobile 155-mm guns, radar, anti-submarine and anti-motor-torpedo-boat nets, booms across Hull Gut, and Italian prisoners-of-war. Fort Revere mounted .50 caliber machine guns, 37-mm and 3-inch antiaircraft guns, radar, searchlights, and AMBT Battery 941 (90-mm). In 1943, the obsolete guns of Batteries Ripley and Sanders were scrapped.

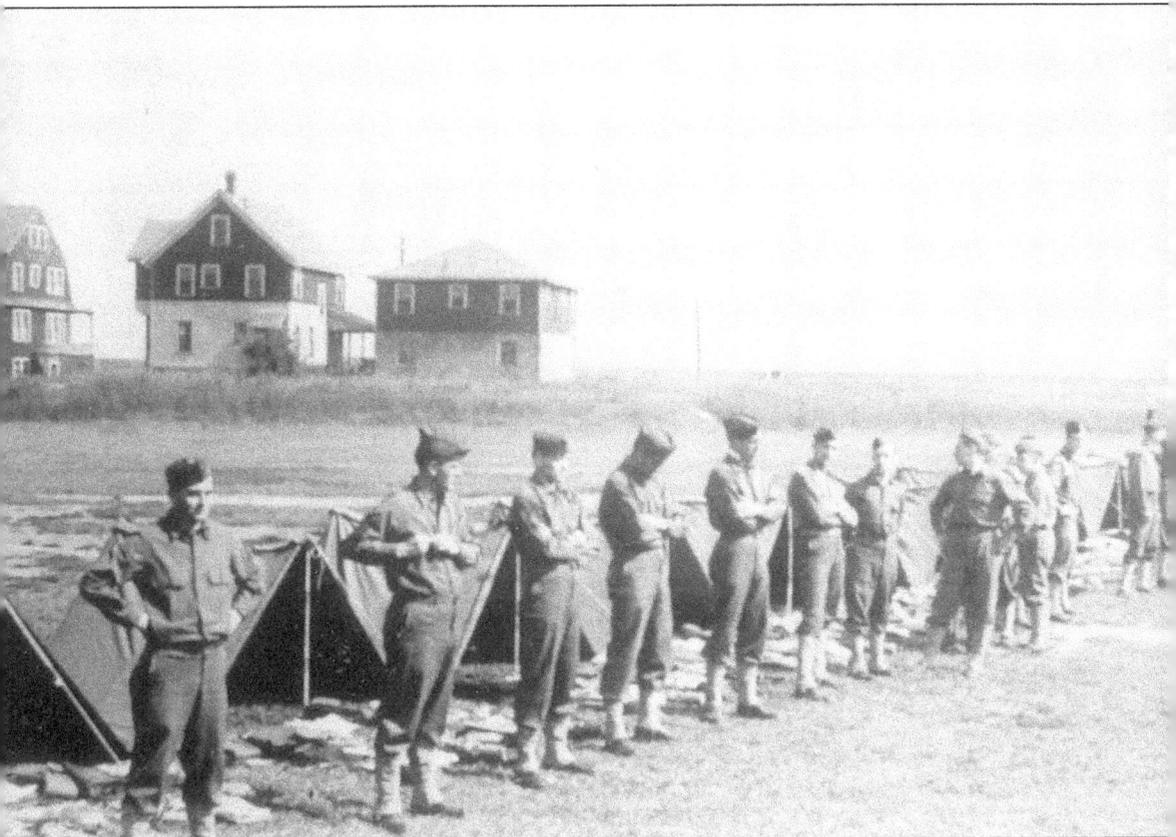

Throughout WW II, Beach Patrols, seen here at Field Kit Inspection in 1944 at the James Sullivan Playground (the Dustbowl), guarded Nantasket Beach and the Islands. Artillery officers and men trained at the harbor forts, and top-secret research was carried out in radar-directed gunnery, anti-submarine warfare, and communications—experiments that continued into the 1970s. The Brewsters received masonry piers, Great Brewster getting searchlights, AMTB Battery 942 (90-mm), and a mine observation casemate. Outer Brewster received Battery Jewell, a self-contained fort of 6-inch guns in armored turrets with a desalination plant, searchlights, and a radar station. Strawberry Hill and Point Allerton observation stations were modernized and Allerton received a new observation tower (1943) and a radar station. By the late 1940s, all the Hull military sites except Fort Duvall were on caretaker status and slated for auction.

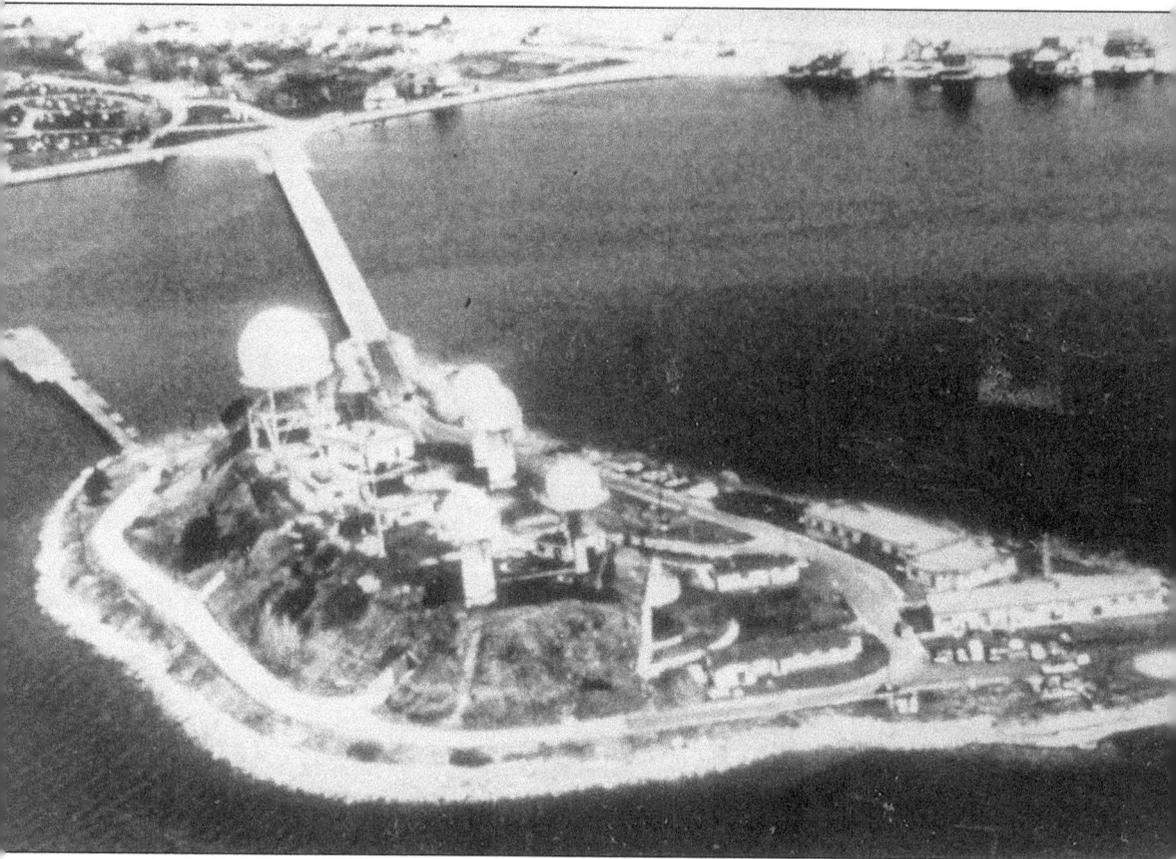

In 1950, Fort Revere's 75 acres were divided; 8.5 acres were added to the town's cemetery, while the remaining parcel sold for $38,550. Fort Duvall, shown here c. 1968, became the radar control site for the Nike-Ajax guided missile launchers in Weymouth, in what is now Webb State Park. The Point Allerton and Strawberry Hill observation stations became private homes. In the late 1980s the Spinnaker Island Condominiums were constructed on the site of Fort Duvall. In the 1970s Fort Independence, Batteries Pope and Sanders, the water tower, and one of the Married Officers' Quarters were preserved as Fort Revere Park by the Town of Hull, the Metropolitan District Commission, and the Fort Revere Park and Preservation Society. Peddock's Island and the Brewsters passed to private owners, then to the Commonwealth of Massachusetts to become part of the Boston Harbor Islands State Park in the mid-1970s. In the 1990s they became part of the Boston Harbor Islands National Recreation Area, under the National Park Service.

Eight

LIFESAVING
"THEY HAD TO GO OUT . . ."

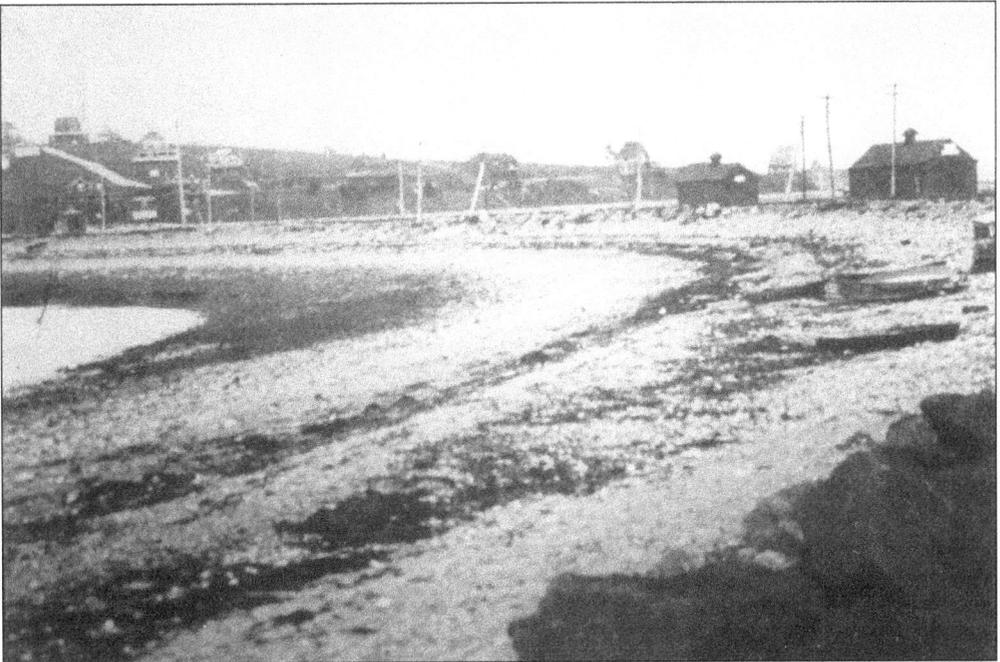

Organized shore-based American lifesaving began in Boston Harbor in 1786 when the Massachusetts Humane Society formed. The alliance of doctors, merchants, clergymen, and philanthropists hoped to end the threat of death by exposure to the elements along the Massachusetts coast. The following year the Society placed three houses of refuge on what they deemed to be high-risk stretches of the shore—on Lovell's Island in the Harbor, in Scituate, and on the outer beach of Nantasket. In 1807 the Society began building lifeboats and boathouses, watched over and manned by local volunteers. As seen above, both a boathouse and a mortar station sat on Stony Beach during the latter half of the 19th century.

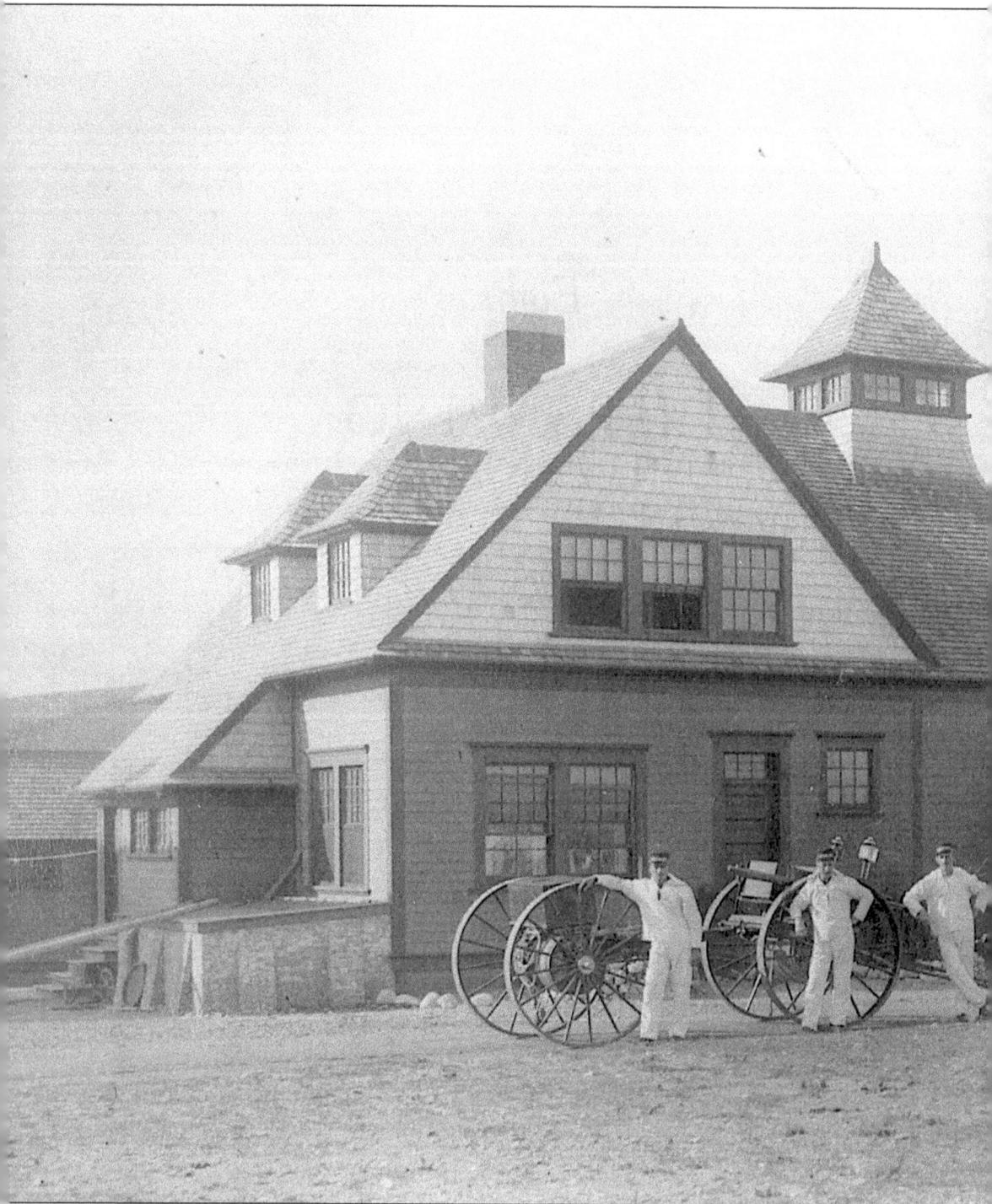

In March of 1890, the United States Life-Saving Service opened the doors to Point Allerton station on Stony Beach. Operating under the Department of the Treasury since 1871, the Life-Saving Service at first saw no need to build a station in Hull, due to the incredible ethic of the Hull volunteers. Eventually they gave in to local pressure and constructed and manned the

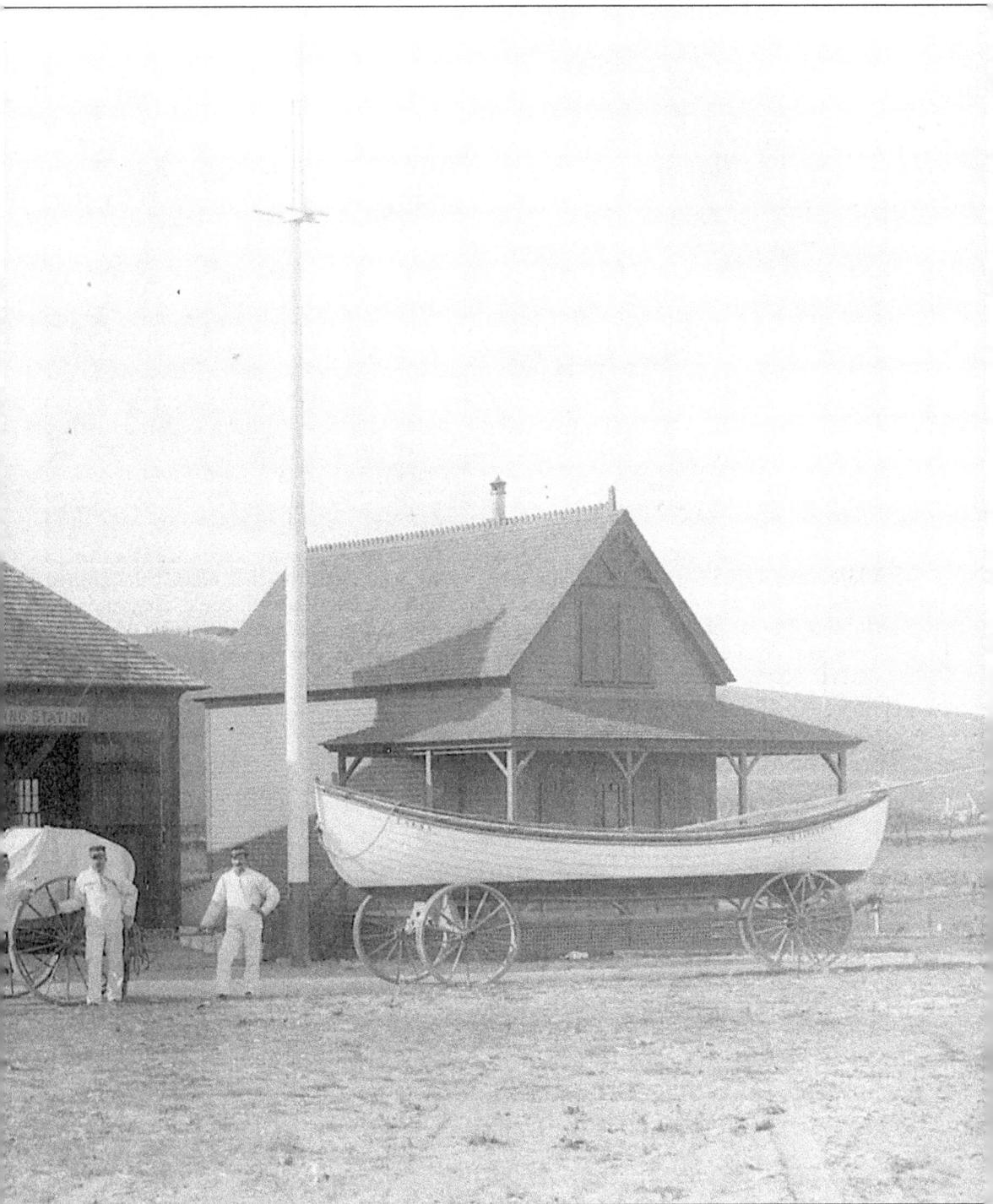

station. Stocked with a lifeboat and beach apparatus, the station originally housed six surfmen and a keeper. A seventh surfman came aboard during the winter months to ease the strain of walking the nightly patrols through ice, wind, and snow.

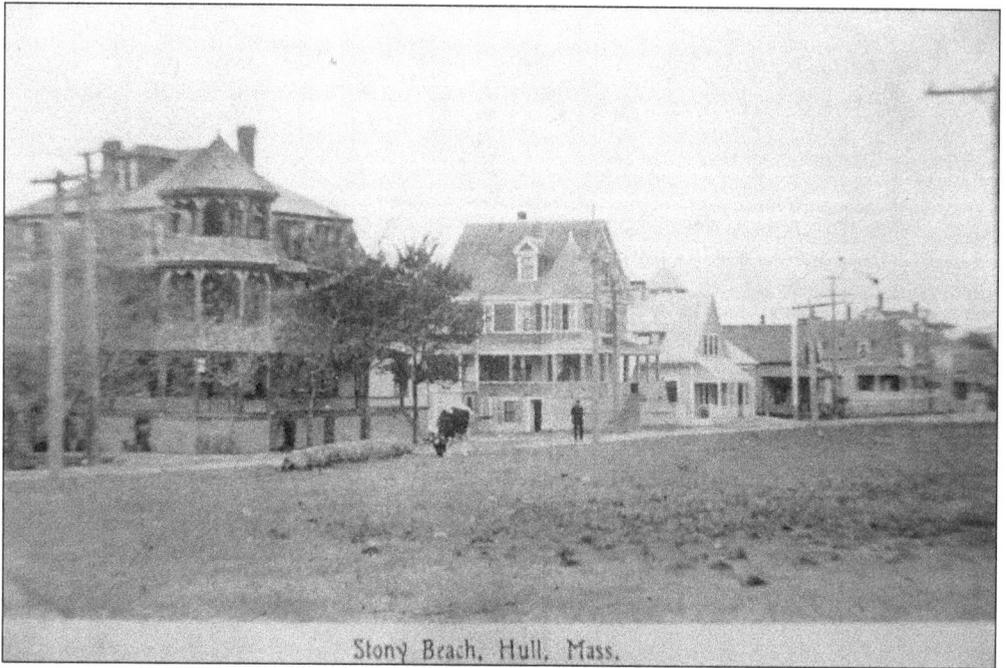

Stony Beach, Hull, Mass.

While many USLSS stations sat quietly on remote and barren beaches around the United States, the men of Point Allerton station, third building from the left, could claim no such hardship. On the left stands Vining Villa, the hotel owned by the local heiress and newspaper editor who donated the land on which the station was built. On the site of the Villa today stands the town's wastewater treatment facility.

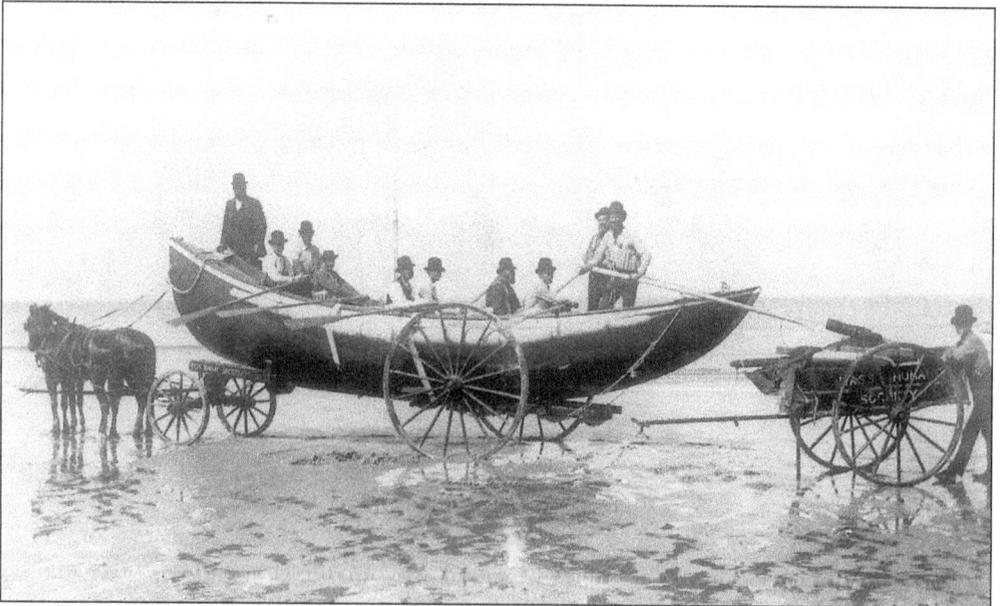

Between 1848 and 1898, Hull's volunteer lifesavers earned 275 decorations for bravery. In 1888, local mariner and hero Captain Samuel James, standing in the bow, designed the surfboat *Nantasket* for use in the waters off of Nantasket Beach. Still intact, she today rests at the Hull Lifesaving Museum, after an amazing career.

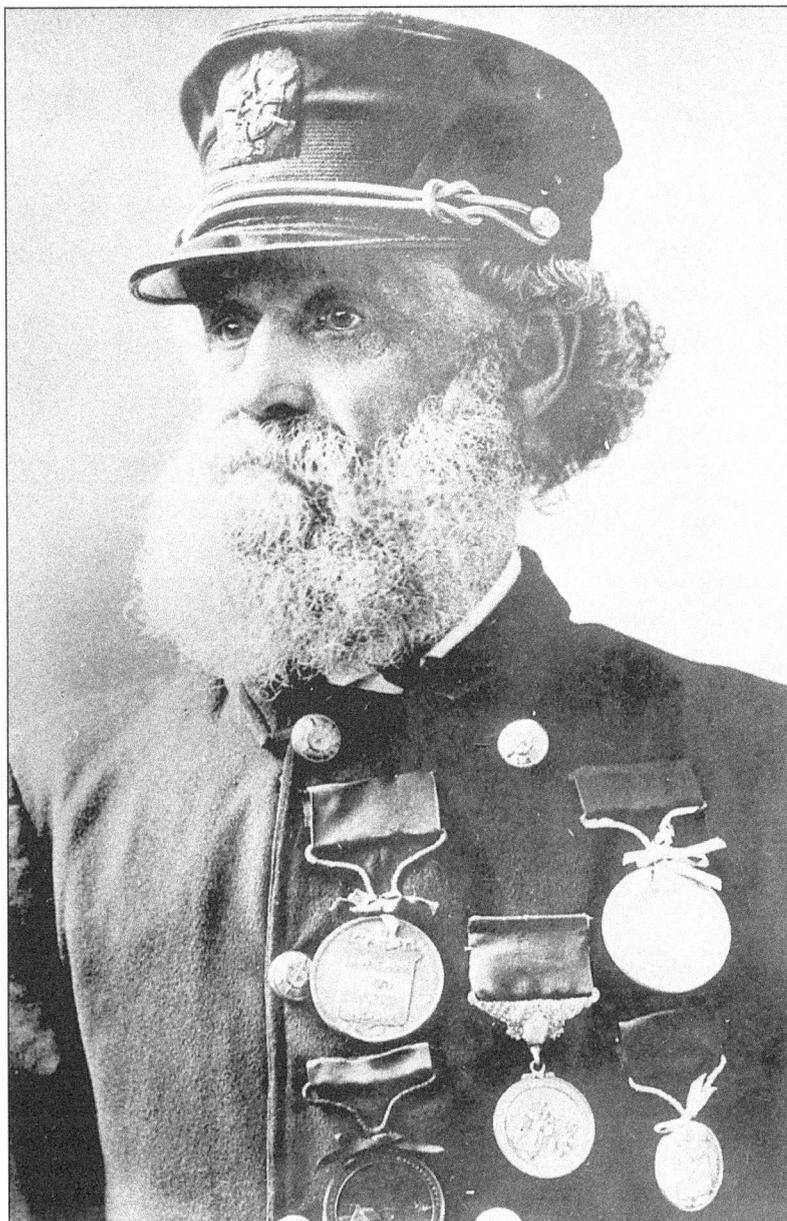

Born November 22, 1826, Joshua James watched sadly as his mother and baby sister drowned before his eyes in Hull Gut on April 11, 1837. Four years later, in December of 1841 at age 15 he jumped into a lifeboat with the local volunteer crew and aided in the rescue of the crew of the *Mohawk*. He continued to work at saving lives for the next 61 years, taking over as the Massachusetts Humane Society's Hull boatkeeper in 1876 at age 49, and becoming the first Point Allerton keeper in 1890. With more than 1,000 lives saved to his credit, 540 from 1890 to 1902 alone, James's memory serves as a guide for all young members of the Coast Guard to follow. He remains a shining example of the personification of the Coast Guard's core values: honor, respect, and devotion to duty. His name and image blanket the town, on the Hull Harbormaster's boat, on the patch of the Hull Department of Fire, Rescue and Emergency Service, and numerous other places.

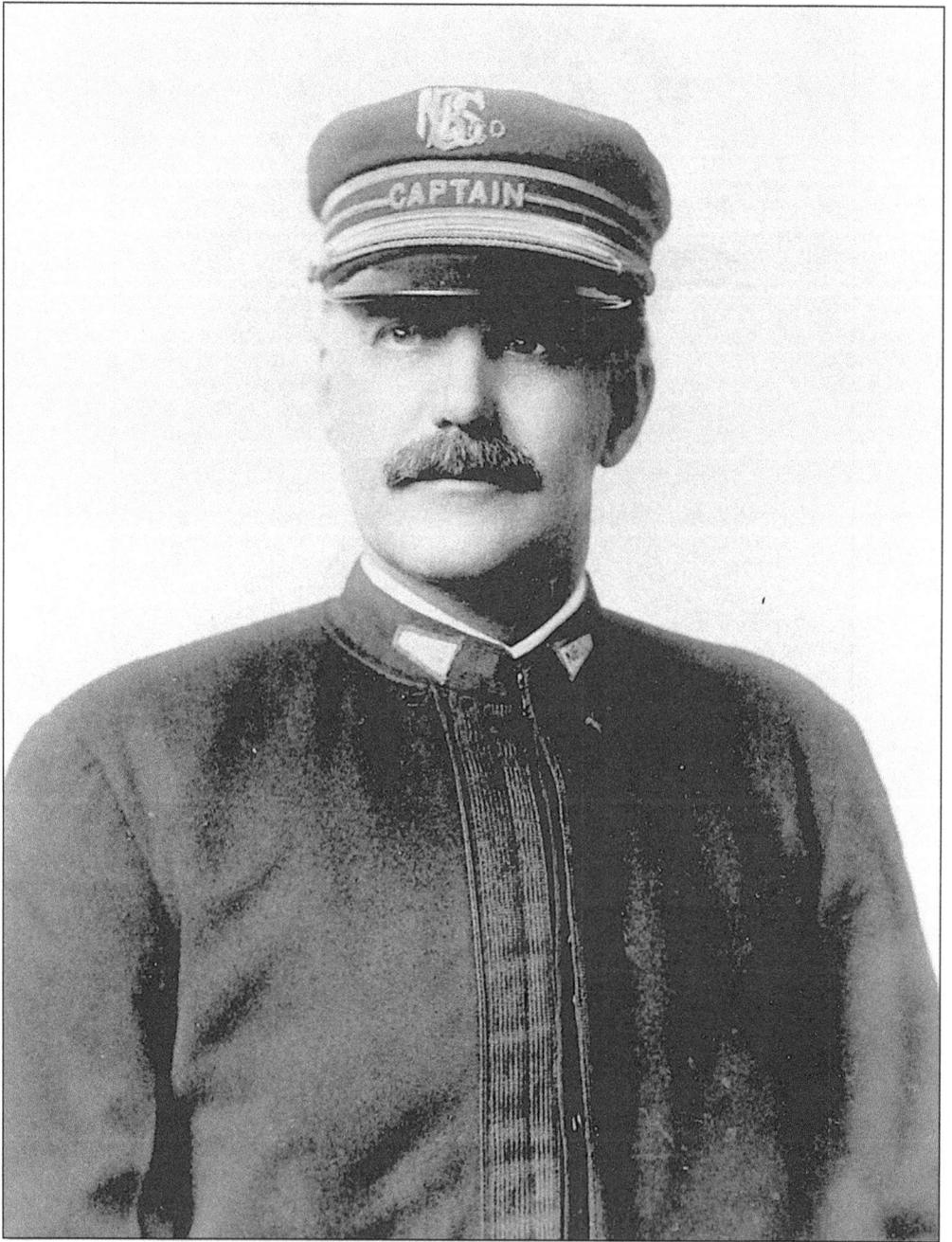

Joshua's only surviving son, Osceola, followed his father's path to lifesaving glory, replacing him as the keeper of the Massachusetts Humane Society's boats when his father took over Point Allerton station in 1890. Born in 1865 and one of the six surviving children of ten born to Joshua and Louisa James, Osceola served alongside his father in the Great Storm of 1888, earning a silver lifesaving medal. He led volunteer crews to the aid of the schooner *Ulrica* in 1896, to four separate wrecks during the Portland Gale of 1898, and to the wreck of the *Nancy* in 1927. The last rescue meant that Joshua and Osceola, father and son, had saved lives in Hull for 87 consecutive years.

92

On November 26, 1898, the worst storm in New England history struck the coast of Massachusetts. Between New Jersey and Nova Scotia, more than 350 vessels succumbed to nature's wrath over the ensuing 48 hours. Five hundred people were killed, 192 aboard the steamship *Portland* alone. The *Henry Tilton* came ashore on Stony Beach the morning of the 27th, and the combined crews of the government's hired men and the local volunteers rescued all seven sailors aboard by breeches buoy.

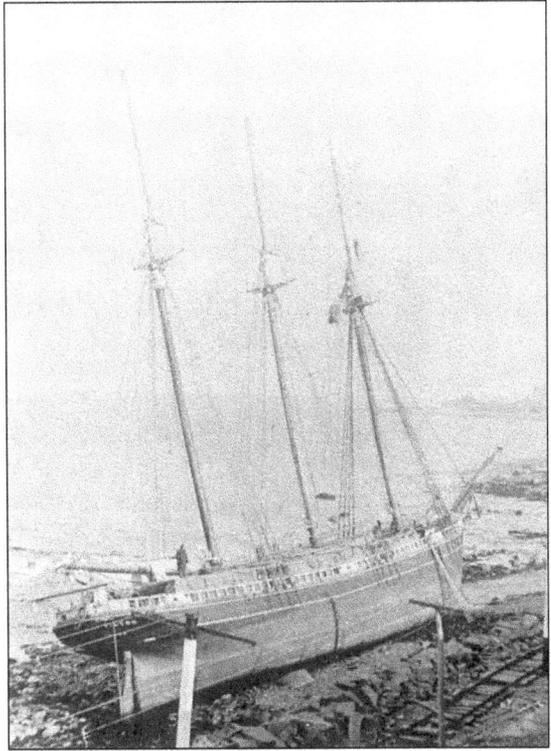

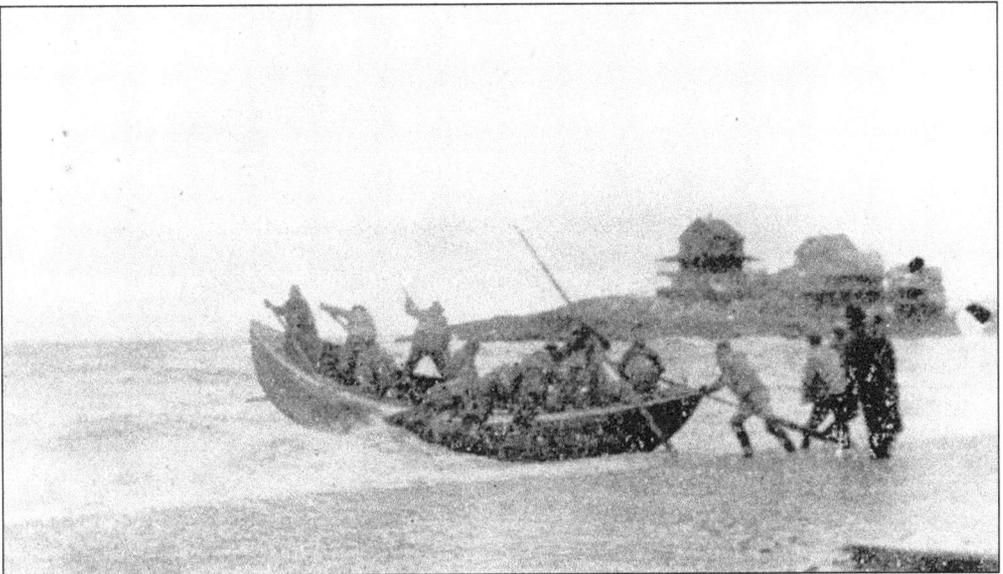

On the afternoon of the 28th, the lifesavers hauled the *Nantasket* 6 miles south to Gun Rock Beach and launched her into the churning waters to save the crew of the schooner *Lucy Nichols*. They had already rescued five men from the *Calvin F. Baker* ashore at Boston Light. Over the course of two days, Hull men saved 20 mariners from four vessels.

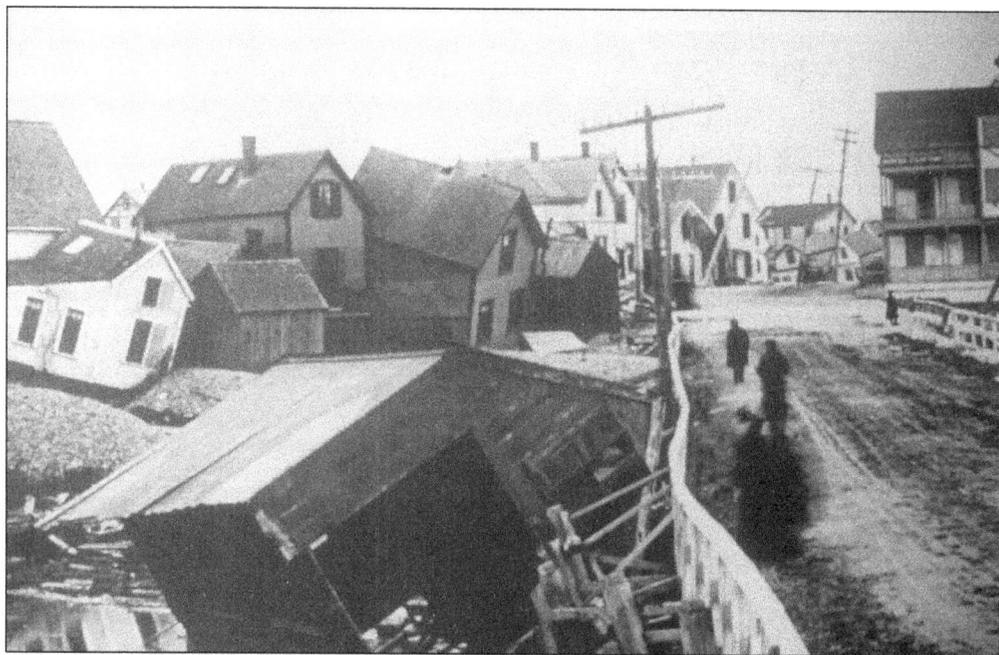

The storm tossed houses around, uprooting them from their foundations and blowing them down the streets, as can be seen here on Atlantic Avenue in the Gun Rock section of town. As one woman on Cape Cod later said, "Everything that wa'n't good 'n' strong was blowed down." The Gun Rock House is on the right.

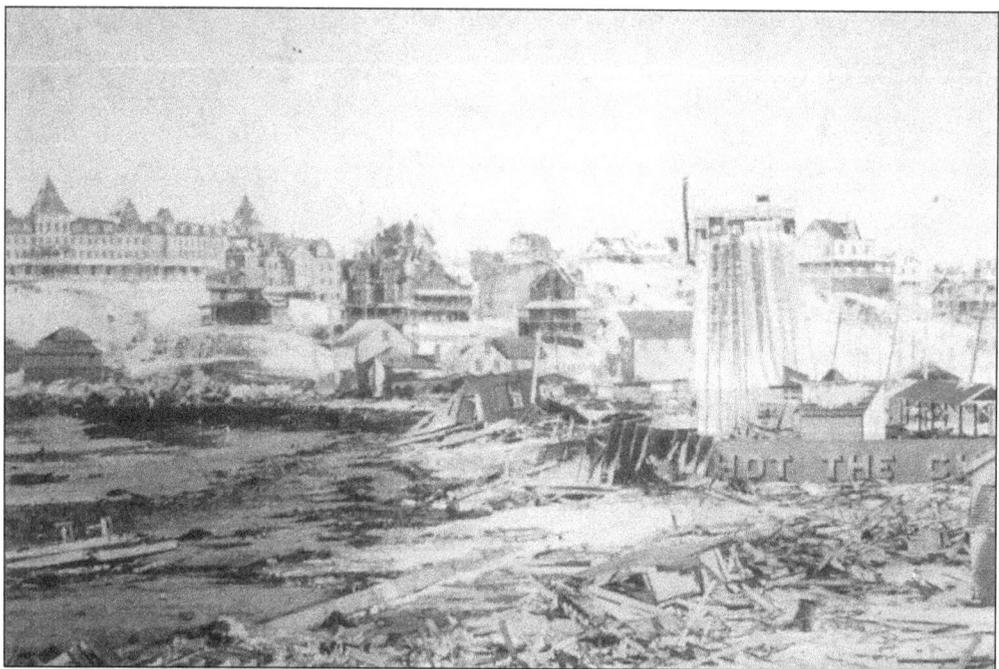

The magnificent seaside resort lay in ruins after the storm passed, with hotels and cafes reduced to not much more than firewood. As newspaperman David Porter Mathews put it, "Old Boreas shot the Chutes Nov. 27."

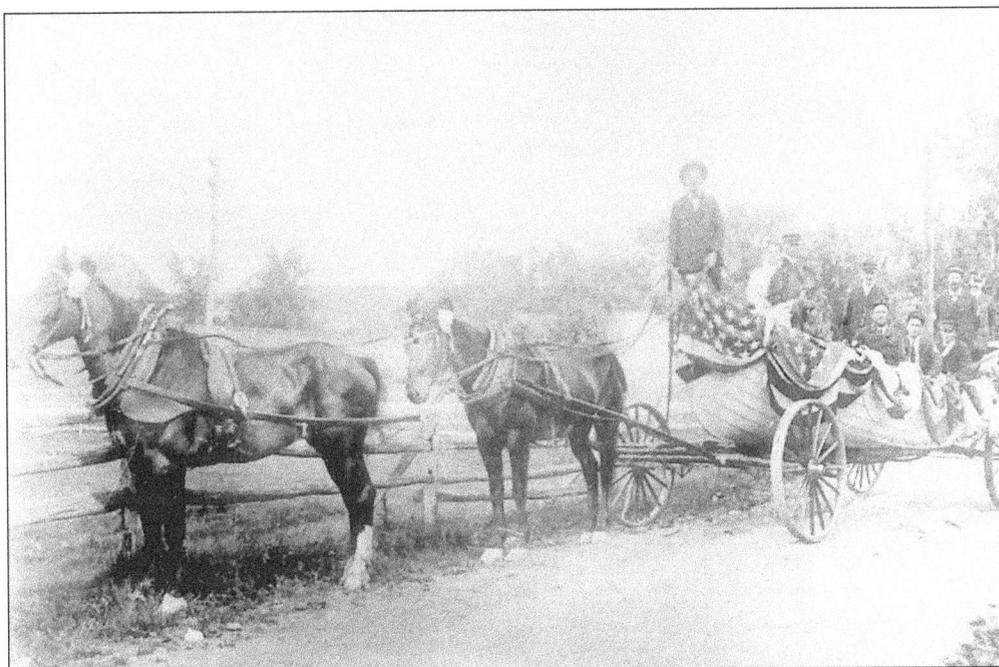

Three and a half short years later, the town lost Joshua James. After hearing the sad news of the Monomoy disaster of March 17, 1902, in which an entire station's crew but one man had perished in a rescue attempt, James ordered his men out for an extra early morning boat drill. Satisfied with their work, he ordered the boat in, leaped out, and collapsed and died awash in the breakers.

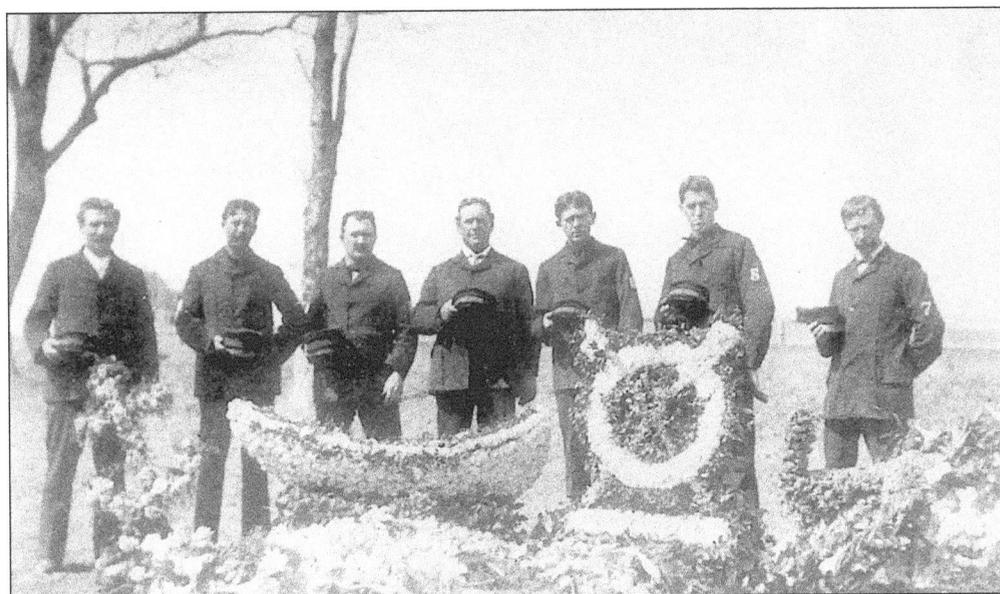

James's surfmen Francis Mitchell, James Murphy, Fernando Bearse, William Gray, James Donovan, Edward Kane, and Hulver Gillerson served as his pallbearers. The inscription on his tombstone, paid for by the Humane Society, reads, "Greater love hath no man than this, that a man lay down his life for his friends."

James's successor, William Sparrow, began his career in Provincetown in 1897 at Wood End station. Although he shared a common surname with the district superintendent who appointed him, Benjamin C. Sparrow, they had no relation, which cooled all the talk of nepotism that surrounded his quick rise to a keeper's position.

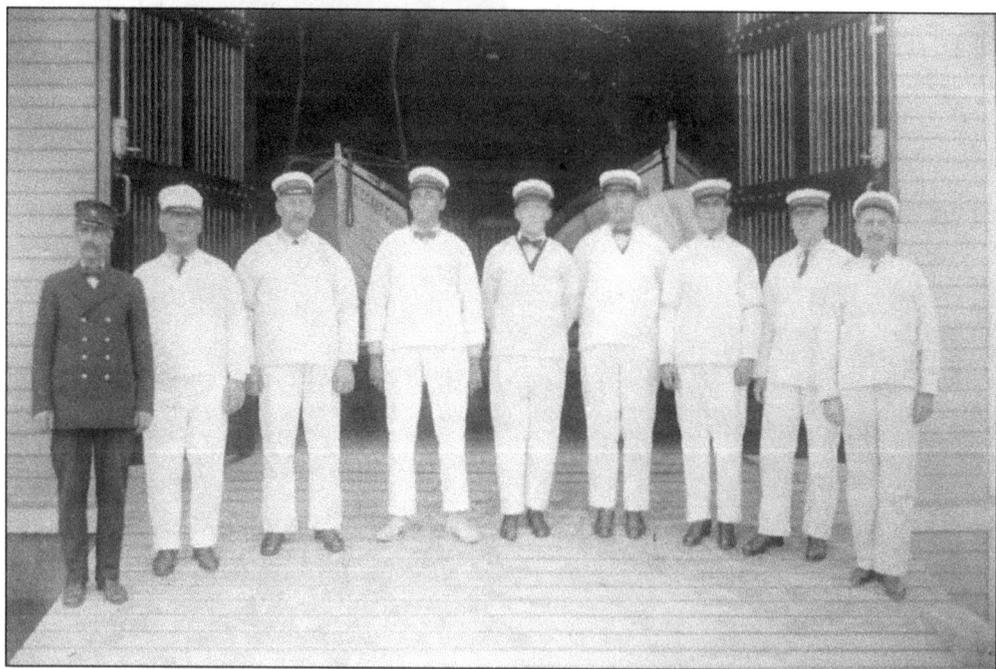

Sparrow served at Point Allerton until 1920, present for the 1915 merger between the Life-Saving Service and the US Revenue Cutter Service that resulted in the creation of the Coast Guard. With him are William Gray, Andrew Benson, Louis Cole, Sigwald Tonneson, George Goldthwaite, Alfred Dears, George Woodman, and James Murphy.

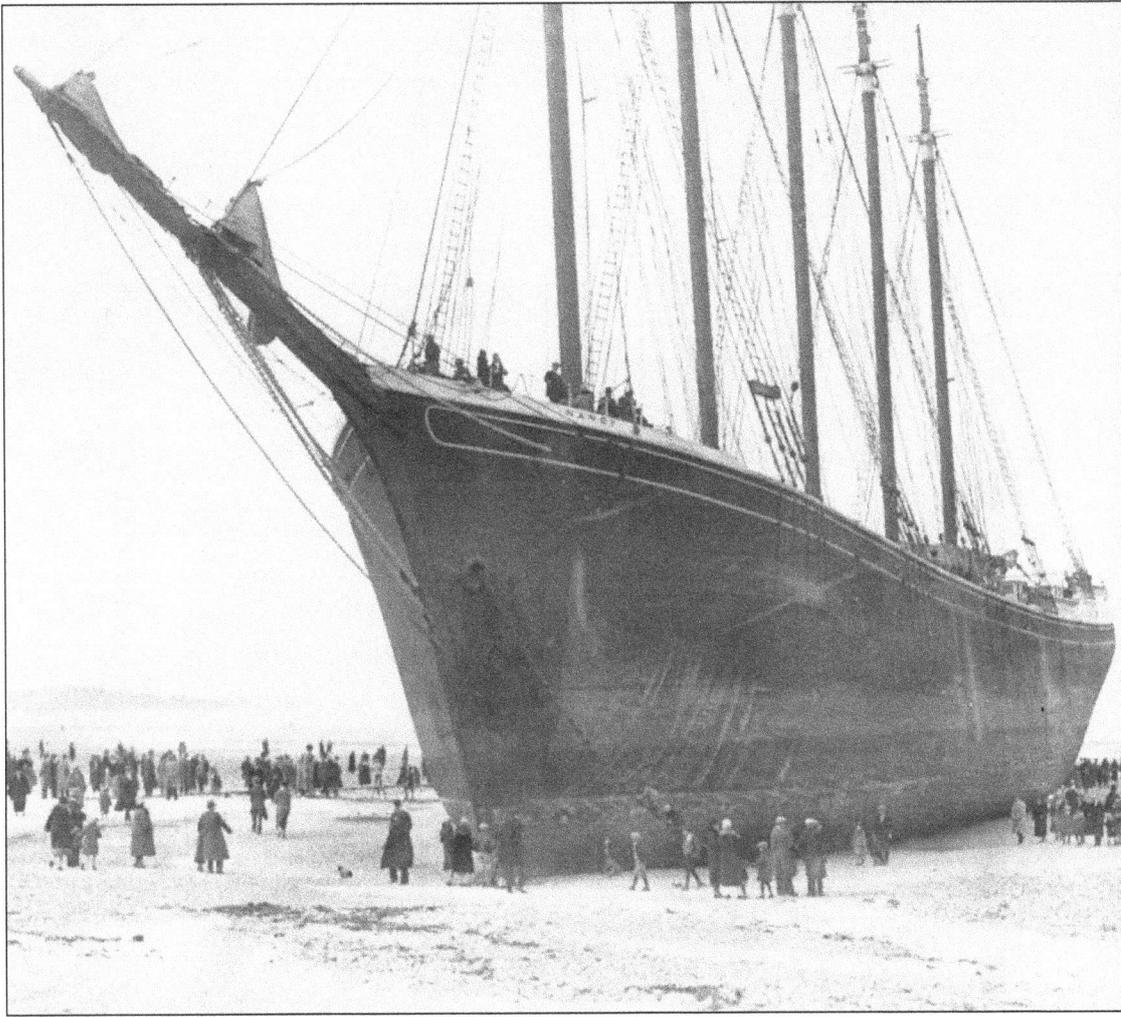

The five-masted schooner *Nancy* had already discharged her load of coal in Boston and headed out of the harbor when her captain decided to drop three anchors outside of Harding's Ledge and ride out the approaching storm on February 21, 1927. The chains quickly parted, though, and the schooner narrowly avoided striking the ledge, driving ashore at Nantasket Beach instead. Patrolman Ned Gleason spread the word that the vessel had stranded and called for a rescue team. Osceola James, now 61 years old, led eight others in a tough row aboard *Nantasket* to the *Nancy*, rescuing all eight men and the ice-covered ship's cat. The vessel was never re-floated, remaining on the beach for more than a decade as a tourist attraction, an advertising billboard, and a haven for pyromaniacs. By 1937, WPA workmen had burned the hull down to within 6 feet of the keel, still buried in the sand on Nantasket Beach.

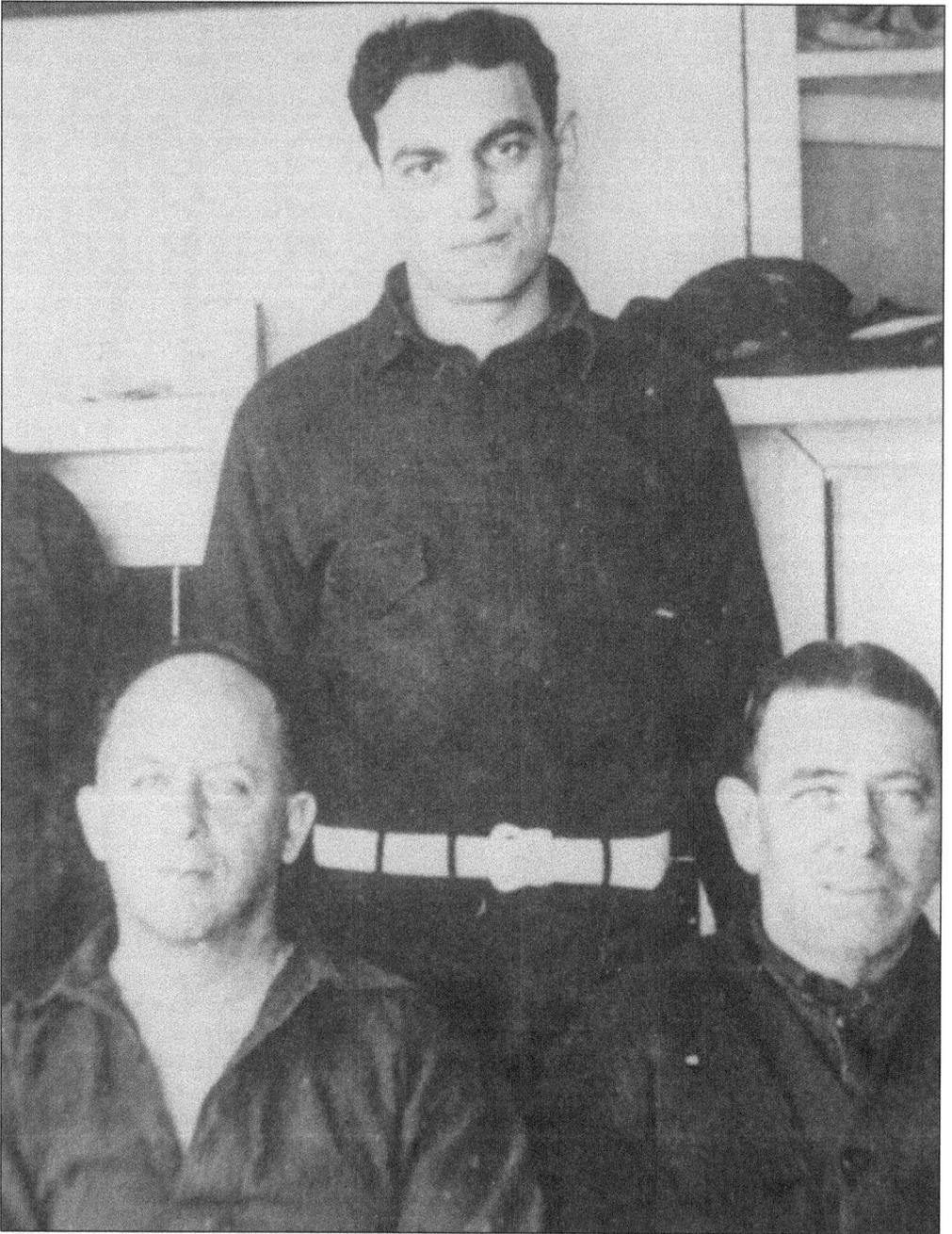

No chapter on the history of lifesaving in Hull would be complete without mentioning Joe Ottino, center. Joe arrived at Point Allerton Coast Guard Station from Plymouth on October 8, 1932, and spent the better part of the next 20 years in Hull. He married the daughter of James Henry Murphy, one of Joshua James's longtime surfmen and together they spent the rest of their lives living in a small house across the street from the station. During Prohibition he chased rumrunners, and during the Second World War he taught Navy coxswains small boat handling before leaving to land Marines on Guadalcanal. His legendary role as a prankster and his wry always-up-to-something smile endeared him to nearly everyone with whom he came in contact.

Nine

FAMOUS RESIDENTS AND VISITORS
CELEBRATED NAMES AND FAMILIAR FACES

The promise of cooling summer breezes and the omnipresent scent of the ocean coaxed even the stodgiest of characters to Hull's shoreline to swim, relax, and generally enjoy life. Ralph Waldo Emerson claimed to have lost his fear of salt water by bathing at Nantasket; Henry David Thoreau wrote about his visit in his book *Cape Cod*. Myles Standish, Isaac Allerton, the Marquis de Lafayette, Admiral d'Estaing, and Daniel Webster all visited at one time or another. George M. Cohan (whose most famous song was "Over There," which he sang in Hull and which became America's First World War anthem), actress Sarah Bernhardt, and opera singer Enrico Caruso all performed at Hull's hotels. As a very young boy in 1918, future President John F. Kennedy, at right, spent time on Nantasket Beach, visiting the summer home of his grandfather Mayor John Fitzgerald of Boston. JFK's older brother, Joseph P. Kennedy Jr., was born on Beach Avenue in Hull in 1915.

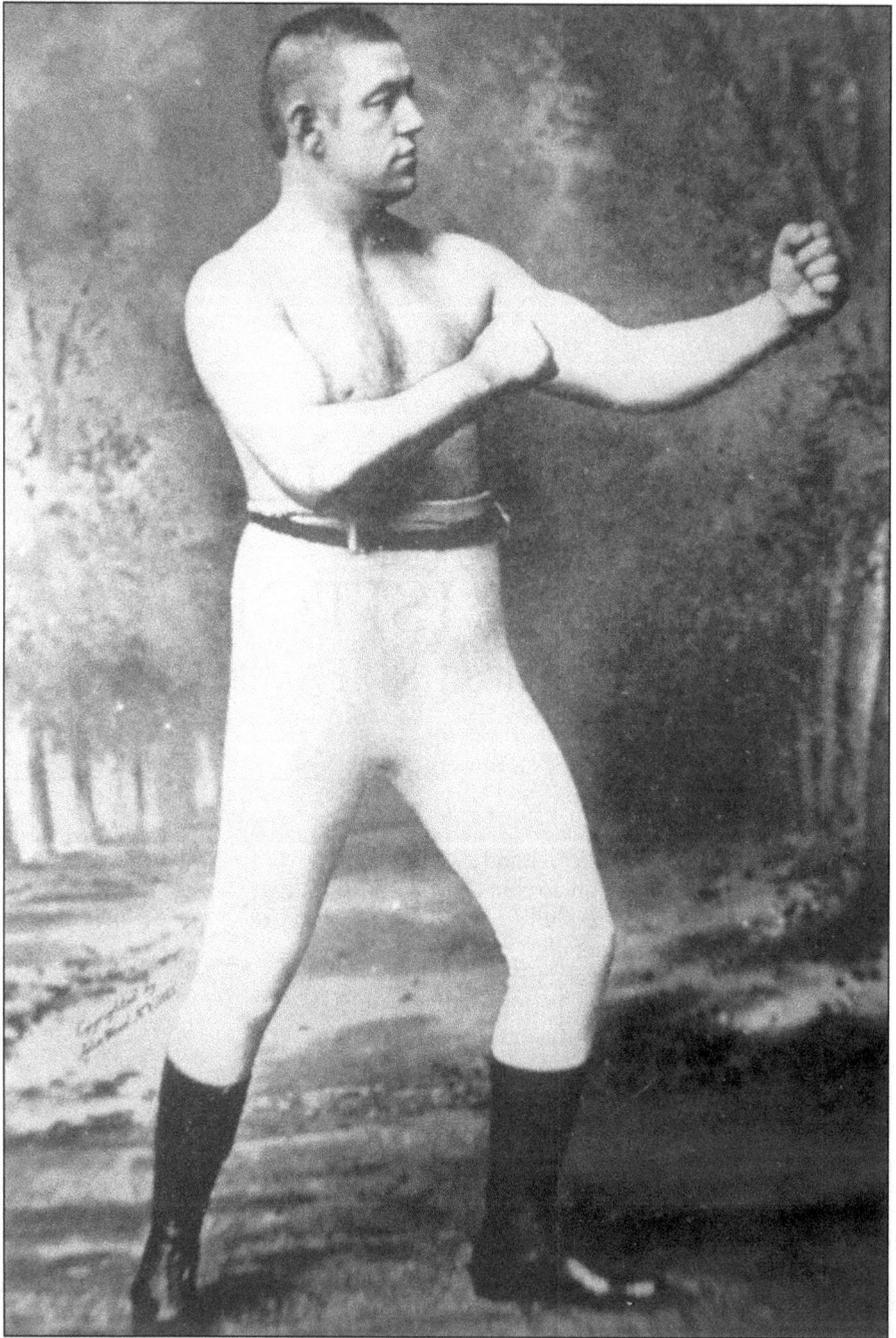

The Boston Strong Boy, John L. Sullivan, allegedly agreed to donate the proceeds of one of his prizefights to the Irish Catholics in Hull for the construction of St. Mary of the Assumption Church. After losing his title to Gentleman Jim Corbett in 1892, his legendary right hand left its mark in Hull. Chasing a bar patron who had called him a name at Pogie's Saloon on a July Sunday in 1896, Sullivan slammed his fist through a door and grabbed the man, dragging him back to pay for his remark. The owner of the establishment removed the door and affixed it to the wall with an engraved brass panel describing the event.

Perhaps Hull's most famous export of the early 20th century was coloratura soprano Bernice James DePsquali, who sang alongside Enrico Caruso and under the baton of Conductor Gustav Mahler. In 1908, after her Metropolitan Opera House debut, the audience called her out for 26 curtain calls. Born at 30 Main Street in Hull Village, a great niece of lifesaver Joshua James, DePsquali usually returned home to sing "Silent Night" each Christmas Eve at Elm Square. She is buried in the Hull Cemetery with the epitaph "With deepest sorrow we mourn and cry / Until we meet again good-by, dear heart, good-by."

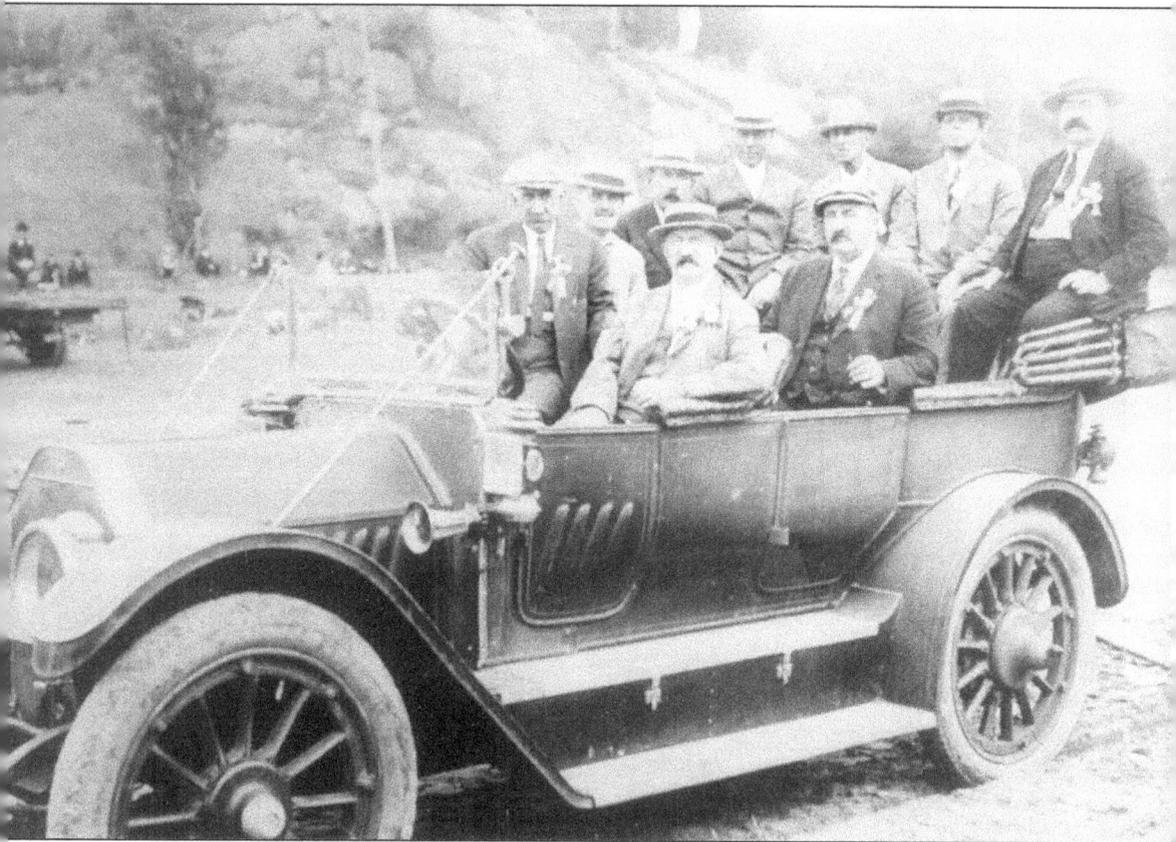

Boss John Smith first took a seat as a Selectman in 1893, and the town was never the same again. Unabashedly practicing his own brand of questionable politics, he impressed the likes of the "Boston Mahatma" Martin Lomasney, and incurred the wrath of John "HoneyFitz" Fitzgerald. Fitzgerald publicly blasted Smith and his machine, and spent the rest of that season with a deep trench around his house, dug by Hull town workmen.

In 1900, Smith formed the Republican Citizen's Association, later known as the "Old Ring." By exchanging favors for votes, using pre-marked ballots, and any other means possible, the "Old Ring" captured every seat in every town election until 1939. That year William M. "Doc" Bergan, local dentist and perennial anti-administration candidate, took advice from Boston Mayor James Michael Curley and exposed a rift in the party to earn a seat as Selectman.

Born in 1887, Henry John Stevens began his public service career as a special summer officer for the Hull Police Department in 1906. Two years later he joined the force full time. After a stint at the Atlantic Hill headquarters, he became Hull's first motorcycle officer in April of 1917. He fearlessly risked his life to save others on numerous occasions. Dragging an incapacitated woman from the path of an oncoming train at Whitehead Station, and plunging into waist-deep mud to pull a man and a woman to safety are just a few examples. At midnight on April 30, 1918, Stevens reported for duty as the town's new fire chief, as the entire department left on strike. In August 1926, upon the death of John Smith, Stevens added Selectman to his long list of jobs. In 1930 the town combined the jobs of fire chief and police chief under the title of commissioner of public safety, a title he held until his death in September of 1938.

Outlandish, outspoken, and self-proclaimed "Mayor of Hull," Floretta Vining vigilantly scanned the Hull peninsula for any signs of immorality or bad taste, all of which she considered fodder for her series of nine South Shore newspapers. She balanced her nosiness with wonderful philanthropic and public-spirited endeavors, financially, politically, and spiritually changing Hull for the better.

Irish-born poet John Boyle O'Reilly escaped imprisonment in Australia and found his way to Boston, where he became editor of the Irish Catholic *Pilot*, and a leading voice for the creation of a cosmopolitan world in the 1880s. One year after building his new summer home in Hull, he died there of a drug overdose, which was possibly intentional.

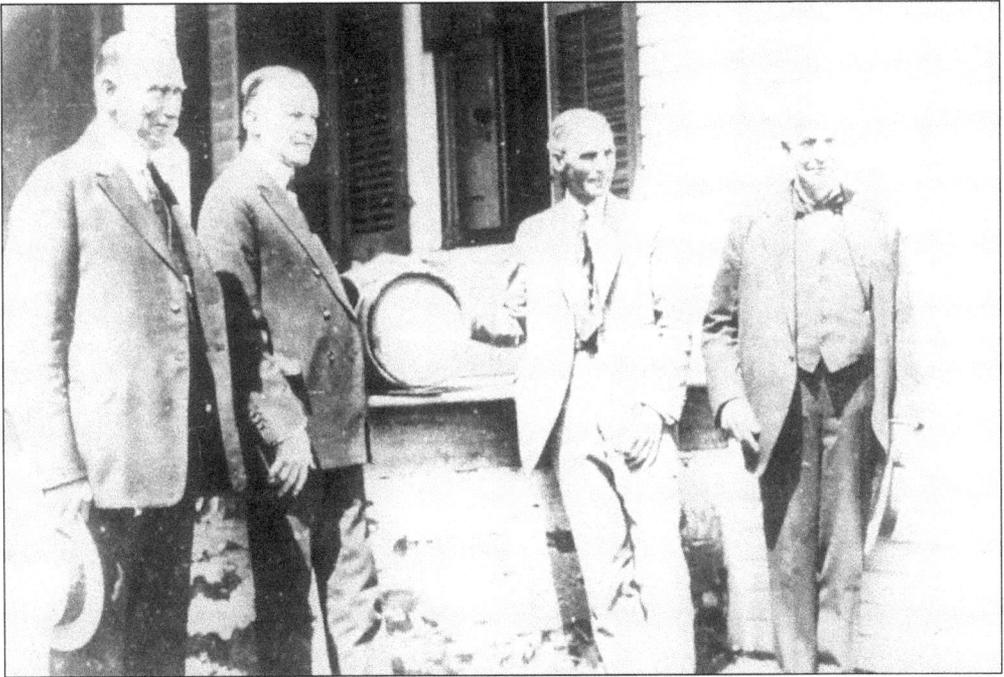

Where else but Hull would you find such a collection of American legends? Standing left to right are the following: an unknown gentleman, Massachusetts Governor and American President "Silent" Cal Coolidge, industrial entrepreneur Henry Ford, and inventor extraordinaire Thomas Alva Edison.

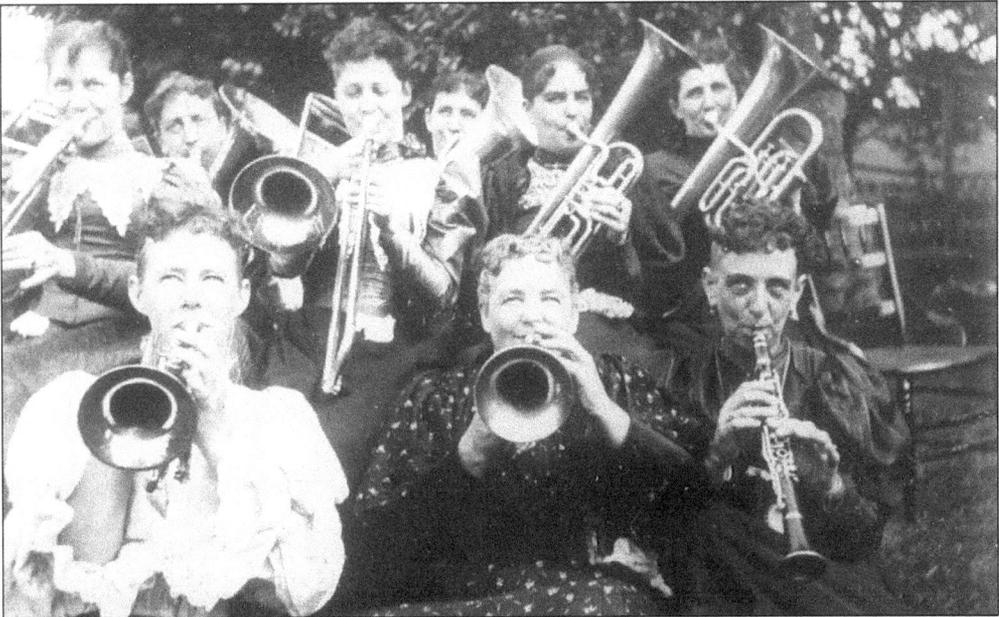

An extremely musical family, Hull's James family had their own ladies orchestra. Pictured here from left to right are as follows: (front row) Tudy Galiano, Esther Lucihe James Pope, and Arabella Pope; (back row) Bertha James, Gracie Dowd, Edie Galiano, Ettie Mitchell, Mary Ellen Knight, and Lou Pope.

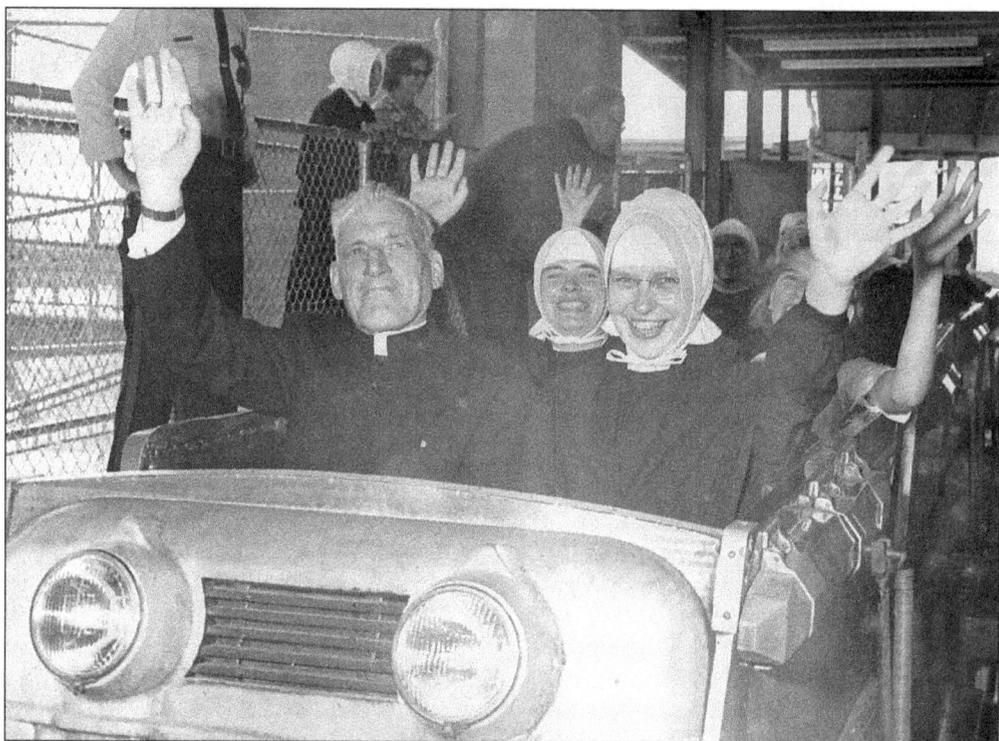

His Eminence Richard Cardinal Cushing often visited the Sunset House, a non-sectarian summer camp run by the Archdiocese of Boston on Sunset Point. A frequent visitor as well to Paragon Park, he always tried to cajole a few of the nuns in charge to take a spin with him on the Park's famous roller coaster. Sunset House is still in operation in Hull.

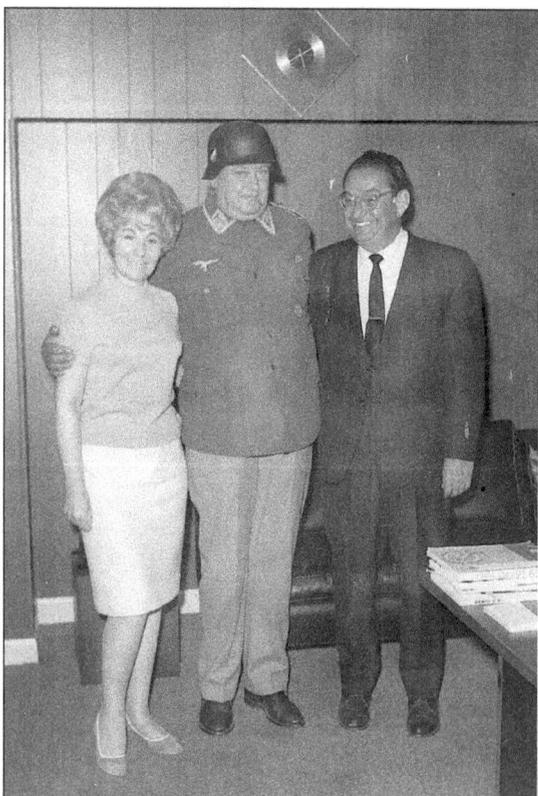

John Banner, who played Sergeant Schultz on TV's "Hogan's Heroes," visits Hull in full uniform. Shown in this photo are Banner with the owners of Paragon Park. They are from left to right Phyllis Stone, Banner, and Lawrence Stone. When asked about the whereabouts of his boss Colonel Klink (Werner Klemperer), he said he knew nothing.

Kennedy connections continued in Hull. Then Congressman John F. Kennedy spoke at the dedication of the Memorial School in 1948. A young Ted Kennedy made frequent appearances at political and community functions. Here he is greeted at Paragon Park by Lawrence Stone and Dr. Harold Turner.

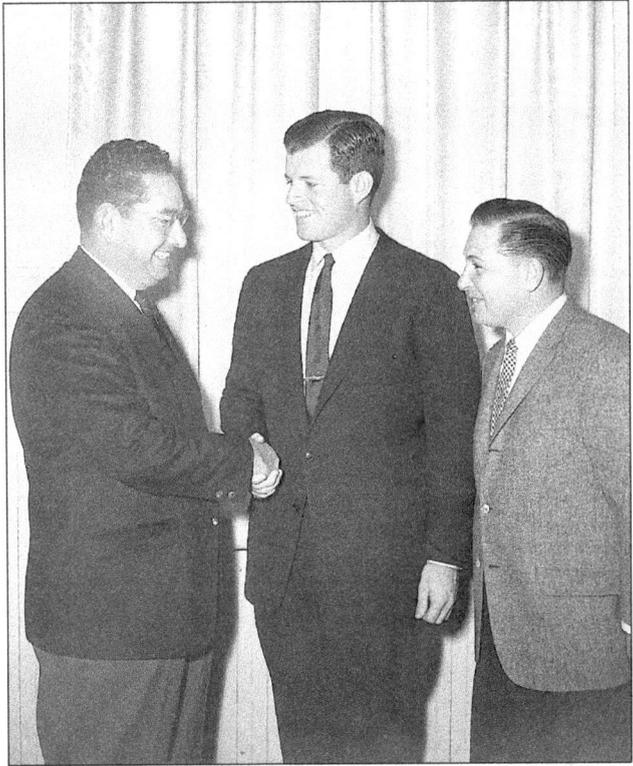

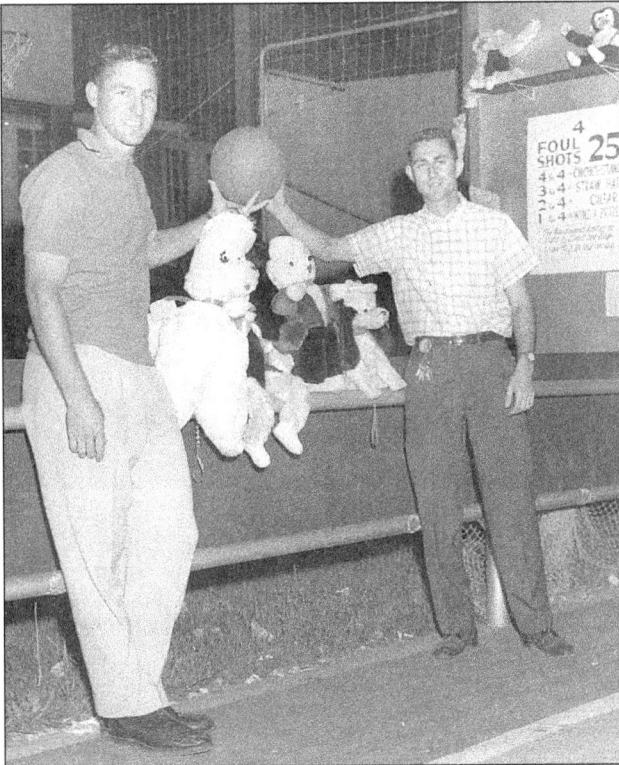

Boston Celtic great Bill Sharman (left) visited Paragon Park in 1958. Here he is giving Myron Klayman, Paragon's game manager, a lesson in foul shooting. Sharman spent 11 seasons with the Boston Celtics, won the NBA Free Throw Shooting title 7 times, and was chosen for the NBA All Star First team 4 times. He and Bob Cousy made up one of the finest back court pairs in NBA history.

A truly humble American hero, Hull's "Papa" Louis Anastos pulled 50 people from the horrific Cocoanut Grove Fire on November 28, 1942. He was on leave from his Coast Guard duty on Martha's Vineyard and was walking down Piedmont Street in Boston when he saw flames bursting out of the nightclub. Unhesitatingly charging into the fire, he rescued as many souls as he could before succumbing to smoke inhalation, waking up days later in the Chelsea Naval Hospital. A family friend located him and got word to his family in Hull, who had feared the worst. At home a few days later, he told his story to his father, and then years later, once more to his wife Adrienne. After that moment, he never told the story again. In his later years he operated Anastos Corner Restaurant, today still a popular local eatery run by his son and family.

Ten

PARAGON PARK AND LOCAL AMUSEMENTS

CAROUSELS TO SALT WATER TAFFY

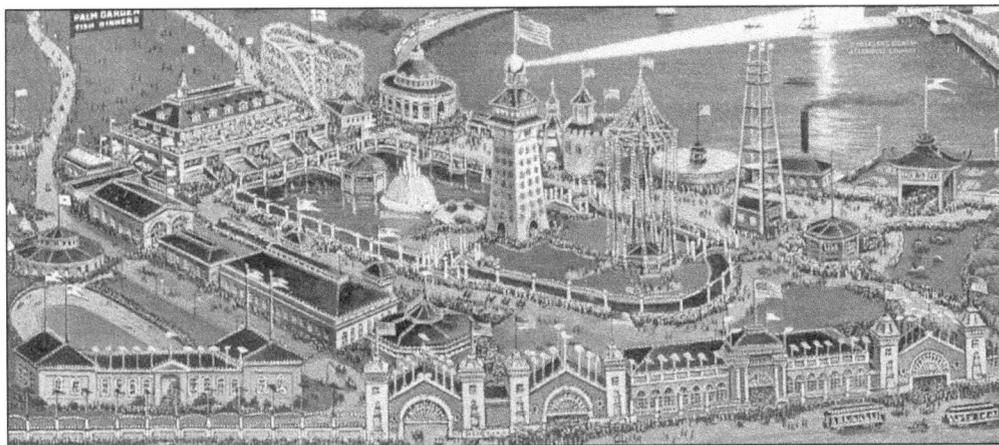

The southern end of Nantasket Beach has been a popular resort area since the 1870s when various amusements, restaurants, and an aquarium lined the beachfront. When Paragon Park was built in 1905 by a group of Boston businessmen, it was advertised as "New England's World Fair," a "$500,000 creation with 50,000 electric lights." George A. Dodge managed Paragon Park until David Stone saved it from bankruptcy in 1920. The Park was owned and operated by David and Rose Stone, and later by their sons, Joseph and Lawrence, and Lawrence's wife Phyllis, until it closed in 1985. Although many fires devastated Paragon Park throughout its history, continuous renovations helped it remain popular until it was sold.

The rialto flourished during the Paragon Park years and continues to this day with restaurants, penny arcades, and souvenir shops. Paragon Park and the surrounding area provided thousands of summer jobs for local residents over the years, as well as making Hull a popular destination and the source of many happy memories for millions of New Englanders.

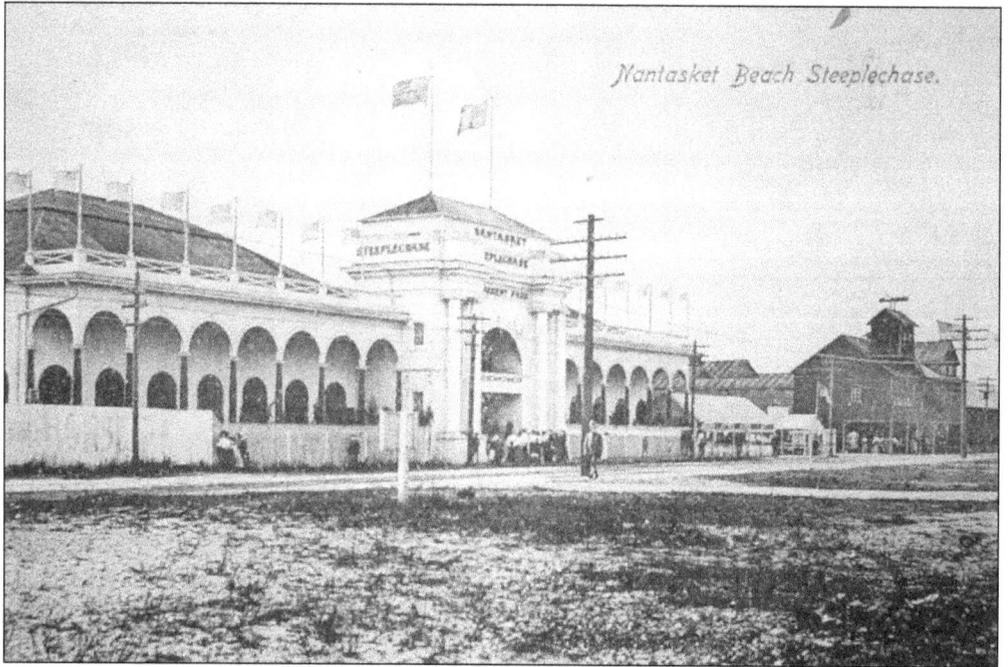

The Steeplechase, located at the intersection of Park and Nantasket Avenues, predated Paragon Park. Little is known about this attraction, but it was rumored to involve monkeys riding horses in a race.

Shoot the Chutes, another predecessor of Paragon Park, was located at the base of Atlantic Hill on the southern tip of Nantasket Beach until it was destroyed by the Portland Gale of 1898.

Grant's Coaster, built in 1901 for the Nantasket Point midway, was moved to the beach across from what is now Anastos corner when that park was dismantled. The 55-foot-tall coaster was initially considered so frightening that it had to be modified to attract customers.

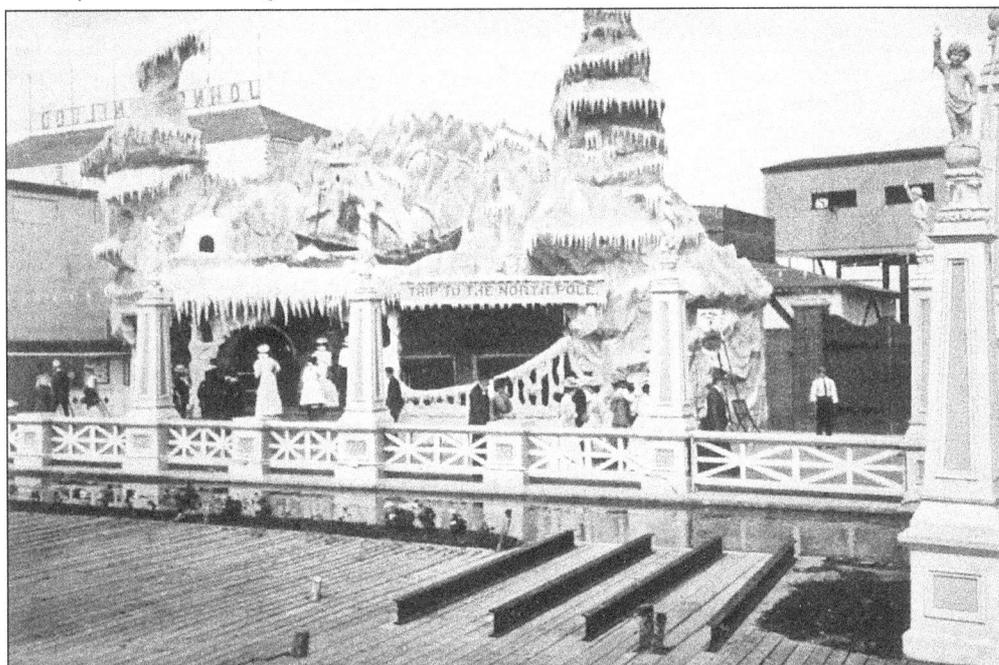

A trip to the North Pole was one of the many scenes from Paragon's days as "New England's World Fair." The Johnstown Flood is to the left, an exhibition based on the famous 19th-century disaster. The original design of Paragon Park was inspired by the Chicago Exposition of 1898.

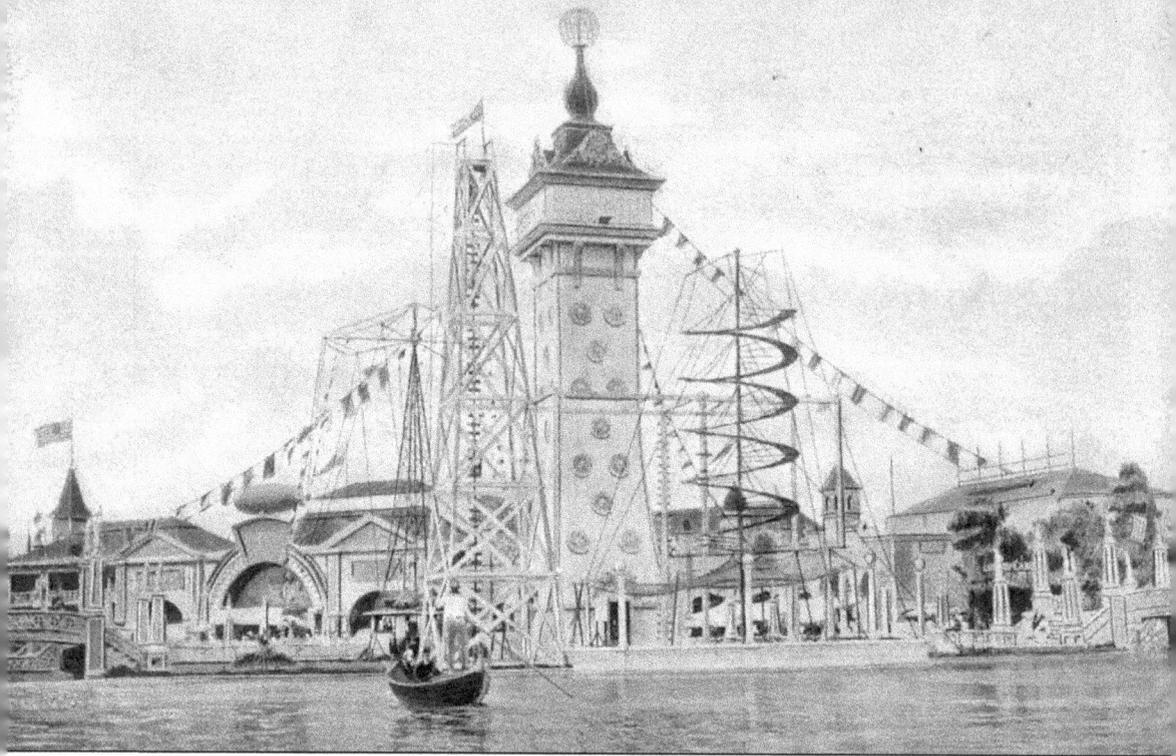

This ground level view of the original Park shows a genuine gondola and gondolier from Venice, the 110-foot platform from which a daredevil dove into 4 feet of water, the 150-foot Beacon Tower, and the entrance to a tree lined Lover's Lane behind the bridge. In addition to rides and exhibitions, Paragon provided an open air circus featuring animal acts, gymnasts, trapeze artists, an "aeronaut" who parachuted from a balloon at 1,000 feet in the air, and "The Demon," who slid down a wire into the lagoon while engulfed in flames.

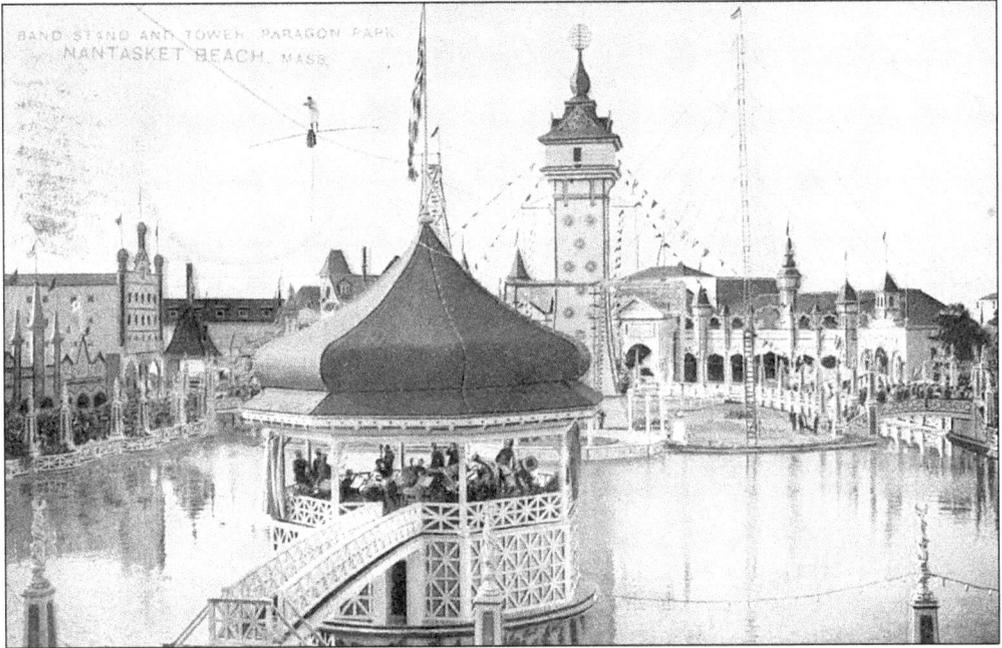

The bandstand in front of the Palm Garden extended into the lagoon to allow patio diners, as well as Park patrons, to enjoy the frequent free concerts held there.

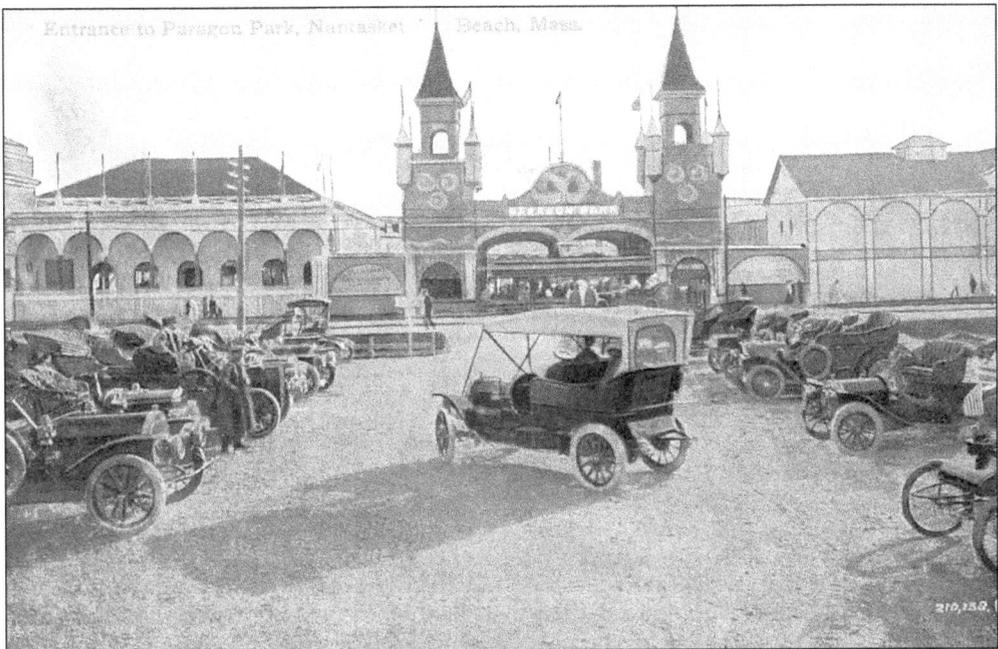

The majestic entrance to Paragon Park was designed to recreate the look of a European castle. Its 20 acres of amusements were said to be the equal of any in the world.

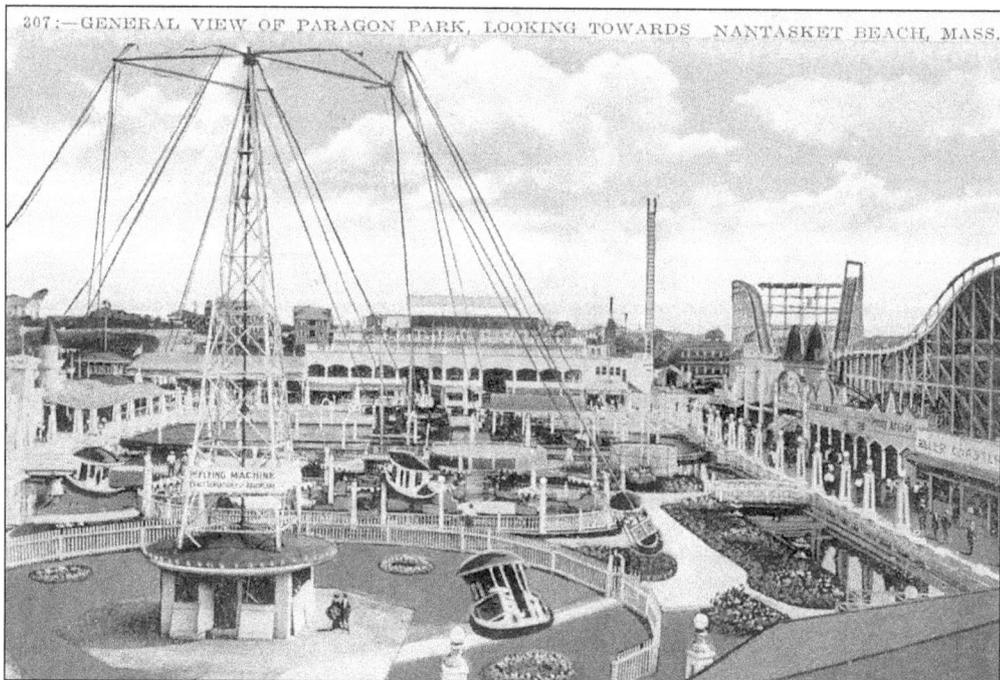

This view from the front of Paragon predates the building of the Carousel Pavilion in 1928. The Flying Machine ride in the foreground operated under a series of different names until the late 1960s.

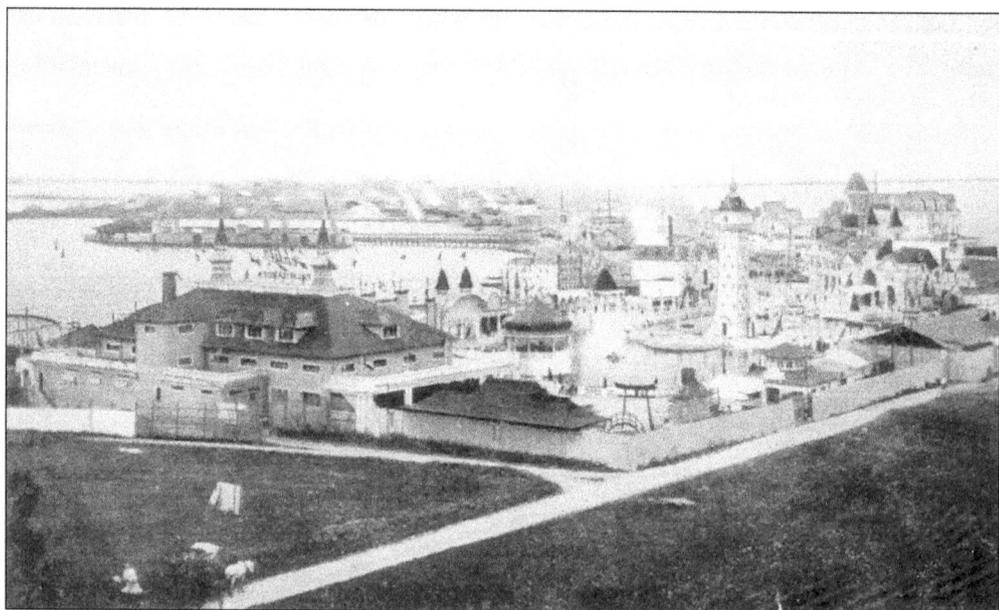

This view from the Rockland House, c. 1910, includes the Beacon Tower, the lagoon, the Great Buddha, and other attractions at the original Paragon. The Palm Garden is at the bottom left. The steamship landing at Nantasket Pier and Sagamore Hill are in the distance to the left. The Hotel Nantasket is to the right.

114

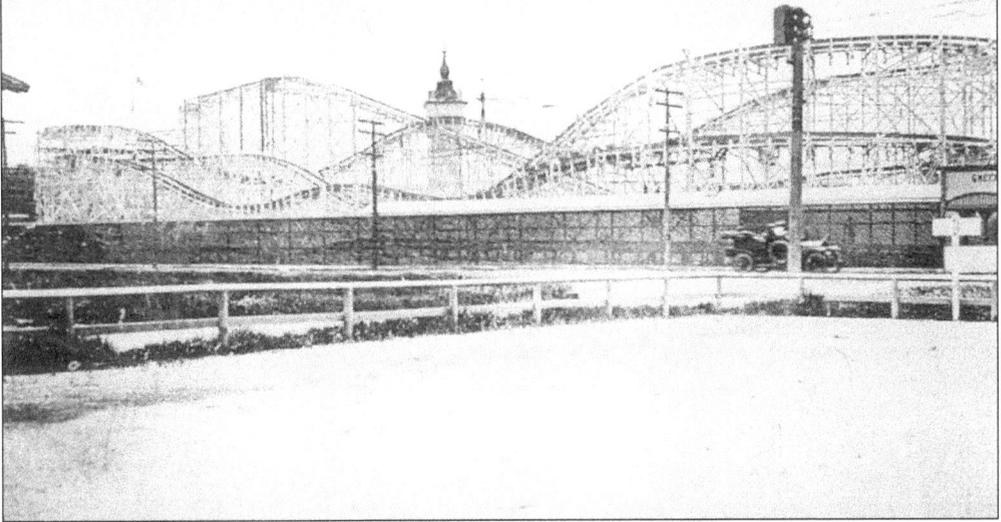

New Roller Coaster,
Nantasket Beach, Mass.

Paragon's roller coaster changed many times over the years. This "new" edition was built in the 1920s. At one time this coaster was said to be the largest in the world.

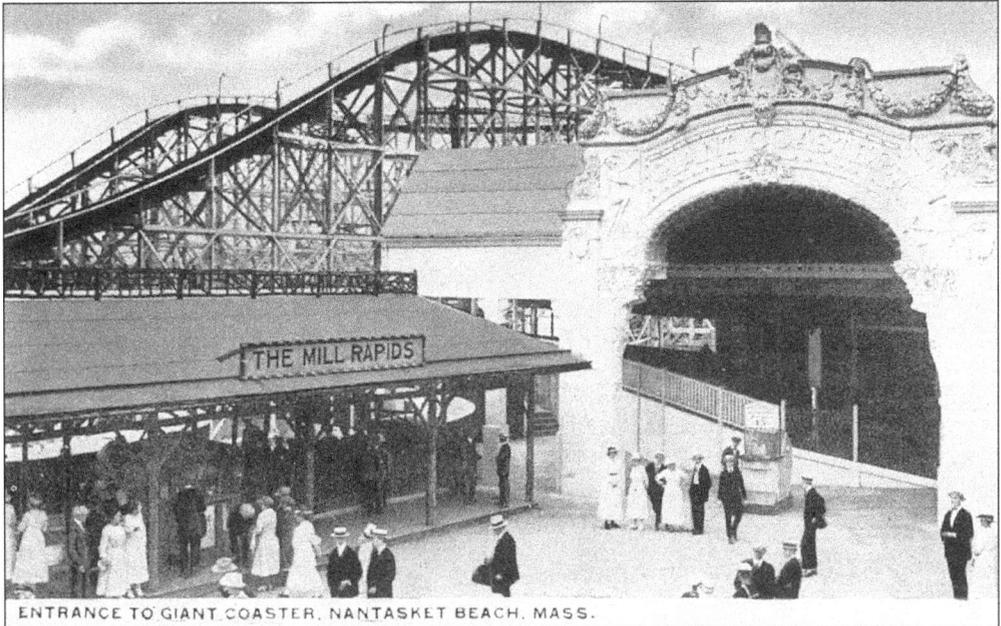

THE MILL RAPIDS

ENTRANCE TO GIANT COASTER, NANTASKET BEACH, MASS.

Shown here is the entrance to the Giant Coaster and the Mill Rapids, c. 1920. The Mill Rapids later became the Red Mill, which featured scenes from popular fairy tales. When the Red Mill was destroyed by fire in 1963, Paragon's tunnel of love became The Jungle Ride. The name was changed the next season to the Congo Cruise. The Bermuda Triangle, a water ride, was Paragon's dark ride in this location. Regardless of the names given to the rides, they all featured a surprise splash down into a pool of water at the ride's end.

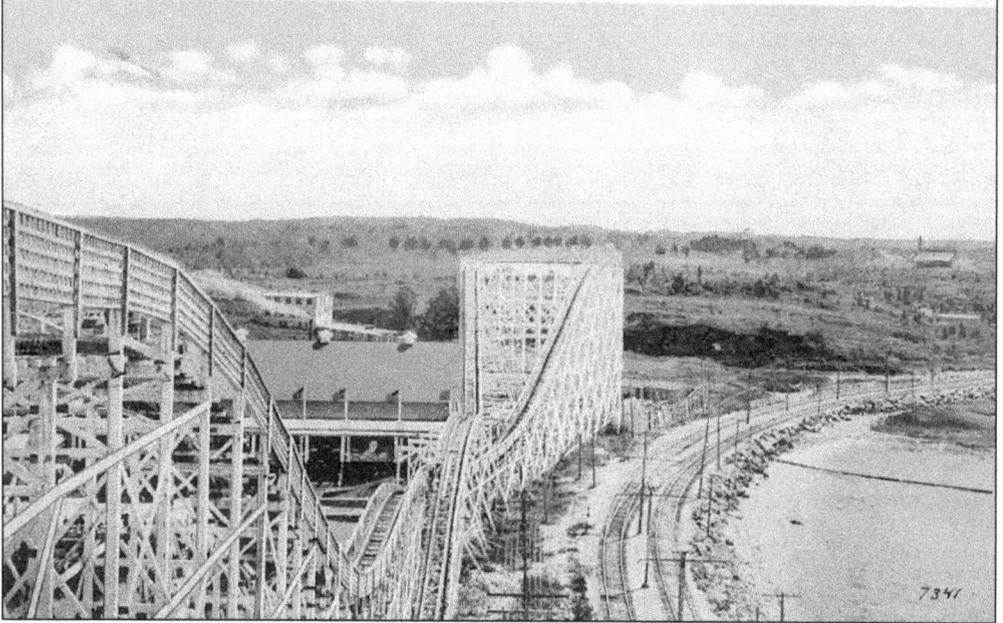

Roller Coaster, Paragon Park, Nantasket Beach, Mass.

This photograph of the far curve of the Giant Coaster, *c.* 1920, also shows the railroad tracks next to the bay. In later years, this part of the bay was filled-in to provide land for George Washington Boulevard.

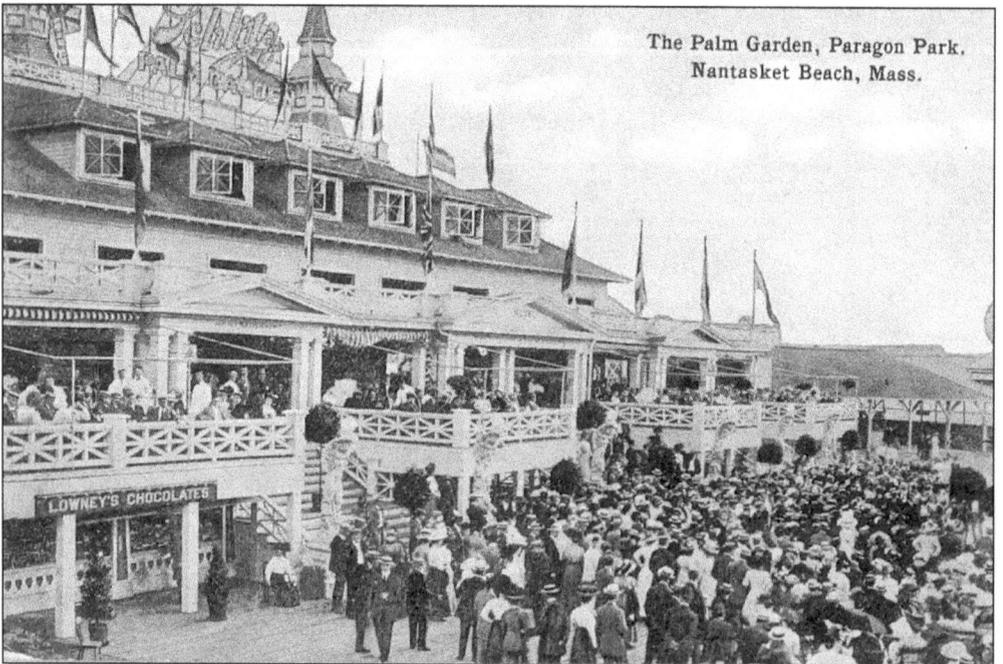

The Palm Garden, Paragon Park, Nantasket Beach, Mass.

LOWNEY'S CHOCOLATES

The Schlitz Palm Garden, styled after a traditional German beer hall, was famous for its fine food and outdoor patio dining. The Palm Garden played a large role in Paragon's early popularity offering minstrel shows, a banjo orchestra, a cabaret, and free band concerts.

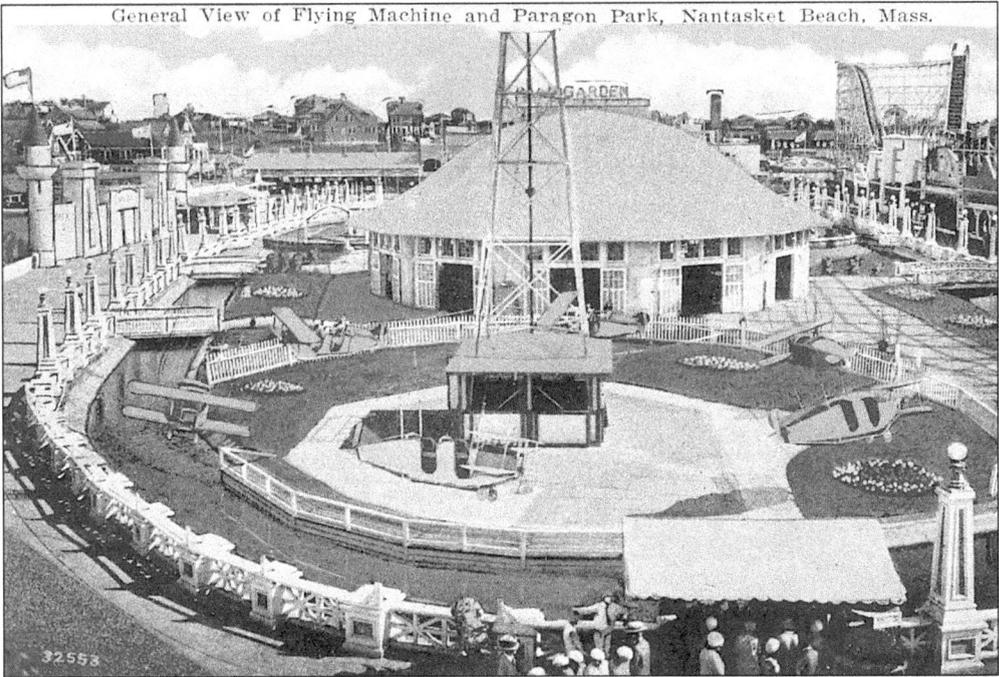

General View of Flying Machine and Paragon Park, Nantasket Beach, Mass.

The Flying Machine's gondolas had been changed to biplanes in this view after the 1928 construction of the "Carousel Pavilion." Notice the small bridges that span the lagoon.

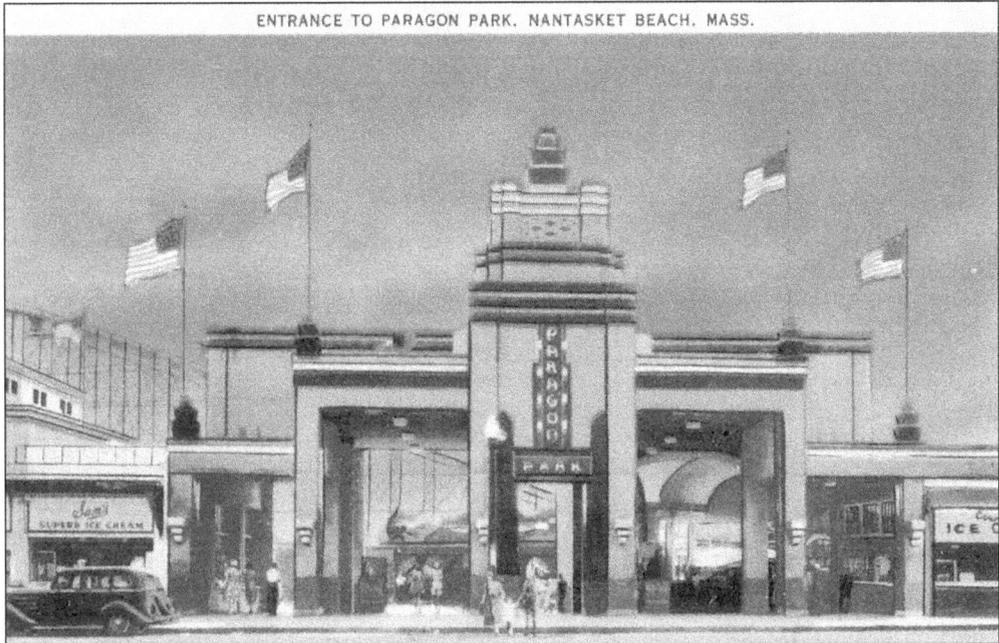

ENTRANCE TO PARAGON PARK. NANTASKET BEACH. MASS.

This Art-Deco-style entrance to Paragon from the 1930s was bright yellow and blue, and remained a landmark until a massive fire consumed it in April of 1963. The fire also destroyed the Red Mill, two refreshment stands, and the back end of the roller coaster. In order to open for the 1963 season, a chain link fence, large sign, and tall flagpoles became the new front entrance.

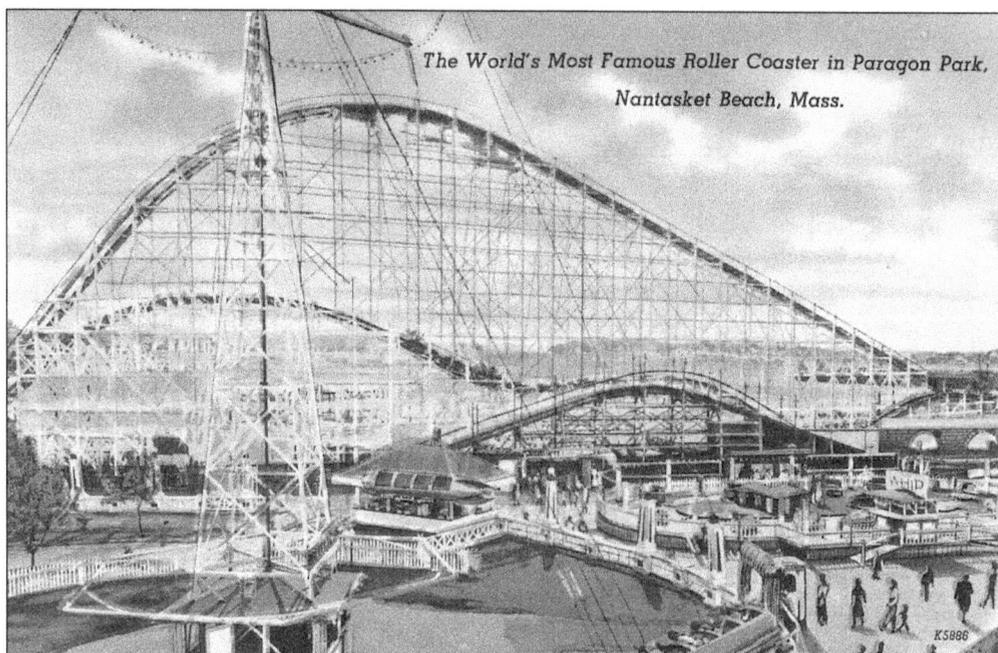

The World's Most Famous Roller Coaster in Paragon Park, Nantasket Beach, Mass.

Looking toward the bay, this photograph shows the Flying Machines, now called the Rocket Swings, as well as the Whip, the Red Mill, and the Giant Coaster.

The Philadelphia Toboggan Company built the Paragon Carousel in 1928. The carousel contains 66 hand-carved horses and two Roman chariots. With its horses standing four abreast, it is considered a "grand" carousel. When Paragon closed in 1985, the Carousel was sold to local investors, who moved the Carousel and the Pavilion to its new location next to the Clock Tower. The Friends of the Paragon Carousel, Inc. own and operate the Carousel, Hull's only remaining ride from Paragon Park.

118

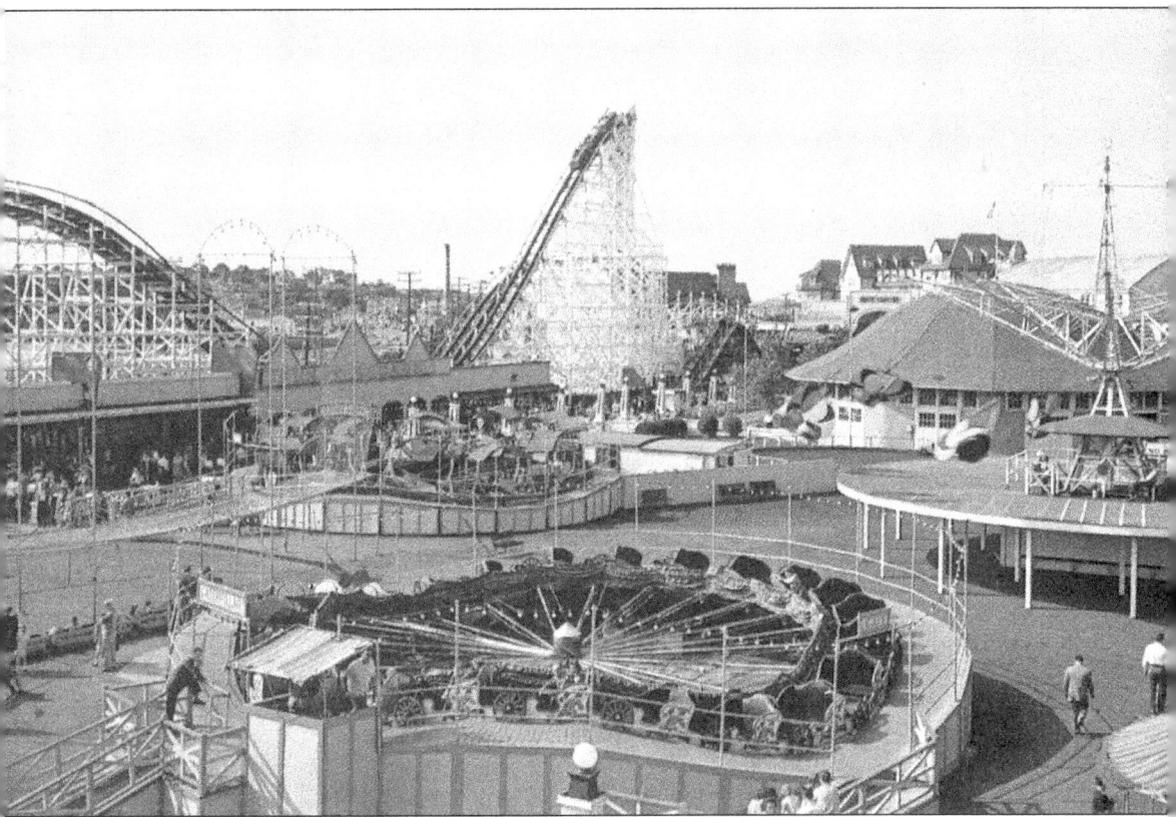

This photograph from inside Paragon, looking east, shows the Caterpillar, Lindy Loop, Flying Scooters, and the Carousel Pavilion, then more commonly known as the merry-go-round. The building along the midway contained a penny arcade and many "games of skill," such as Shooting Waters, Hoopla, dart games, ball toss, and others. Thousands of stuffed animals were won there each summer. A trapeze act is set to perform in the area to the left. The white building beyond the Carousel is the famous funhouse Hilarity Hall. The Hotel Nantasket is also visible in the distance.

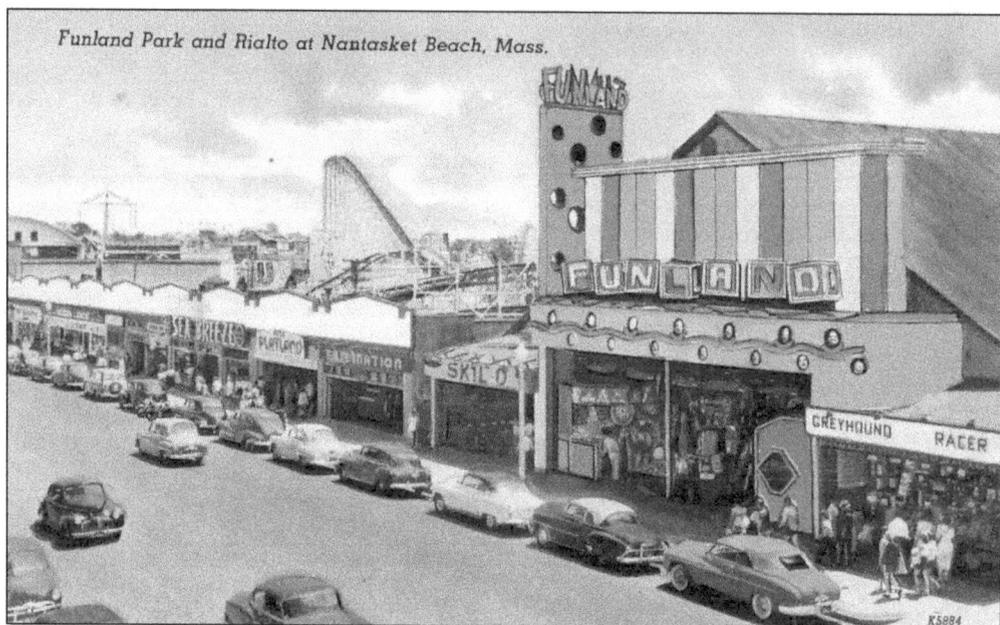

Funland Park and Rialto at Nantasket Beach, Mass.

Nantasket Avenue's rialto area offered numerous attractions in the 1940s and '50s, including the Sea Breeze Restaurant, Walking Charlie, Skil-O, Fascination, Playland Arcade, and Funland, a small, satellite amusement park which survived into the 1980s. At that time the outdoor amusements were replaced by a water slide. A miniature golf course has subsequently replaced the water slide. The Funland building remains an arcade, now called the Dream Machine.

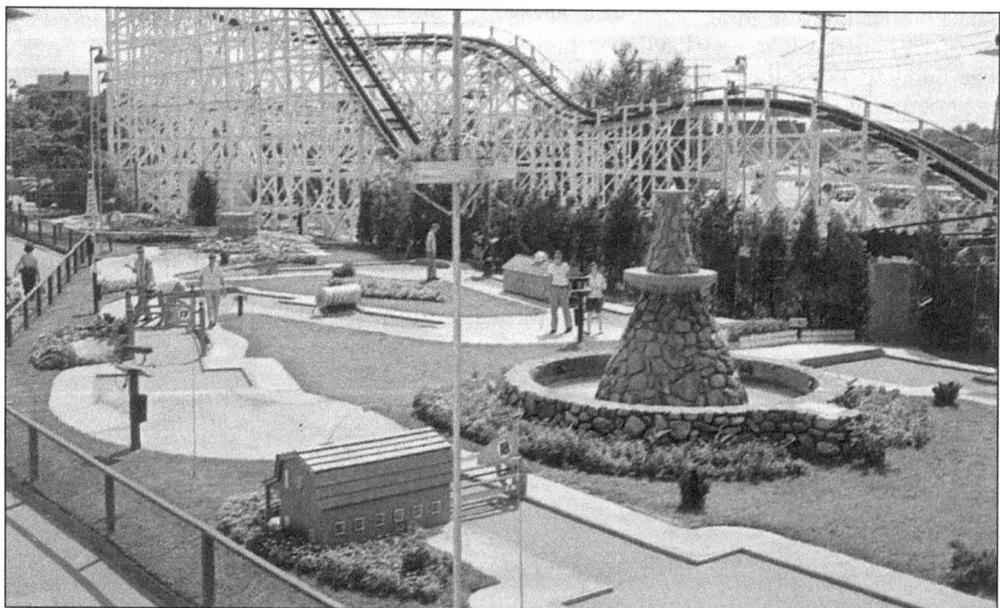

Golfland at Paragon was a beautiful 18-hole miniature golf course notable for its fountains and dozens of colorful flowerbeds. Two passageways connected the nine holes inside the far turn of the Coaster with the nine outside. Larry Stone, Leonard Gelfand, and Myron Klayman owned this concession.

120

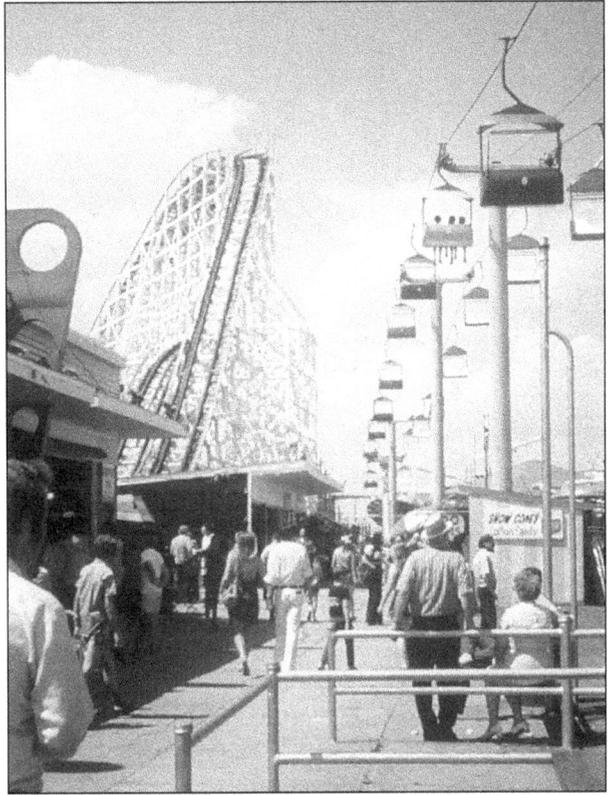

The SkyLark was a popular aerial ride, similar to a ski lift, which gave the rider a magnificent view of the Park, the bay, and the Atlantic Ocean. On the left is the 96-foot drop of the first hill of the Giant Coaster.

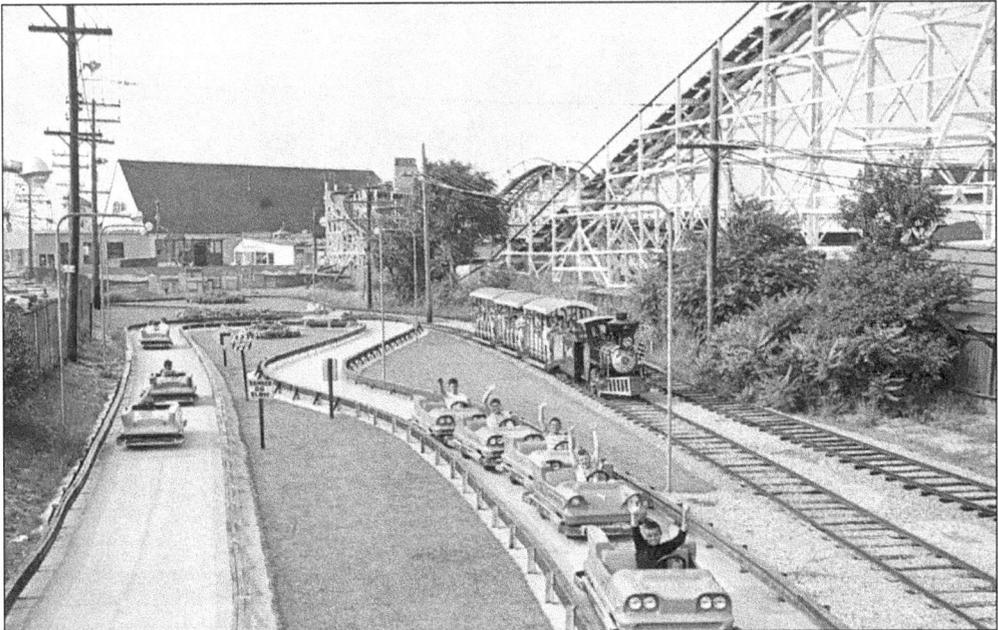

Paragon's Magic Mine Train and the Turnpike were built where the Old Colony and New Haven Railroads once ran. The Turnpike cars were go-karts with fiberglass bodies, featuring the rear fins popular in the 1950s. Funland's arcade building and Ferris Wheel are in the distance.

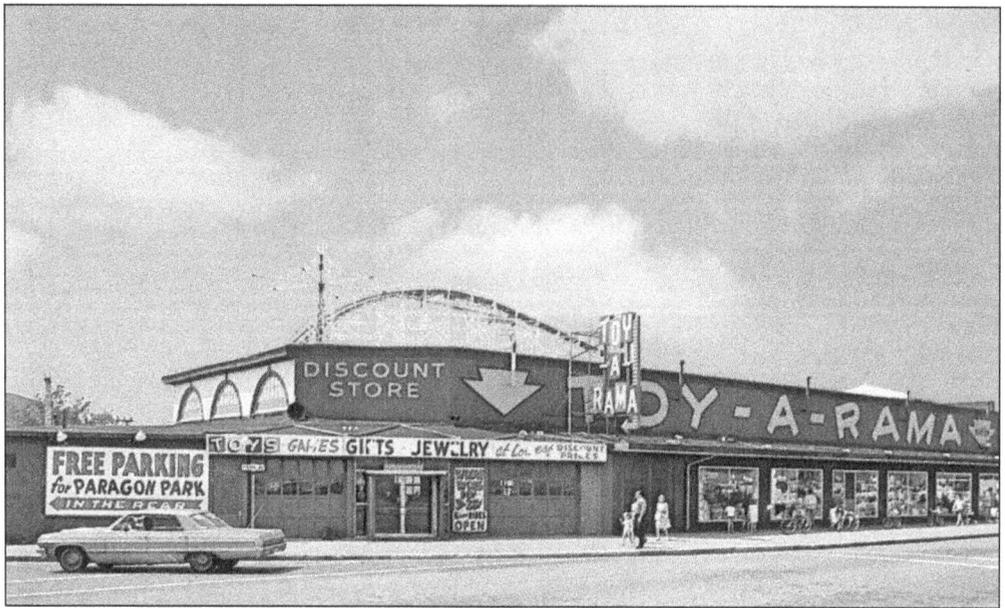

Toy-A-Rama, located in the building that once housed Paragon's skating rink, was one of the forerunners of the discount store. Another store of this type was Arcade Bazaar, which was located up the street at Funland Park. Utilizing space that served as arcades during the summer, these stores were open from mid-September through early January, attracting customers from the South Shore and greater Boston area.

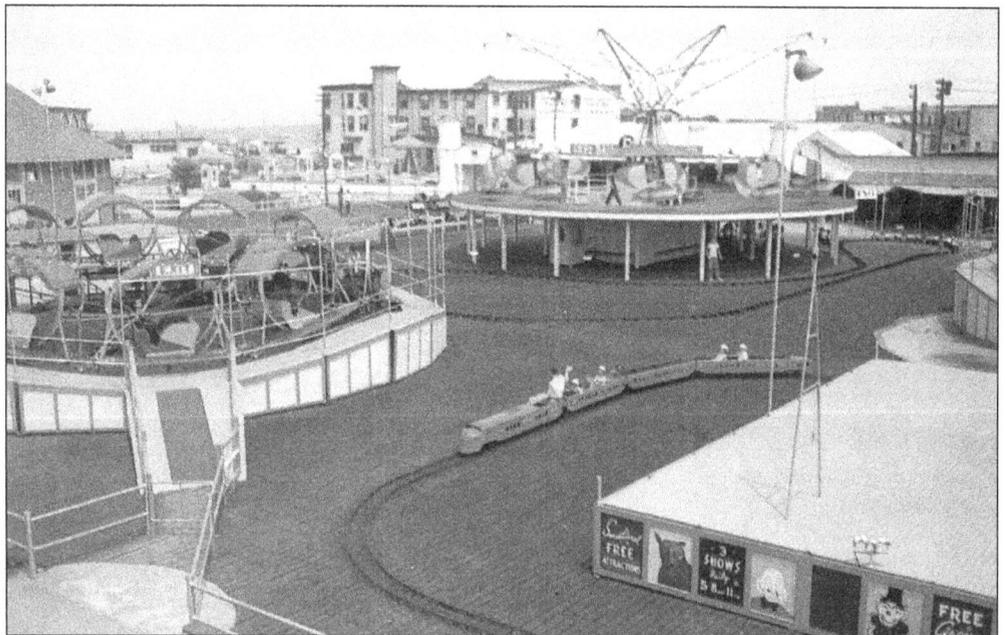

This Paragon view of Lindy Loop, Kiddie Train, Flying Scooters, and Skeeball Arcade, shows the outdoor kiddie park in the upper left. The stage in the foreground was the site of three free shows daily featuring famous circus acts, acrobats, daredevils, trained lions, tigers, elephants, dogs, and pigs, as well as many television, radio, and movie personalities.

122

The Giant Coaster at Paragon Park was built by John Allen of the Philadelphia Toboggan Company. It was 3,400 feet long and 96 feet high, making it at one time the highest and longest coaster in New England. In the 1960s, the *New York Times* named it one of the top ten coasters in the world. The ride may have lasted only a minute but the thrill was unforgettable. Paragon's Giant was a Perennial favorite of the Roller Coaster Enthusiasts of America.

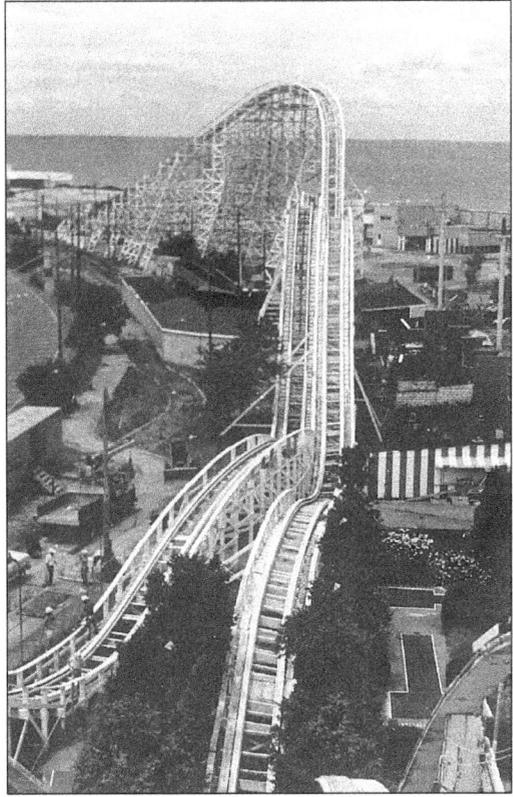

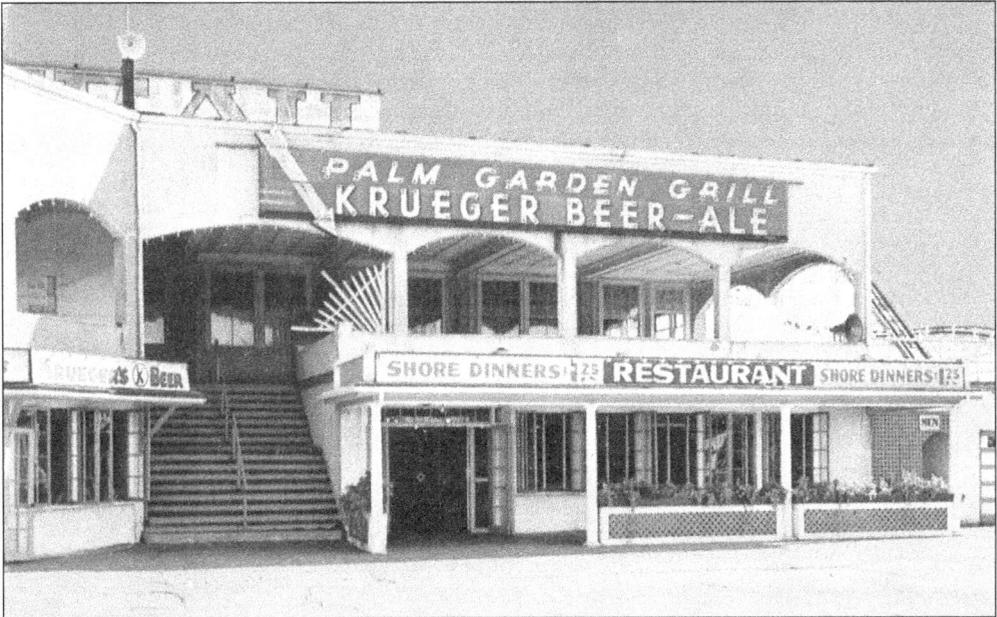

The Palm Garden and the Chateau Ballroom had lost some of their lustre by the 1950s but remained popular for their dances and auctions. Professional wrestling exhibitions held there featured Killer Kowalski, Haystack Calhoun, and many other well-known wrestlers of the time. When the Palm Garden burned down in the 1960s, the Blue Bunny nightclub replaced it.

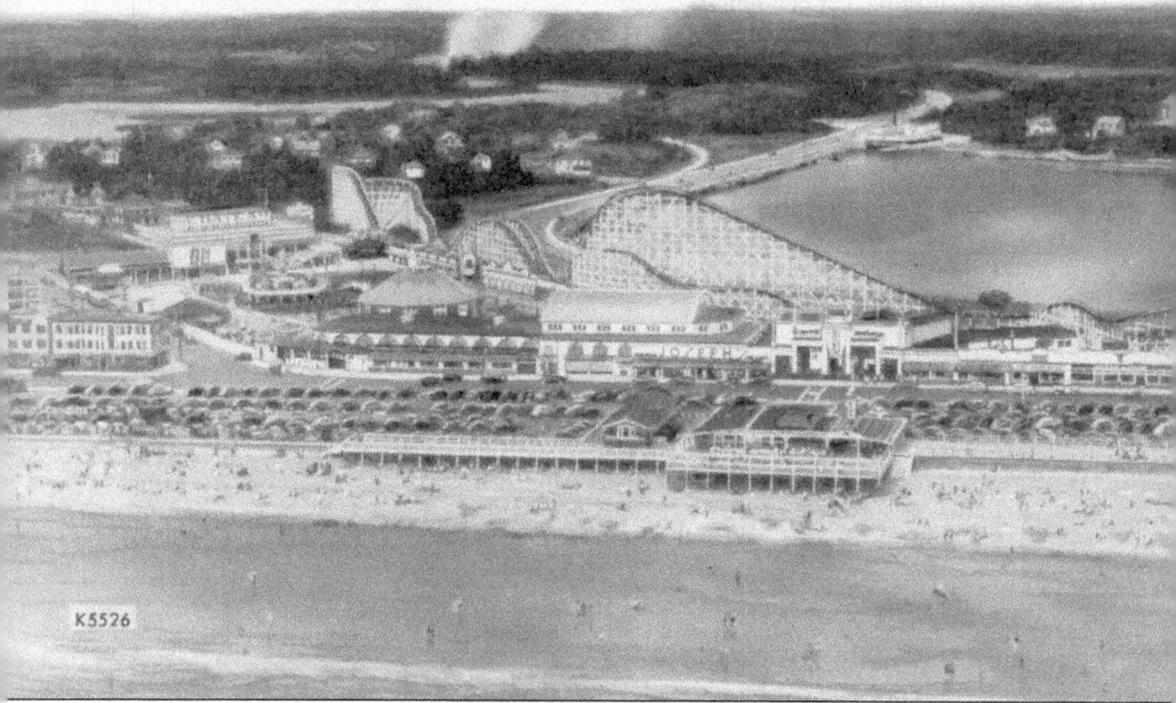

This aerial view of Nantasket provides an overview of the beachfront in the mid-1950s. Tivoli Pavilion, on the beach, was destroyed by a storm in the late '50s. Paragon's roller skating rink, Hilarity Hall, the Carousel, Flying Scooters, Bumping Cars, Chateau Ballroom, and the Giant Coaster are also prominent. The *Mayflower* steamship, renamed the Showboat after it was brought on shore to become a nightclub in 1948, is visible in the distance.

BIBLIOGRAPHY

Readers wanting more information on Hull and Nantasket Beach may find the following materials helpful, several of which were used in researching this volume. The Committee, which welcomes references for additional information, pictures, and postcards concerning Hull and Nantasket Beach, can be reached c/o The Hull Public Library, Main Street, Hull, MA 02045, tel.: 781-925-2295.

Bergan, William M. *Old Nantasket*. Quincy, MA. Christopher Publishing House, 1968.

Butler, Gerald W. *The Guns of Boston Harbor*. Unpublished manuscript.

Homer, James Lloyd. *Notes From the Sea Shore*. 1848.

Jennings, Harold. *A Lighthouse Family*. Orleans, MA: Lower Cape Publishing Co., 1989.

Kimball, Sumner J. *Joshua James*. Boston, MA. American Unitarian Assoc., 1909.

McGarigle, Bob. *Transportation Bulletin "Nantasket Beach Branch."* Warehouse Point, CT. Connecticut Valley Chapter of the National Railway Historical Society, Inc., 1981.

Means, Dennis R. E.A. *Bartlett's Nantasket Beach-A Pictorial Introduction to Hull, Massachusetts During the 1890s*. Hull, MA: Privately Published, 1995. [The photograph on page 65 is (c) Dennis R. Means 1999, from an original glass negative of E.A. Bartlett.]

Moore, John. *History of Hull: Hull, MA*. Hull Beacon, 1900. (On file at the Hull Public Library.)

O'Reilly, John Boyle. Selected Poems. Cincinnati, OH: Friendly Sons of St. Patrick, 1914.

Roche, James Jeffrey. *Life of John Boyle O'Reilly*. Philadelphia, PA. John J. McVey, 1891.

Smith Jr., Fitz-Henry. *Storms and Shipwrecks in Boston Bay and The Record of The Life Savers of Hull*. Boston, MA. Privately Printed, 1918.

_____. *The French at Boston During the Revolution*. Boston, MA. Privately Printed, 1913.

_____. *The Story of Boston Light*. Boston, MA. Privately Printed, 1916.

Snow, Edward Rowe. *The Romance of Boston Bay*. Boston, MA. Yankee Publishing, 1944.

_____. *Storms and Shipwrecks of New England*. Boston, MA. Yankee Publishing, 1943.

Sweetser, M.F. *King's Handbook of Boston Harbor*. Boston, MA. Reprinted by the Friends of the Boston Harbor Islands, Inc., (617-740-4290).

Thoreau, Henry David. *Cape Cod*. New York, NY. Thomas Y. Crowell Co., 1961.

For additional information and exhibits about Hull-Nantasket Beach the reader is directed to:

Boston Light Preservation Society, c/o 5 C Street, Hull, MA 02045, (781-925-1587)

Enjoy! Hull Committee, Municipal Building, 253 Atlantic Avenue, Hull, MA 02045 (1-888-925-HULL; 4855)

Fort Revere Park and Preservation Society, Inc., P.O. Box 963, Fort Revere, Farina Road, Hull, MA 02045

Friends of the Paragon Carousel, Inc., 1 Wharf Avenue, Hull, MA 02045 (781-925-0472)

Hull Historical Commission, Municipal Building, 253 Atlantic Avenue, Hull, MA 02045 (781-925-2000)

Hull Historical Society, c/o 26 Vautrinot Avenue, Hull, MA 02045, (781-925-0195)

Hull Lifesaving Museum, Inc., P.O. Box 221, 1117 Nantasket Avenue, Hull, MA 02045, Hull, MA: (781-925-5433)

Hull-Nantasket Chamber of Commerce, 115 Nantasket Avenue, Hull, MA 02045 (781-925-9980)

The Hull Public Library, Main Street, Hull, MA 02045, (781-925-2295).

ACKNOWLEDGMENTS
AND DEDICATION

This book is not the product of one person's labors, but rather represents the contributions and support of many people. While there was a core group which met for many days and evenings, including during the terrific (and often hot!) summer weather, many others contributed to the success of this project. Whether they came to meetings, called with ideas, lent us pictures, or even just offered support and encouragement, they all had a part in the making of this history. One kind resident, Mary Salerno, eagerly lent us the photographs literally off her walls of views we had not seen elsewhere, after they were observed at her home during her son's wedding. Another community friend and former resident (does one really ever stop being a resident of Hull?), Theodore Lorentzen, loaned us his terrific postcard collection. Longtime resident Phyllis Stone, who owned Paragon Park with her family, dug out old photographs of some of the famous people who visited our town and Paragon Park. Each person had a story to tell—a remembrance of the history of this beautiful seaside community.

At the risk of omitting any names, and with apologies if we do, we want to acknowledge the help of all the residents and friends of the Town, including (in no special order) the Hull Historical Society (which has a phenomenal exhibit at its museum), the Hull Lifesaving Museum (a true gem of a museum with fascinating exhibits about the maritime history of Hull and Boston Harbor), the Fort Revere Park and Preservation Society (where one can enjoy fantastic views from the observation tower and view military artifacts), the Friends of the Paragon Carousel (featuring a working 1920s Philadelphia Toboggan carousel), Hull Public Library (a charming Victorian building, which is the former home of Irish poet John Boyle O'Reilly and full of knowledge), Nick Cotoulos of Pasquale's Prints, Ginny Capo, Hull Senior Center and Hull Council on Aging, Lynne Layman (photograph on p. 54, top, (c) and courtesy of Lynne Layman, Photographer), Barbara Kiriakos, Hildred Parent, Hull Assessor's Department, Mary Shaner, Ethel Farrington-Smith, Josh Cutler, Wayne Eckerson, Theodore Lorentzen, Adrienne Anastos, Ruth Harrington, Tom Hannon (photograph on p. 54, bottom, (c) and courtesy of Hannon Air Views), Dan McGrath, Mary Salerno, Gerard Sperry, Judeth VamHamm, Phyllis Stone, Hull Redevelopment Authority, Hull Municipal Light Plant, Gerald W. Butler, Dennis R. Means and the Means Library (photograph on p. 55 (c) and courtesy of

Dennis R. Means and the Means Library), United States Coast Guard, Sue Fleck and Family, The Hull Historical Commission, Gladys Means, Carol Muldoon, Joseph Winn and Fieldstone Publishing Company (map p. 6 (c) and courtesy of Joseph Winn and Fieldstone Publishing Company), The Hull Board of Selectmen, The Hull Nantasket Chamber of Commerce, The Galler Family, the O'Brien Family of Jake's Seafood, Town Hall, Fred B. Seitz Jr., Roslynd Cutler, Lawrence Hallahan, Kathleen Atwood, Al Schroeder, the Metropolitan District Commission, Commonwealth of Massachusetts, the Hull Police Department, the Hull Fire Department, The Boston Light Preservation Society, *Hull Times*, *The Patriot Ledger*, Noble's Camera Shops, Norm Rogers, Nantascot Place Condominiums, The Hull Public Schools, Town Manager Philip E. Lemnios, and of course our families and friends, who excused us from spending time with them so that you could spend time with Hull.

We all owe a special debt of gratitude to several people who are no longer with us, but who nonetheless instilled in our community great civic pride and interest in our history. We know that if they were here today, they would be right in the middle of this project. Their insight and dedication has been a constant source of energy for us. We salute their efforts for our Town—Anne Kinnear, Helen Raymond, Philip Thayer Sr., Chief Daniel Short (Hull Police Department, Ret.), Chief Roger Means (Hull Fire Department, Ret.), and Dr. William M. Bergan.

In recognizing that our past history helps us understand the present and future, we dedicate this book to the residents and friends of Hull's past, present, and future—we of today express our gratitude to those of the past and to those who will follow into the future of our wonderful town!

The Committee for the Preservation of Hull's History

Regina Burke • R. Francis Cleverly • John J. Galluzzo
Daniel J. Johnson • Janet M. Jordan • Myron Klayman
James B. Lampke • Peter T. Seitz • Richard C. Shaner • Brison S. Shipley

(